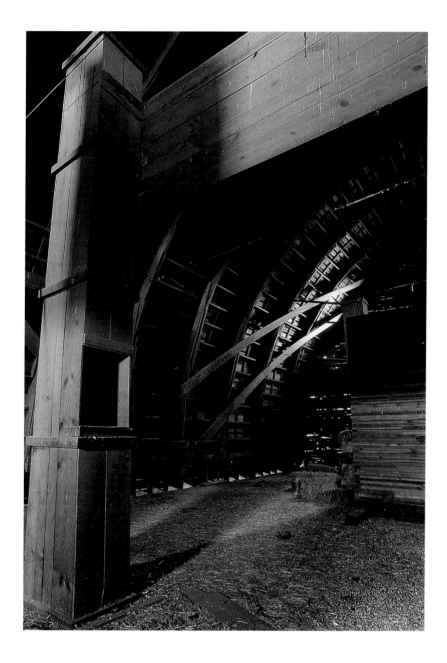

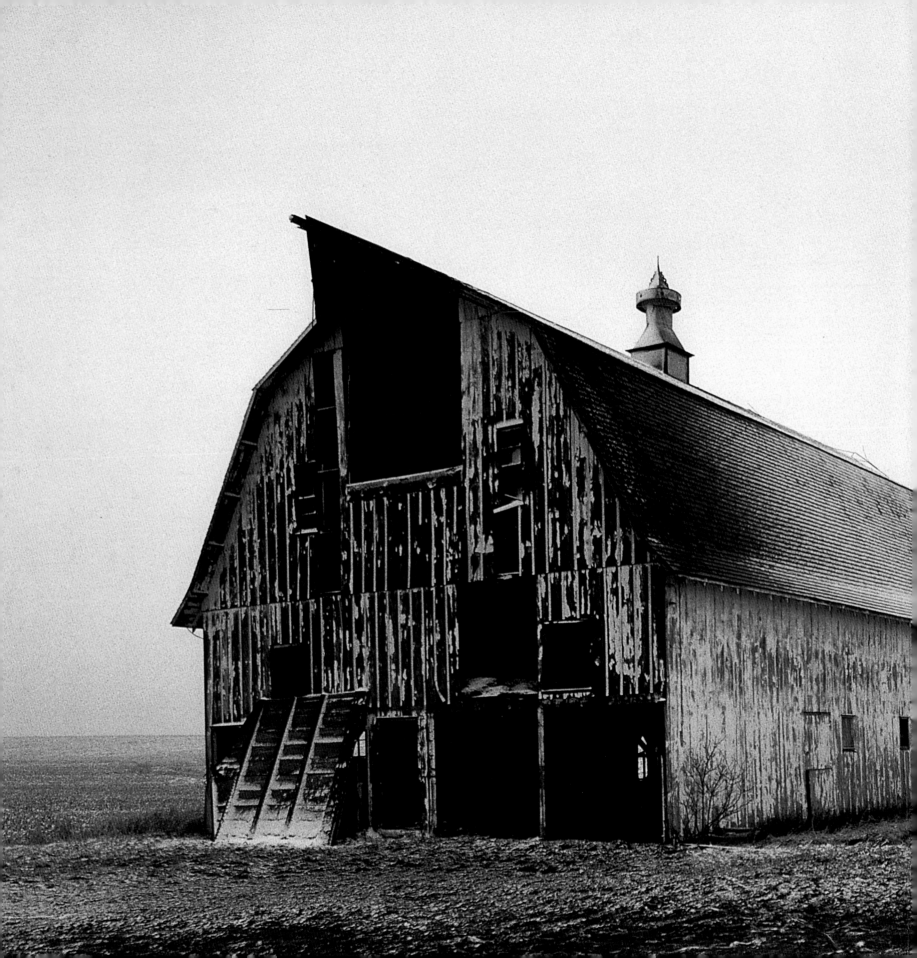

THE
AMERICAN
BARN

Randy Leffingwell

Motorbooks International
Publishers & Wholesalers ®

Dedication

This book is dedicated to my friend,
the late Jan Dryden (1944–1993),
photographer, poet, architect.

First published in 1997 by Motorbooks International Publishers &
Wholesalers, 729 Prospect Avenue, PO Box 1, Osceola, WI 54020-0001

© Randy Leffingwell, 1997

Motorbooks International is a certified trademark, registered with
the United States Patent Office

The information in this book is true and complete to the best of our
knowledge. All recommendations are made without any guarantee on
the part of the author or Publisher, who also disclaim any liability
incurred in connection with the use of this data or specific details

We recognize that some words, model names and designations, for
example, mentioned herein are the property of the trademark holder.
We use them for identification purposes only. This is not an official
publication

Motorbooks International books are also available at discounts in
bulk quantity for industrial or sales-promotional use. For details write
to Special Sales Manager at the Publisher's address

Printed in Hong Kong

Library of Congress Cataloging-in-Publication Data Available
Leffingwell, Randy.
 The American Barn / Randy Leffingwell.
 p. cm. — (10x10 series)
 Includes index.
 ISBN 0-7603-0109-3 (alk. paper)
 1. Barns—United States. 2. Vernacular architecture—
United States. I. Title. II. Series.
NA8230.L45 1997
728'.922'0973—dc21 96-52378

On the front cover: Sears, Roebuck and Company offered a variety
of barns through its mail order catalog. Helen Marie Taylor's beautiful
horse barn in Orange, Virginia, is a 1929 model. Sears kits included
virtually all material required and could even be ordered with Sears
carpenters to handle the assembly.

On the frontispiece: Gothic arch barn interior, St. John,
Washington.

On the title page: Romantic notions aside, a barn is ultimately a tool.
Renovation must be weighed against very real business considerations.

On the back cover: Top: A dairy barn at sunrise in Hardwick,
Massachusetts. Bottom: Dozens of Amish and Mennonite hands (and
a few English) raise a wall. With some 300 workers on site, this Amish
barn was constructed in a single day.

CONTENTS

ACKNOWLEDGMENTS

\mathcal{I} am deeply indebted to Vernon Kline and his family of Shreve, Ohio, for allowing me to enter their lives and photograph the raising of their barn. I am also grateful to Joseph J. "Josie" Miller of Apple Creek, Ohio, for his help, cooperation, and trust, and for his ongoing education in the art of barn building.

My education continues (to this day) thanks to generous efforts from John Brooks, Hardwick Frame Company, Hardwick, Massachusetts; Elric Endersby, the New Jersey Barn Company, Princeton, New Jersey; Bernard Herman, Vernacular Architecture Foundation, Department of Architecture and Urban Planning, University of Delaware, Newark, Delaware; Silas Hurry, archeological curator, Historic St. Mary's City, St. Mary's, Maryland; Professor Thomas C. Hubka, School of Architecture and Urban Planning, University of Wisconsin, Milwaukee, Wisconsin; Duncan Keir, Liberty Head Post and Beam, Huntington, Vermont; Henry Miller, director of research, Historic St. Mary's City, St. Mary's City, Maryland; Joseph J. Miller Jr., Apple Creek, Ohio; Larry C. Miller, treasurer, Butler Manufacturing Company, Kansas City, Missouri; Stephen S. Miller, curator of agricultural history, Landis Valley Museum, Lancaster, Pennsylvania; Bruce Brooks Pfeiffer, curator, archives, Frank Lloyd Wright Foundation, Taliesin West, Scottsdale, Arizona; Orlando Ridout, Maryland Historical Trust, Baltimore, Maryland; and Christopher Witmer, Kleinfeltersville, Pennsylvania.

I thank Bill Blair, interpretive supervisor, Yorktown Victory Center, Yorktown, Virginia, for help in photographing the tobacco barn and in understanding tobacco growing; Carol City at Plimoth Plantation, Plymouth, Massachusetts, for help in photographing their thatched-roof Dutch barn; Susan R. Duerst, administrator, Vermont Farm Bureau, Richmond, Vermont, for making available their monitor-roof bank barn; Randolph Harris, director, Historic Preservation Trust of Lancaster County, and Lew Reynolds, executive director, Lancaster House, for giving me access to the Hoober/Eby barn in Lancaster, Pennsylvania; Nina Maurer, administrator, Piscataqua Region, Society for the Preservation of New England Antiquities, for her willingness to completely disrupt her schedule; Sally Morse Majewski, director of marketing and development at the Hancock Shaker Village, Hancock, Massachusetts, for allowing me to wait out the weather to shoot the extraordinary round barn; Beth Mylander, marketing coordinator, Taliesin Preservation Commission, Spring Green, Wisconsin, for her repeated access to Frank Lloyd Wright's Midway Barns at Taliesin North, near Spring Green, Wisconsin; Debbie Padgett, Yorktown Victory Center, Yorktown, Virginia, for instant access to the tobacco barn; and Dennis Pogue, director of restorations, and John Riley, assistant to the director, George Washington's Mount Vernon Estate and Gardens, Mount Vernon, Virginia, for educating me about George Washington's threshing barn.

I am grateful to Harley E. Warrick, Belmont, Ohio, for his reminiscences of 45 years on the road and on the sides of barns for Mail Pouch chewing tobacco.

I owe much thanks to many people for their help. Their interest in their own barns and their leads to finding other significant and interesting barns around the

United States and Canada have made this book what it is:

William B. Armstrong, Harrington, Washington; Fred Asplen, Irvine, Kentucky; Marilyn Auen, Dennison, Iowa; Sue and Fred Bender, Walde, Ohio; Ralph and Horty Carpentier, East Hampton, New York; Lyle Cigler, Bozeman, Montana; Helen and Nunce Cina, Viroqua, Wisconsin; Allison Clark, Denver, North Carolina; Tom and Patt Cotter, Sherrills Ford, North Carolina; Marciel and Mel Cronrath, Harrington, Washington; Dorothy Ellis, Springfield Township, Michigan; Guy Fay, Madison, Wisconsin; Christina Fraioli, Lincoln, Vermont; Larry and Wendy Friesen, Altona, Manitoba, Canada; Milton Good, Dalton, Ohio; Raymond Hafer and Ruth Wren, Oley, Pennsylvania; Frederick and Frances Halverson, Brooklyn, Wisconsin; Ron and Marilyn Hamm, Altona, Manitoba; Elwood Hoch, Oley, Pennsylvania; Brian, Lisa, Douglas, and Christopher Jacobson, Edgerton, Wisconsin; Rick Jost, Sagaponack, New York; David B. Kaufman, Oley, Pennsylvania; Patricia Kellogg, Kamloops, British Columbia, Canada; Janis King, Walnut Creek Farm, Knoxville, Illinois; Paul and Thelma Kleffner, Helena, Montana; Dee Lambert, New Pine Creek, Oregon; Bob Lang, Waitsfield, Vermont; Alberta Lewallan, Linden, California; Melanie and Larry Maasdam, Clarion, Iowa; Jeff Marks, Denver, Pennsylvania; Frank and Martha McDougald, Pennington, New Jersey; Mark and Barbara McLaughlin, Milwaukee, Wisconsin; Kevin McQuillen, Hadley, Massachusetts; Joe Miller Jr., Kidron, Ohio; Laura Mitchell, Crystal, North Dakota; Ralph and Ruth Odenkirk, Orrville, Ohio; John O'Rourke, Accokeek, Maryland; Herman and Donna Ostry, Bruno, Nebraska; Alice Outback, Waitsfield, Vermont; Wayne and Edith Patenaude, East St. Johnsbury, Vermont; Albert and Madeline Petramala, Pinon Heights, Colorado; Mary and Bob Pollack, Denison, Iowa; Dan Popowich, Buckland, Massachusetts; Dorothea Purdy, Burns, Oregon; Jerald and Madolyn Redman, McComb, Illinois; Jerry and Liz Reilly, Hardwick, Massachusetts; Susan Salter Reynolds, Venice, California; Berkley Robertson Jr., Accokeek, Maryland; Nelson Rohrer, Lancaster, Pennsylvania; Dean and Debbie Ruebush, McComb, Illinois; Clyde, Mary, and Craig Rust, Davis, California; Jack Savage and Cheryl Kimball, Middleton, New Hampshire; Tony and Kay Schimpf, DX Ranch, Knutsford, British Columbia; John Skolfield, Winter Park, Florida; the Honorable Helen Marie Taylor, Orange, Virginia; Paul and Margaret Timmons, Barrington, New Hampshire; Robin Tucker, Los Angeles, California; Mrs. Aldine Valent and Jim and Frank Valent, Salamanca, New York; Julie and Rick Valenti, Pitt Meadows, British Columbia; Ruth Wheeler, Hardwick, Massachusetts; Gil and David White, St. John, Washington; Sarah Williamson, Huntington Center, Vermont; and June Zalewski, Viroqua, Wisconsin.

I am grateful to Lorry Dunning, historical consultant, Davis, California, for his vocal challenges and his gentle, thoughtful suggestions in getting this project started.

Finally, I thank my friend Michael Dregni for proposing this book idea; Larry Armstrong, my friend and director of photography at the *Los Angeles Times,* for his enthusiasm, support, and encouragement; and Amy Huberty, the book's designer, my editor, Zack Miller, and publisher Tim Parker, all at Motorbooks International, for making this happen.

PREFACE

I keep a quote from Joseph Conrad above my computer in my office. It reads: "Work is never finished, it's only abandoned." I have never felt the truth of that statement more than with this book.

I set out with the hope of tracing what happened to the barn from when it arrived in the New World to the present day. What I've come to understand clearly in the nearly three years I've been working on this book is that in order to really do that, I would have needed nearly as long as the barn has been in the New World. And it probably still would require a staff of researchers, historians, builders, and thinkers every bit as large as the crew that Josie Miller assembled for the barn raising that begins this book.

The subject—seemingly just the history of an agricultural building—is so much more convoluted and interwoven into cultural anthropology and politics, religion and economics, agriculture and industry, shipbuilding and railroading, personalities and animal husbandry, sociology and law, that even if I'd had nearly 400 years and 600 people, what I could know, what I would have photographed and drawn would not possibly fit into one volume. I've found, read, and studied books nearly this size dedicated to *one* style of barn during one short period of time in one geographic region. To do what I set out to would take a work of encyclopedic proportions.

What began as a single book project has infected me, and this complex subject will remain my interest for a long time to come.

Barns are referred to as "vernacular architecture" by scholars of North American history, architecture native to a country or region. But after all the work, the reading and researching, the time spent crawling around barns and photographing them, and interviewing barn builders and owners and historians, I think Webster's definition of vernacular as a noun describes better what an American barn really is. It is architecture *in the vernacular*, in "the common, everyday language of ordinary people in a particular locality."

Remember that definition as you read about—and see the barns of—such ordinary people as George Washington and Frank Lloyd Wright. They were farmers just as were the Society of Shaking Quakers in Hancock, Massachusetts, or Peter French in Oregon, or Daniel T. Skolfield in his retirement in Maine.

While this book is titled *The American Barn*, it is only *one* story of what happened to the barn between 1607 and tomorrow.

That said, I abandon this work to you. I hope you'll enjoy it.

—*Randy Leffingwell, Los Angeles*

INTRODUCTION

This book could be considered a tourist guide to the American barn. It follows the route from east to west across the North American continent, just as settlers did for nearly three centuries. Everyone who has driven down a country lane or across the continent can recall seeing barns teetering precariously or even collapsed into a mess of gray wood. Yet for each of those, there are 10 or 100 others still standing, still at work. It is those barns, built throughout the continent from the dreams and ambitions of millions of farmers that fill this book.

On a clear spring night in April 1993, fire destroyed a 150-year old barn on an Amish farm in central Ohio. The blaze set into motion a series of events common not only to the Amish but known throughout agriculture for the past 1,000 years.

A new barn was needed. Timber-framed barns raised by hand were a tradition brought to the United states centuries ago. With their first crops in the ground, the earliest settlers then put up permanent buildings, structures that mimicked the styles of those they'd left behind in England and Europe.

The Amish men and women who raised the new barn in Ohio were a living, practical link to their ancestors. Building a traditional English-style barn reinforced that connection. The Amish still raise barns in much the same way that builders did long ago. The story that opens this book provides a look at historical practices preserved through tradition.

The first half of *The American Barn* considers how barns were established in the New World. The English settled, followed quickly by the Dutch, Germans, and Swiss and the rest of Europe, each bringing their own heritages and traditions. In their new country, the immigrants encountered problems and challenges that demanded modifications to the barn traditions they had carried with them. From their adaptations came American barns.

As the population migrated west, sometimes covering vast distances before choosing a place to settle, ideas moved as well. This explains why a roof style that first appeared in Vermont in a single river valley appeared next in central Virginia and finally in central California but nowhere else. Ideas were transplanted but they often made no stops along the way.

Local conditions and building materials greatly influenced the image of the barn carried in the settlers' minds. In the northeast wood was abundant, but it bordered on scarce in other regions. In Pennsylvania and Wisconsin where limestone and other rock could be readily quarried builders adopted stone as a construction material even while architectural styles of the buildings remained faithful to customs and habits of the homelands. Later in the far west, scarce water and fierce winter winds influenced which crops and animals could be raised , and dictated the shapes and functions of barns. All across the continent, local factors such as these reconfigured the barns built by migrants.

By the early 1800s, the effects of technology were recognizable. The Industrial Revolution's efficient machinery decreased the individuality of human works. Mill-sawn lumber standardized timber dimensions, introducing the first hint of sameness to barns and buildings. Transplanted Connecticut carpenter Augustine Taylor inadvertently accelerated this homogenization when he built a church in Chicago, in 1830, using slender wall studs rather than traditional timber frame construction. By the late 1800s, his carpenter's adaptation had led to the nationwide dispersal of precut, ready-to-assemble, nearly identical kit barns purchased from Midwest mail-order catalogs like that offered by Sears Roebuck. Where unique ideas had traveled westward on foot 100 years before, mass production spread out like spokes of a wheel, and carried the styles of barns and their construction from catalog offices in Chicago and lumber yards in St. Louis. What had been visions in imaginations became full-color illustrations with catalog numbers. Cut it out, fold it up, carry it in a billfold.

Farm journals also contributed to more standardized barns. As writers learned of new concepts or techniques, they wrote about and illustrated what other farmers, builders, or regions had to offer. This information spread to a population of farmers hungry to succeed and anxious to learn how.

Though the wide distribution of catalogs, magazines, plans, and kits did diminish some of the regional differences among barns, they also suggested new ideas that could be integrated into interesting, individual barns. By the early 1900s many of America's earliest barns had been outgrown or were beginning to fail and were ready for replacement. A near frenzy of building followed, a virtual barn renaissance

Today's farming business had little use for tradition and heritage. There is too much money at stake and too little profit returned. Reconfiguring a healthy barn or saving one at peril can be more costly than removing it and building a new steel structure. Still, barns are preserved, modified for new uses to contain new machines. Fortunately for barn enthusiasts and historians, there are many farmers who are willing to occasionally ignore profitability in the interest of tradition and heritage. What they preserve may be their own family tradition or ethnic culture, but the act of barn salvation transcends a single family to embrace the entire community and provide a link to our country's heritage.

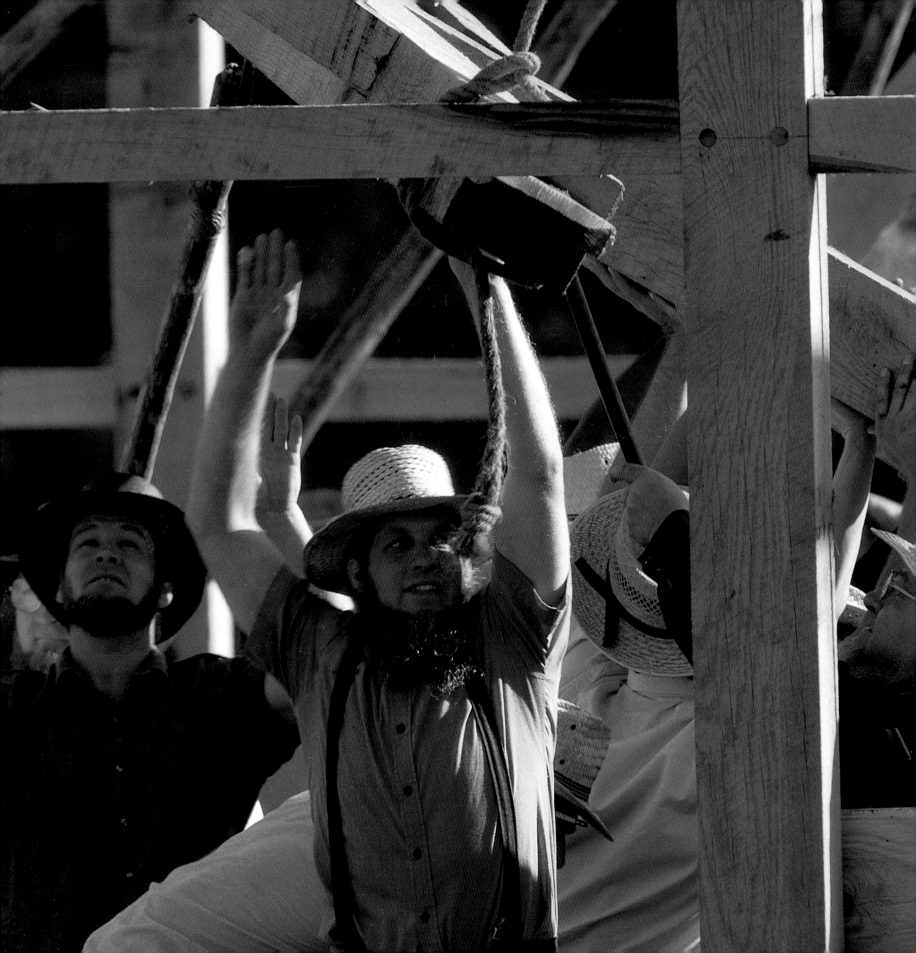

TIMELESSLY,
A BARN IS STILL
BUILT IN A DAY

"I don't make blueprints," Josie Miller explained as he stepped carefully among the purlins, kneebraces, summers, and girts. The pieces resembled a giant, do-it-your-self barn kit. But all the instructions were in Miller's head. Miller's architecture has been in his mind for years.

"Oh, sure, I make drawings sometimes. To figure the beam lengths," Miller went on. "But how it goes up? I know all that."

At 6 A.M., in the cool, presunrise mist, his breath was visible, emerging in brief, forceful clouds, sandwiched between his long, straight, white beard and his tan straw hat. Miller is compact, elfish, with piercing dark eyes. He turned 75 in September 1994, three months after finishing this barn, and he has been building barns—nearly a dozen each year—since 1940.

This day, the Amish master barn builder would raise a dairy barn and hay shed for another Amishman whose barn was destroyed by fire. Arson was suspected in this fire. Several other barns had burned in central Ohio in the weeks before this fire. This one started near the road on a clear night. The Amish use no electricity, and the stationary diesel engine used to operate the milking pumps was at the opposite end of the building from where the flames first appeared. But fire bugs love big fires, and this owner's 150-year-old wood barn burned hot and fast.

Saturday, 7:30 A.M.
"*On nuf, on nuf!*" On up, on up, the barn builders cry, and dozens of men lift the heavy bents. This bent already has left some of the hands, the lifting taken over by the spike poles. Other hands and an older gentleman's cane continue the push closer to the base of the bent. Green oak, such as these men are laboring into place, weighs about 5.3 pounds per running inch in 8x8 beams. Each of the bents can weigh thousands of pounds.

Friday, 5:00 P.M.
Interior bracing is cut and fit carefully. Each 2x4, 2x6, and 2x8 is chalked with its intended destination. Master barn builder Josie Miller judged the dimensions of the barn based on the farm owner's acreage and the number of cows the family kept in its dairy operation. Miller worked with three local lumber mills to get the massive order completed in time.

Friday, 5:00 P.M.
The tenon at the foot of a post awaits the struggle that will come the next morning. This is one of nine that will seat the entire 92-foot-long, 16-foot-tall front wall. This will be the last wall raised, awaiting the full complement of some 350 workers to heft into place the nearly 16,000-pound timber frame.

Framing plan sketched by Josie Miller.

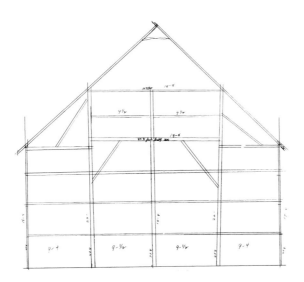

"It's the Amish way to raise a new barn within 30 days after a tragedy," Miller's son, Joe Jr., said later. "Raising a new barn is not the same. Maybe 100 men will show up. It can take some time. A tragedy is different. Even on the outskirts of our community here, we'll have maybe 300 or 400 men show up."

Josie Miller stepped lightly over the sidewalls that were laid out jigsaw puzzle-like. The massive 8x8- and 7x8-inch oak crossbeams, posts, and diagonal support braces were formed during the previous week into structural support sections, or bents, that define the size and shape of the barn. They were laid out in the order that they would come up. First wall, hay shed, east side, was on top of the pile at the far corner. South wall, the main front long wall, the last one raised, was on the bottom, closest to the yard.

"The fire was four weeks ago yesterday. We started working the next day," Miller said. "The owner settled on the size barn he wanted. I had crews in the forests a few days later harvesting the oak. The milling was done at four separate yards." His last truck of lumber had arrived only the afternoon before. Green wood—fresh, unseasoned—was used because there was no time to locate aged timbers in the quantities needed. Properly milled and properly assembled, this lumber would dry—shrinking slightly—in place; it would tie the barn together even more tightly. Miller moved over the push poles, 12-, 15-, and 20-foot-long spiked wooden poles worn smooth by maybe 30 years of Amish

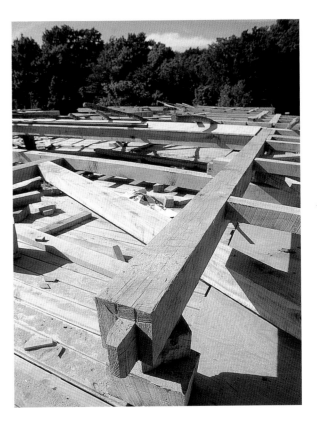

hands heaving up walls. He slipped around the 1-inch ropes that the men would use to pull up the walls or to hold the bases of the posts, the vertical beams. These helped guide the tenons—those tips carved out of the ends of timbers—into the mortise holes in the floor sills, without snapping the tenons or damaging mortises.

His four foremen, a Mennonite and three Amishmen, hustled up stacks of siding and roof rafters using a tiny Bobcat loader and a larger propane-powered forklift truck.

"I didn't sleep too good last night. I woke up at 4:30." Conversation with Miller often comes in brief exclamations. In the past, many times in the past, he said, he did not sleep at all during the night before a barn raising. But now, after more than 500 barns, his mind allows his body a fitful rest.

Half a dozen times, Miller barked commands to his foremen. These short, flat, single syllables sounded like two broad boards slapped together. The four men responded quickly and silently. They each knew in advance what Miller needed or wanted checked again.

The first volunteers arrived at 6:30. Their buggies made a rhythmic clatter as they rolled down the paved road rising and falling through the wooded hills. The fog seemed to muffle the sound, then make it louder when it arrived, inflating it suddenly.

Greetings among the men were few and spare. Amish communities are centered around their churches and each is small, counting 25 to 35 families. It would be the first time many of the men working here would meet the man working next to him. The men and women unhitched their horses and led them to the hay wagons where they would be tied for the day. The wives unloaded pans of meat loaf, noodles, Amish dressing, Jell-O with fruit, cakes, and pies. The sun cleared the trees, edging through the mist. The temperature jumped, and steam eased up from the damp ground.

Rush hour began at 6:45. Every 30 seconds another volunteer arrived by buggy or bicycle or in vans operated by Mennonite drivers from around the counties. A small crowd of men stepped onto the

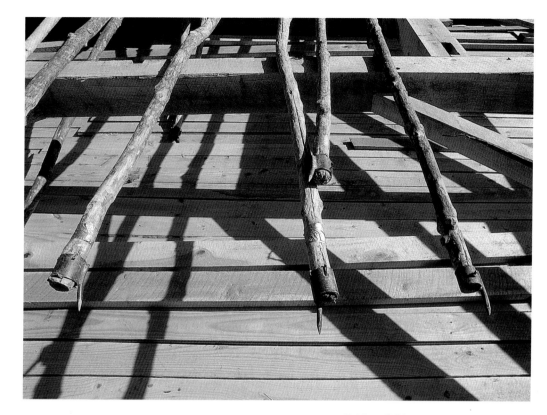

Friday, 5:00 P.M.
Late in the afternoon before the barn raising, pike poles lie waiting for the next morning's work. Once the heavy timber frame has been tilted up off the barn floor, the crew pushes it above their heads. Workers jam these spiked ends into the top plates and cross beams as the bents lever up toward vertical.

Typical English barn framing.

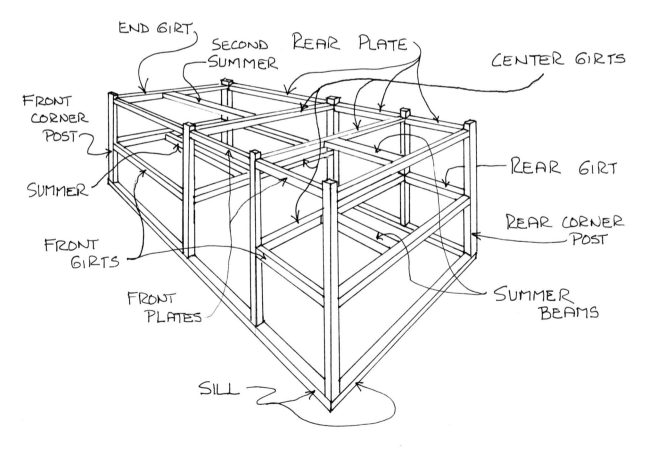

Buggies full of workers and families
begin to arrive shortly before 7:00 A.M.
and continue until nearly 9:00. Word
of an Amish barn raising spreads far
and wide through the Amish
community and the "English" world
outside the faith. No offer of help is
refused, and a number of "English"
carpenters join in the construction.

Saturday, 8:00 A.M.
All the heavy oak frame members are
joined by mortise-and-tenon joints
carefully measured and cut into the
wood and secured by 700 oak pegs.
Because of the urgency of replacing
an Amish barn after a loss by fire or
other tragedy (tradition says the work
must be completed within 30 days),
barn builders often construct the
replacements out of freshly harvested
"green" oak, relying on the wood to
age in place and tighten securely
around each joint.

THE
AMERICAN BARN

barn at 6:55 with Miller in the middle of it all. Every
man wore a straw hat, in black or tan. All of them
wore carpenter belts stained dark brown from use
and sweat, with well-worn hammers hanging from
their right hips.

Miller spoke, pointing frequently with his car-
penter's square. "Speeches *always* make me uneasy,"
he explained later. "A long time ago, a man told me,
'Hold a square. And just pinch it while you talk.'"

His voice filled the yard. In a loping cadence,
speaking in "Dutch," the centuries-old dialect of
German spoken by the Amish, he reminded the men
of the risks and dangers inherent in raising a barn, in
lifting heavy walls, in climbing monkey-like to the top
of the 30-foot-high rafters. The men milled around,
ready to begin. Miller went on and explained the
assembly sequence.

The barn they would build was large, nearly
5,000 square feet on each of its two levels—a con-
crete-block ground floor and a wooden first floor.
This was a bank barn, built into the side of a hill. The
dairy cows, as many as 30 at a time, would enter and
exit the ground floor concrete milking stalls from
the opposite corner to the milk storeroom. The

milking parlor, 40x92 feet, adjoined a 40x40 foot,
8-horse stable stuck like a T off the north wall. The
foundation had already been rebuilt, using nearly
4,000 concrete blocks to form the ground floor walls.

When this barn was complete, horses pulling
wagons would enter the first floor through large
sliding doors. The main floor would be used for hay
storage for the livestock. Wagons were meant to be
driven in broad doors, unloaded, and then backed
straight out.

Knowing that many of his volunteers had milk-
ing and other chores to attend to before they could
help build a barn, Miller counted on only about 50
men for the first hour's work. So the short walls
would go up first.

Miller walked away leaving his foremen to get
things started. At this point, he could trust them to
pursue the big jobs. He would keep to the tiny
details that might cause an injury or that could splin-
ter or shatter a wall.

"*On nuf. On nuf*!" The shout interrupted all the
other murmurs of the morning. At 7:05, the 50 men
fought the east wall of the hay shed, straight above the
horse barn. Arms lifted, hands pushed. Long spiked

poles jabbed into cross beams—the girts—far out of human reach, to continue to lever the wall up.

"*On nuf, on nuf. On nuf*!" On up, on up. On up! Men with steel pike poles nudged the protruding tenons toward the floor sill mortises. The wall settled in with a thud. Even as it still shook and wiggled, two carpenters climbed up the 4-foot spans like children on a giant jungle gym. Once on top, they waited.

Within a moment, the crew swarmed across the 40-foot maze and again, "*On nuf, on nuf*!" The west wall came up with the grunts and strains of a crowd now grown to nearly 75. Again, two and then three men clambered to the top to wait.

"*On nuf. On nuf! ON NUF*!" The north wall of the hay shed slowly leaned up. There was shouting now. Both east and west walls had to be leaned slightly out to let the north wall in. Men and ropes strained. Another shout. A deep subtle thump and another. Rapidly more men climbed to the top. It was barely 7:15.

Pegs of solid oak, each 8 inches long and 1 inch in diameter, appeared from aprons and joined the walls together from top to bottom. In all, 700 pegs would bind the barn.

The hammering that would go on uninterrupted for the next 11 hours began now. Another two dozen men walked onto the barn. A stream of wagons, vans, and men on mountain bikes and boys riding 10-speed racers with wooden toolboxes tied over the back wheel continued to arrive. Across the road, up and down its length, and in neighbors' driveways, dozens of plain black buggies edged the pavement. Up the hill behind a shed used today as the cook house, 30 more buggies were parked, scattered away from the autos and vans of other volunteers and the few invited "English" guests.

To the Amish, the world is populated by two kinds of people. They are Amish, or Dutch, a misunderstanding from their arrival at U.S. immigration a century ago when they explained that they were German, *Deutsche*. Everyone else, no matter what race or heritage, is English. Having long been persecuted for their religious beliefs and in recent decades having been plagued by tourists, they have withdrawn even further into their communities, largely avoiding

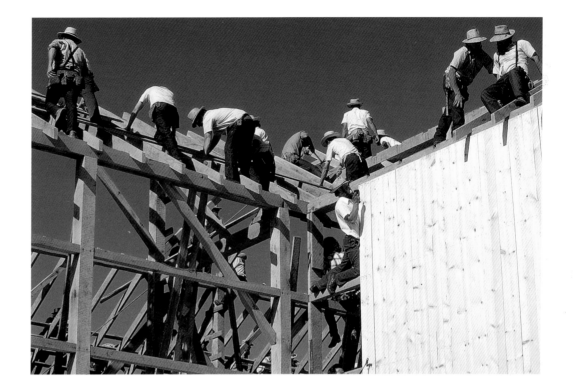

contact with outsiders. More liberal churches will accommodate some of the modern conveniences that seem beneficial. It is only the most liberal ones, the Mennonites, who have adopted such amenities as rubber-tired tractors, electric lights, cordless telephones, and even fax machines. The Mennonites are the buffer between the English and the Dutch. They were the ones who invited the guests. Among the outsiders were architects, barn enthusiasts and restorers, and historians.

But word of a barn raising spreads fast through the Amish and the English communities. By 8:00 A.M. when the volunteer crew was ready to raise the east gable end—the fifth wall to go up—there were nearly 250 men working on the barn. And in the yard around it, there were as many more plainly dressed Amish women and children who sat visiting with each other or watching quietly. Nearly 100 amateur and professional photographers and videographers and their friends worked to uphold their reputations as rude, insensitive English. Lenses more frequently focused on faces than aimed at the barn.

Shortly before 9:00 A.M., the crowd of workers had increased to nearly 350. The final wall began to

Saturday, 9:10 A.M.
Once the timber-framed walls are raised, workers spread out to a variety of tasks. Josie Miller reckoned that many of the crew working this day had already done at least one barn raising because so many of them knew what to do without direction or even instructions. The pine siding went onto the barn with machine-like efficiency. Young boys pre-nailed each piece so that the experienced adults could work more quickly.

TIMELESSLY, A BARN IS
STILL BUILT IN A DAY

Saturday, 9:15 A.M.
The massive front wall was up, and all the perimeter walls were in place. Purlin post-and-tie-beam structures were raised one right after another. By this time more than 350 workers crowded the barn floor. As the bents were raised, crews on the north side of the barn began preparing hundreds of board feet of pine siding while others continued to ferry the remaining interior bents into the barn. A huge crowd of Amish and Mennonite community members looked on.

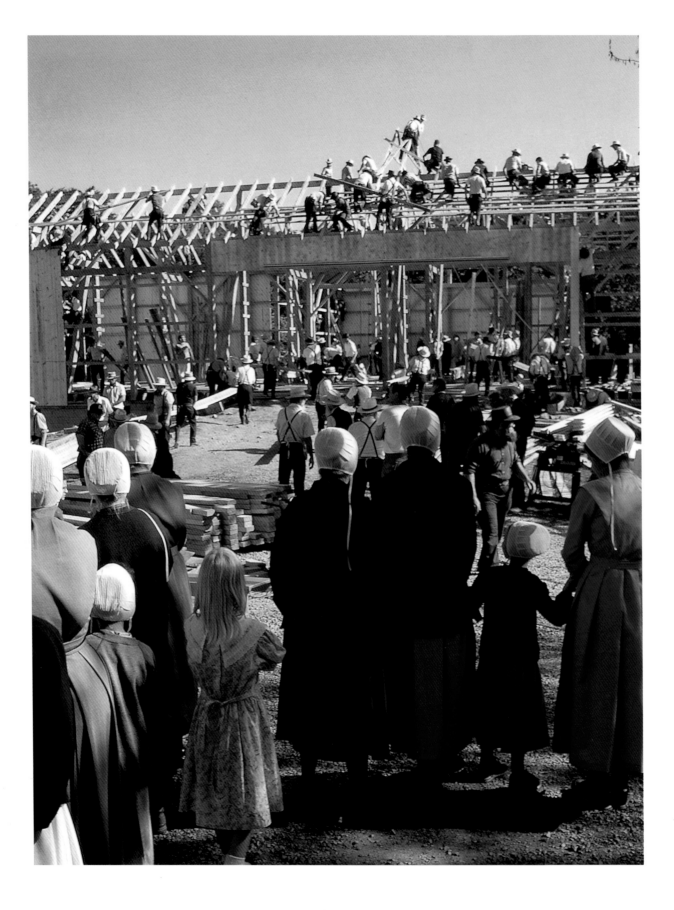

THE
AMERICAN BARN

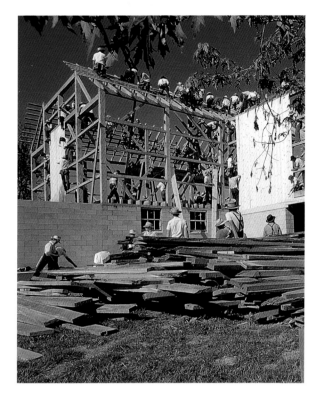

rise slowly from the floor. Josie Miller came back for this one. The wall structure was heavy; all the walls were 16 feet tall and this one stretched 92 feet from east to west. The main girts and plates—the top girts—were spliced together, formed of one 20-foot and four 18-foot beams of freshly cut oak. These 8x8- and 7x8-inch beams weighed about 5 1/3 pounds per running inch or nearly 5,900 pounds for the top plate alone. The entire wall structure was just shy of 8 tons.

"If the lift is not even from one end to the other," Miller told his crew, "the splices—pegged together—can split and shatter." The damage, he explained later to a visitor, would be irreparable. Work could not continue and the standing structure—without its long front wall to close in the whole framework—would be at risk, vulnerable in a strong wind. More than 200 men took hold and shoulder to shoulder, began to lift the wall. "*On nuf! All mit ein ander!*" On up! All together! The commands came from Miller himself. Then a few of the men shouted. Even with the ropes to hold the feet of the wall from falling off the barn deck, that is exactly what had happened. Nearly half the length of wall had slipped and shot almost 2 feet over the edge. It happened in the

hardest part of the lift. The top of the wall was at the full extension of almost half the arms pushing it. It was still too low for pike poles to be helpful and most of its weight was supported by the 100 or so men holding the mid-wall girts—men who then also had to take a giant step backward as well.

Miller's plank-slapping bark charged a dozen men with the steel pike poles. They surged forward through the straining faces and jammed the poles in the floor. They used them as levers to shove the wall back. One more bark from Miller and the entire structure lurched back again and then rapidly up.

When it settled in loudly, no one cheered. There was no show of emotion. The foremen began immediately erecting the interior bents. Miller himself scuttered off to organize human convoys to haul up the crossbeams and gables. There was a barn to put up. There was no time for self-congratulation. Besides, it's not the Amish way.

After the work of raising the seven 16-foot-high walls was completed, the hammering became chaotic noisiness. Pegs were fitted into each corner. By now more than three dozen men clung to the top girders securing walls to corners, making intersections solid. With the sun fully up, men in waves began shedding their jackets and vests.

Saturday, 9:15 A.M.
While one large crew began putting up pine siding around the outside of the hay shed on the barn's north side, others nailed common roof rafters into place against the purlin plates running the 92-foot length of the main barn structure. Below the barn is the milking parlor, while beneath the hay shed extension are stables for the family horses.

Saturday, 9:30 A.M.
With his crew nailing on siding like a well-oiled machine, master barn builder Josie Miller (foreground left) casts a quick glance at the building progress as he heads off to direct a group of workers in another task.

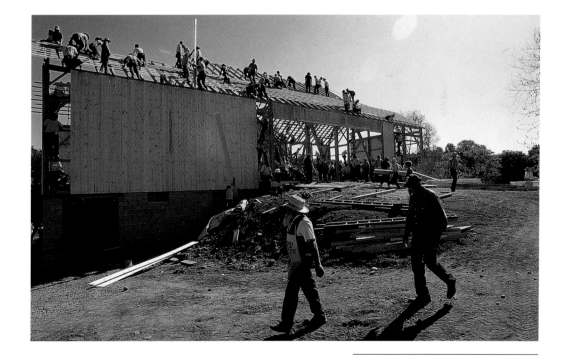

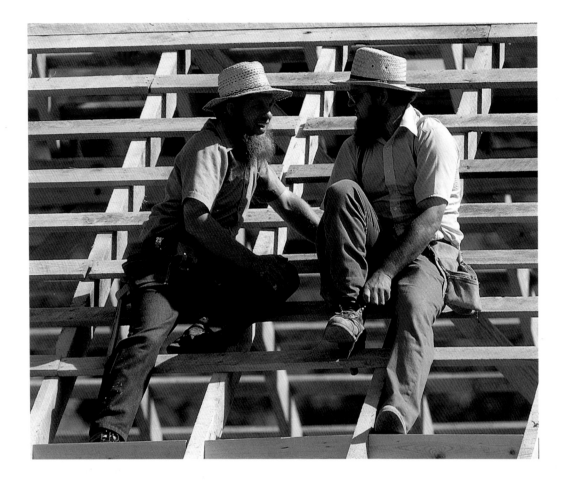

Saturday, 9:45 A.M.
Two of the hundreds of volunteer carpenters enjoy the proverbial calm before the storm. Within moments these two and more than 100 other men would be busy nailing aluminum roofing panels into place.

Interior posts, placed 10 feet in from the outer walls, rose, levered up, quickly, one after another. Already the barn siding, 12-foot-long pieces of 1x10-inch pine, was moving rapidly over the hay shed walls, covering the skeleton.

Miller barked again and outsiders stepped aside as a dozen men threaded the first of eight 1,000-pound purlin plates in through the front doors. Before it was all the way inside, it was roped and it had begun to rise abruptly upward. Miller spun and set off for the next one. Back and forth, back and forth; as soon as one was roped it was raised and man-handled into place. Pegs secured it firmly onto the purlin posts, tying the building even more tightly together.

It was barely 9:00 A.M. and a dozen men were relaying 2x6-inch rafters up to the roof, chased by 1x4-inch roof purlins. Two dozen more men climbed after these boards—the crosspieces that were nailed perpendicular to the rafters—and the precise, plain gridwork went into place with startling speed. Within minutes, 75 men were on the roof, relaying materials along or hammering them into place.

Through it all, no one shouted. No one stood around waiting for an assignment. It was as though all 350 men knew their job exactly and had rehearsed their parts in this compassionate play.

Barns lost through tragedy, whether arson or an act of God such as lightning, are "insured" by Amish Aid. The loss is appraised and a value is set. Of that figure, 75 percent is then divided among all the churches and each church divides its share among its members. The remaining 25 percent is left to the victims, so that they "feel" the loss. But frequently friends help the family and the loss hurts less.

Beyond the cost of nearly 40,000 board feet of oak, hickory, poplar, and pine harvested and specially milled for this barn, only Josie Miller and his foremen would be paid for their work. The labor—and the food—was donated.

These volunteers always seemed to be ready in place as pieces began to arrive. It was a personification of Just-In-Time inventory control. But it was more. Planks for siding, pre-nailed on the ground by young boys hungry to be involved, whisked past spots where an instant later, men's faces leaned out to hammer them into the girts. As two boys labored a long plank around the milking shed, an older man silently pointed upward. There was an uncanny awareness, without obvious prompting, of knowing when to duck, when to stand still, when to move to one side.

On the shed roof, a Mennonite cut off joist overhangs with a circular saw and far above him another used a chain saw to even off the main roof rafter ends. Pieces of 1x6 and 2x4 fell like rain. With another silent gesture, the man on the ground signaled the boys on ahead into the shed during a lull in the cutting.

Inside the barn, 30 feet above the floor, another man lost a rafter. Trying to raise it hand over hand, he ran out of hands and it fell straight to the floor. Miraculously, even though a crew below was nailing down tongue-and-groove flooring, they had just finished

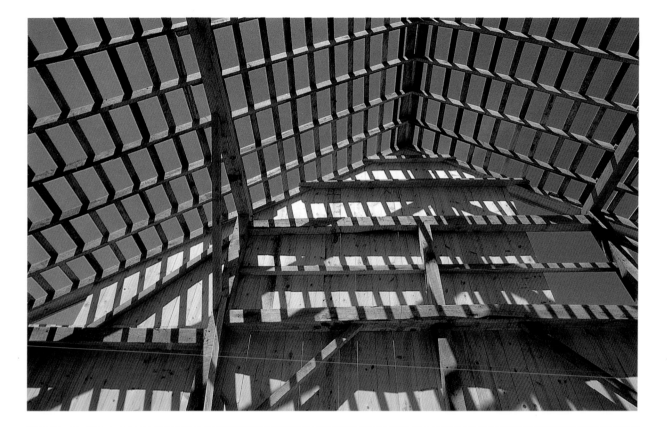

Saturday, 11:00 A.M.
Oak timbers support this barn—and many in North America—in post-and-beam construction. The heavy horizontal cross beam, also known as the girt, is 8x8 while the collar tie above it is 4x4. The purlins (the heaviest roof timbers that run the length of the barn and support the rafters) and the vertical purlin posts that carry them are 7x8-inch oak. This is a "common rafter" system, and this roof has a ridge pole. The diagonal braces below the rafters that help locate the purlin posts are called struts.

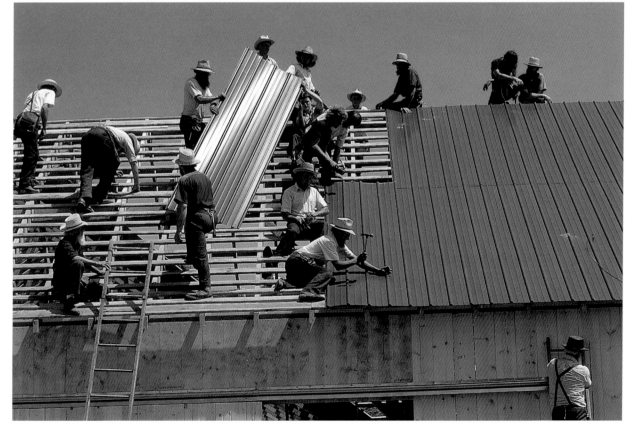

Saturday, 11:30 A.M.
While the barn is a traditional English-style structure built of classical pegged mortise-and-tenon techniques, one clear nod to modern times is the aluminum roofing material. It is lightweight and low maintenance unlike thatch, shingles, slate, or tiles.

TIMELESSLY, A BARN IS
STILL BUILT IN A DAY

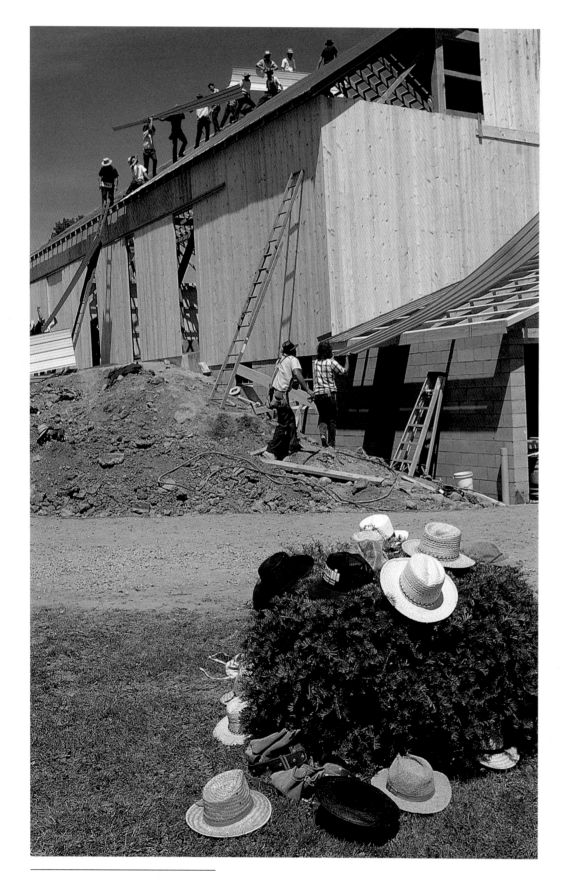

that area and moved away. The 12-foot long 2x6 hit loudly and bounced. It was caught before the second bounce. Checked for true and for splits, it was discarded and another was then handed right back up to the same man who lost it a moment earlier.

Without discernible warning, a handful of men hefted a barn door over the heads of a group building another one. In an ensemble move, the builders stooped and the carriers cleared their heads by barely a foot with the 250-pound door.

Amish barn builders like Josie Miller make a joke about crews like this. They tell their listeners that the barn went up so fast that it was done before they got all the wood harvested for it. Miller, however, can explain their speed.

"A hundred years ago—even 25 years ago—most Amishmen were farmers," he said. "They had to be directed on every step. We didn't have power saws to cut joists or Bobcats to haul siding. Those farmers weren't carpenters." He paused, to catch his breath, to remember his first barns. "Barns took a week to raise. It was done whenever a crew could be got together.

"Today, most of these men working here have jobs outside their farm. Almost every Amishman does. These men here work as carpenters, wood workers, or cabinetmakers. Now, while there are more Dutch in the world, there are even more fires. Most of these men—even some of the young boys—have already worked on a barn or two. Some have probably done a dozen."

By 1:00 P.M., six hours after starting the barn, 80 percent of its walls were sided and a quarter of the tin roof was nailed on. The crew was now so large that it was getting in its own way. Miller had raised barns in the past where the owners had been able to milk their cows and fill their haylofts by the end of the same day. Today he would send his crew to mid-day dinner and then release more than half.

The barn's owner, a man who this day was solemn in demeanor, somber in his loss, and serene in his faith, hoped that all the men would stop to eat at once. He wanted to speak to them, to thank them for their help, their work, their generosity. Amish are used to giving; receiving this much is humbling. But there was

a barn to finish and the volunteers would eat—and pray—in shifts. In front of those released to eat and their families, the owner gave his thanks and offered a spoken prayer. When he called for a silent moment, Miller's men up on the barn continued their offering with their hammers and never missed a beat.

Tables creaked with the load of tins and trays of hot and cold food. Backless benches used for the church services sat in rows in the shade of a large willow tree and they quickly filled with hatless men with freshly scrubbed faces and hands. The bushes near the house had become impromptu hat racks, littered with dozens of hats in sizes simply marked small, medium, large. Most men faced away from the barn.

Still the hammering continued. One-third of Miller's volunteers clung to the roof, nailing corrugated tin in place, or else they leaned out through shrinking holes to finish siding the huge walls. Workers and their families signed in. It was a way for the owner's family to know to whom they owed gratitude. When the last worker and wife and child, and the last guest had signed in and eaten, the count was

two dozen shy of 600 names. Many families had left before dinner, their own obligations calling them home as soon as they could break away from the new barn. And still the hammering continued.

Miller was among the last to eat, wanting to be sure that those who worked for God were fed first. As he headed back to the barn, he stopped a moment to tease another English, Larry Phelan, a researcher with Ohio State University and an accomplished amateur barn builder.

Wood post-and beam construction appeared before 600 B.C. Very early Greek temples were constructed with stone posts supporting horizontal timbers. First century B.C. Roman architect Vitruvius wrote about timber beams laid above the columns "coupled with dowels and mortises." Contemporary Amish barn builders— and others producing timber frame structure— still use much the same joinery techniques. This green oak will shrink slightly around the peg, creating an almost unbreakable connection.

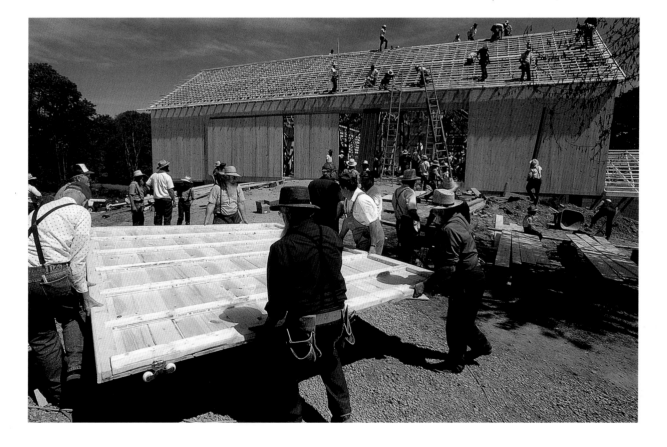

Saturday, 1:15 P.M. Workers carried the third of four doors toward the barn. By this time, dinner was nearly finished. For days before the barn raising, Amish wives and daughters prepared food, and they loaded tables with more than enough to feed nearly 600 workers, family members, and guests.

Saturday, midday
To keep barn construction moving along, Josie Miller suggested that the carpenters and builders eat in two shifts. As the crew stopped to wash before their noonday meal, they removed their hats, relying on bushes near the farmhouse to serve as hat racks. In the background, crews struggle to get aluminum panels onto the roof.

TIMELESSLY, A BARN IS
STILL BUILT IN A DAY

Saturday, midday
Carpenters inside the barn nail down the 2x6-inch tongue-and-groove oak flooring in the haymow. The heavy material is used primarily in the area where the weighty hay-filled wagons maneuver inside the barn. Above, another group races to cover the rafters with the metal sheets.

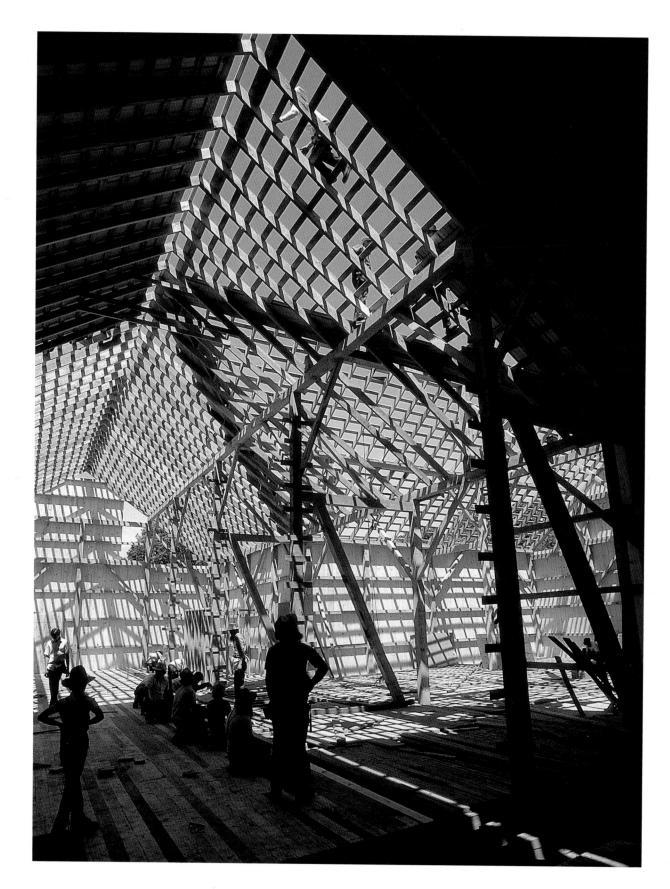

"I made a mistake." Miller's bark softened. Phelan looked up. "I let too many go. I'm not sure we can finish by dark." Phelan, who had labored since midmorning nailing siding to the barn, fidgeted.

"So, get back to work," Miller said. "I'm paying time-and-a-half this afternoon." Relaxed just a little for the first time in hours, he smiled and his eyes disappeared into the wrinkles. Phelan laughed out loud.

By 2:00 P.M. when the last plate was cleared, when many of the crowd had left to return to their own cows and hay harvests, the remaining men working had nearly finished the roof and walls, enclosing the barn. Phelan joined a crew of 30. They were securing the notched 2x6 tongue-and-groove flooring to the massive floor joists. This flooring was used wherever heavy equipment and horses would trod.

The air inside the barn was close and full. In a few days the building would smell of cows and horses, sweet milk and tart manure and hay. But now the barn was pungent with fresh wood and the odors of strong, plain men who had worked very hard. The noise was deafening, like being inside a 125,000-cubic-foot snare drum.

The crowd of Dutch workers and English observers steadily thinned. Families left, boys pedaled off, the vans from all over central Ohio loaded up and pulled away. The heat of the day had peaked. At 4:00 P.M., when the women served lemonade with the last of the pie and slabs of plain vanilla ice cream, the English guessed it at 80 degrees. The Amish men and women faithfully kept their heads and bodies covered before God and the June sun. The only hats removed came off at dinner or tumbled off of the workers on the roof who leaned far over the edge to accomplish gravity-defying tasks.

Then, just before 5:00 P.M., a boy fell from the roof. A young man, actually about 18, he was fitting weather-sealing rubber gaskets beneath the tin crown molding at the peak, 30 feet above the ground. A bunch of the gaskets began to slip away, and he stretched to retrieve them.

The steep pitched roof, warmed in the sun and lightly oiled to retard rusting, was slick and fast as ice. He was down on the ground quicker than he or anyone could shout.

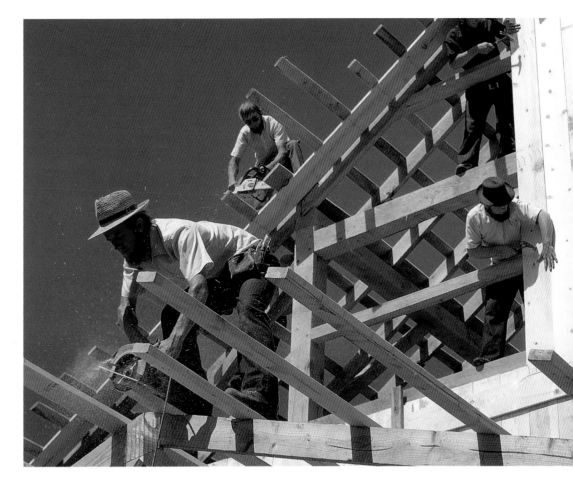

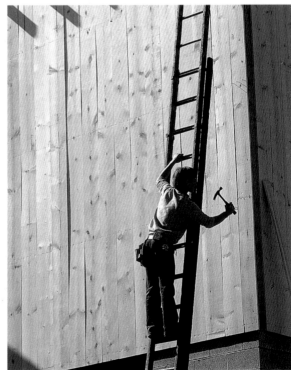

Saturday, midday
Two carpenters finish common purlins using the modern convenience of power tools. One worker trims main roof boards with a chain saw, while below another tidies up the end of the milk house roof with a circular saw. Mennonite carpenters are permitted the use of electric and gasoline power, while the Amish workers typically use hand tools.

Saturday, 3:00 P.M.
Not everyone had previous barn-building experience. A number of young men were getting their first opportunity to participate in a barn raising. This young man was finishing the corners of the hay shed, on the north side of the barn.

TIMELESSLY, A BARN IS
STILL BUILT IN A DAY

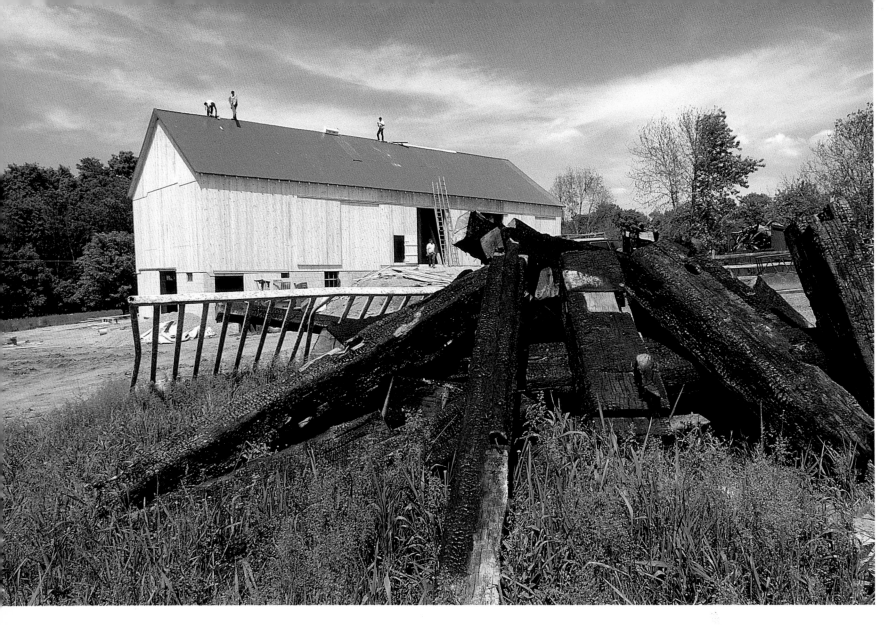

Saturday, 5:00 P.M.
Charred timbers are all that remain of the original barn. Amish tradition calls for barns lost through tragedy to be raised again within 30 days. Most of the community turns out to accomplish this task, aided by other Amish and Mennonite groups that may have traveled some distance.

He landed on his left hip, on the dirt bank heading up to the front door. The boy stood up and hobbled, aching, sore, and dirty. Older men helped him up, helped him clean up, spoke gently to him to help him regain his composure.

A rope meant to catch him was not tied off. When he grabbed at the falling gaskets he missed them, and when he grabbed for the rope, it came down with him. No one was blamed, though everyone knew it was a serious mistake. They had been lucky.

There were wood scraps, jagged triangles of 2x6, barely an arm's length from where he landed. Had he twisted as he fell, had he landed differently . . . A few people blinked their eyes, moved their lips. There were

quick prayers delivered from the Amish whose only purpose in life is to serve God, to work hard, and to wait patiently until their God calls them to his heaven.

Just before 6:00 P.M., the last hammer blow was struck. It was announced after the fact by a ringing silence, a quiet so startling that people looked around. Eyes widened. Was it done? Barely 10 minutes later, the last worker left the barn. Josie Miller sat down for the first time since dinner, only the second time since before 6:00 A.M. He surveyed the work as his own men finished cleaning up the site. His face carried the weight of the day and the load of 500 barns before.

The owner, whose face looked at peace for perhaps the first time in 29 days, had told Miller that he

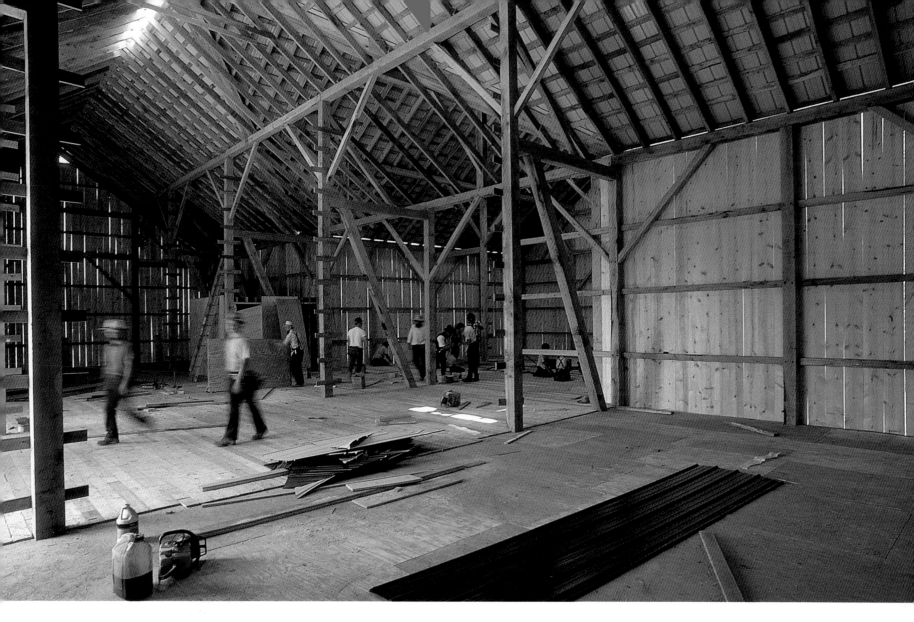

would store his harvested hay Monday. And if the plumbing work was finished, he could milk his herd in his new barn by the end of the week. The word miracle escaped from his lips in earshot of some of his friends.

(The next morning, he and each of his family would venture outside soon after awakening. They would confirm with their eyes what their sleep had made doubtful: had it really happened?)

As the last of Miller's foremen rolled the big doors shut on their tracks, an English, Charles Leik, an invited guest from Washington, D. C., recalled for Miller something that he had heard Amish essayist David Kline say earlier that day at dinner. Kline, too, had come to help, part of the universal family who

rise to the occasion of Amish tragedy. Kline explained to Leik that the Amish have no church meeting houses but gather to worship every Sunday for nearly half the day at the home of one of the members, a different home each week.

"We hold services in the barns," Kline told the visitor. "And if I get bored with the sermon, I just look at the architecture."

For a brief moment, Josie Miller laughed the laugh of two boards slapping together. Then his eyes disappeared in a long blink that filled his face with wrinkles. When he came back he looked rebuilt, a stout man of fresh green oak.

Saturday, 5:30 P.M.
Almost finished, the last of the flooring crew nails down the 2x6-inch tongue-and-groove that will support many tons of loose hay.

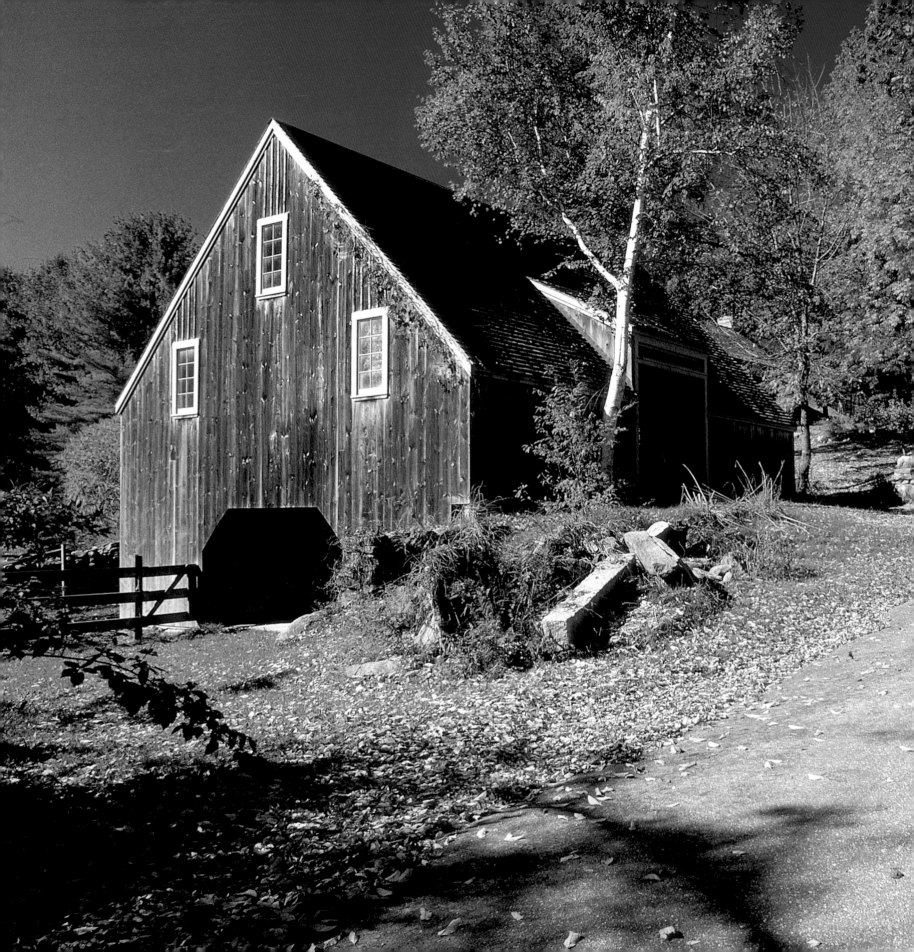

THE ENGLISH
BARN IN AMERICA

*J*ohn Brooks looked for a long time at the hole near his house where the barn had stood. Brooks is a timber framer by profession, and he searched his memories of all the barns he had seen before to find the model for what he'd build for himself. He took his time. His business, Hardwick Frame Company in Hardwick, Massachusetts, kept him well occupied designing and constructing houses, barns, and other structures for clients throughout New England. In his spare time, Brooks reexamined the plans he'd done for others and pored over the books in his library. When he had time, he went back and stared into the hole.

Then, late in the 20th century, he built for himself a 17th century, timber-frame English barn. Just as every barn builder who had come before him had done, Brooks took what was in his mind and memory, and added to that what was in books and history. All this he modified to fit his needs.

"When the pioneers first got here," Brooks explained, "of course, they built a temporary shelter and that was quite often a log home. The land was loaded with timber. And they'd just cut down the countryside and even set a fire to clear the land for crops and animals. But eventually they got around to building a more permanent structure. And timber frame is how they built. That's what they had left behind them in Europe. Things that had been built that way literally for centuries."

**John Brooks barn,
Hardwick, Massachusetts**
Timber-frame builder John Brooks built this barn in 1988 to fit what remained of an existing foundation. The building measures 30 feet by 40 feet, and stands 22 feet, 5 inches to the peak on the north side facing the road but 29 feet, 6 inches on the south side facing the lower yard. He adopted the design of his barn from a painting by Connecticut artist Eric Sloane, taking features from several structures that Sloane illustrated and combining them into his own building constructed against a banked wall.

English barns were not intended to house livestock because winter weather throughout the United Kingdom was not so severe as is experienced in the northern United States or Canada. Its primary use—for grain threshing and storage—brought about its configuration with its main door placed along its long wall. Barns built on flat land had wagon doors on opposite long walls. Both doors opened to allow the wagons to pass through for unloading and the wind to blow through to aid in threshing.

*A*merica's earliest settlers had expected to be more than subsistence farmers. The New World was an entrepreneurial venture with investors expecting riches equal to the gold shipped back to Spain by its explorers.

Instead, the first settlers faced starvation and privation. Their situation remained grim until the establishment of a cash crop that would ultimately reverse their fortunes.

Smoking tobacco was approaching rage proportions throughout England and Europe in the early 17th century. In fact, it was tobacco that would save the New World from economic failure. And it was tobacco that would bring the first need for barns to America.

The London-based Virginia Company recognized the potential of the fertile and apparently boundless soil in its huge colony at Jamestown. However, tobacco farming was labor intensive. The English government came to the colony's aid, exporting paupers and orphans to Virginia by the shipload. Beginning in 1616, the Virginia Company instituted a plan to actually encourage emigration. Any settlers to Virginia who paid their own way to the colony were granted free and clear ownership of 50 acres for each individual. A family of five with

a servant who could afford the £25-sterling-per-person sea fare to the New World arrived in Virginia with 300 acres in their name. The first tobacco exports to England began the next year, in 1617. In 1620, the colonists shipped to England 100,000 pounds of dried leaves—at 300 shillings per hundredweight—and the Virginia Company felt it had discovered a new kind of gold.

Thus by the late 1620s an economy was emerging in America. The Virginia Company investors also saw some profits from fur trading with the Massachusetts Pilgrims. Pigs and cows brought over from England joined corn and beans as foodstuffs for the colonists. Farmers north and south quickly learned that letting the livestock forage freely in the forests fattened them suitably. Southern farmers learned that their New World seacoast suffered winters similar to southern England's, that is, mild enough that none of their animals needed to be sheltered even in the coldest months. Such buildings as existed were constructed to keep corn and tobacco dry. This was not the case in Massachusetts, however, where the long frost season started in November and lingered until April. Livestock had to be housed and fed for four to six months.

The traditional English-style barn interior was divided up into three bays. Wagons were unloaded in the center bay. Its floor, usually of doubled timbers to support the weight of the horses, mules, or oxen and a loaded hay wagon, was later used as a threshing surface. Unthreshed grain—still on its stalks— was stored on either side of the center bay, and the separated grain was kept on the other side.

THE ENGLISH
BARN IN AMERICA

Plimoth Plantation hayrick, Plymouth, Massachusetts
At Plimoth Plantation structures are small, built to the scale of the subsistence agriculture that prevailed during the first decade of life in the New World. This hay barn is more accurately a "hayrick," only 11 feet square, built of 8x8-inch hewn timbers. The thatched roof is typical of English—and northern European—construction materials. The roof height is adjustable to accommodate greater or lesser amounts of hay, and its 32-inch overhang protects loose hay from rain or snowfall. Seven peg holes, each a foot apart, allow the roof height to be adjusted to accommodate hay load.

Brooks keeps a few beef cattle, and feed for them is baled on the east end of the barn. The barn is constructed of oak, a hard wood easily worked. All the wood joints are mortised and tenoned and held together by oak pegs. The basic plan of this barn existed in Britain for more than 400 years before English farmers began their emigration to the colonies. This style of barn is also referred to as a *Yankee* or *Connecticut* barn.

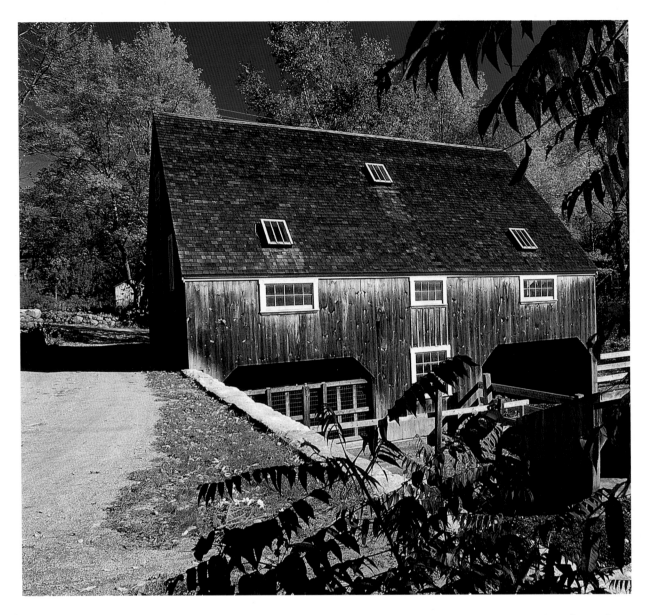

The barns that emigrated to the New World in the heads and hearts of the colonists were large, substantial buildings. The earliest of these structures, built in the 1100s, were essentially warehouses meant for storing the grains grown on vast estates by feudal serfs or by diligent religious orders in monastic communities. Next to the reigning monarchies, churches were a major influence on the lives of the commoners. Just as taxes were paid to the crown in the manner of produce and livestock, so were tithes paid to the churches. The huge stone barns, some more than 40 feet wide and over 140 feet long, were built with steeply pitched roofs (supported by elaborate hewn-timber frames) to shed frequent rainfalls. These buildings strongly resembled the churches, and indeed, these barns were most often "designed" and built by the same craftsmen who had worked on the churches. The grand cathedrals of England and Europe with their soaring interiors were supported by stone posts and spines. These provided the same kind of large, uncluttered interior spaces needed to store grain. Even smaller community churches and barns were constructed along similar lines. These shapes of grain and livestock storage buildings were the mental pictures that most settlers carried to America.

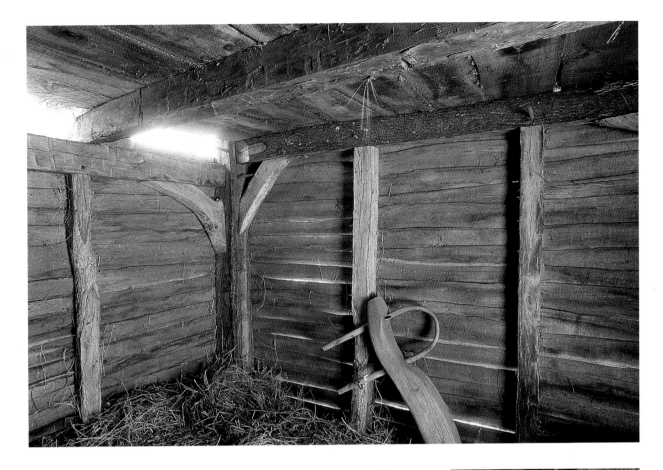

Below the hay storage are two pens intended for winter storage of livestock. The corner posts are sunk directly into the ground, a style of building known as "earthfast." There is no foundation. This offers the benefit of quick, easy, and simple construction; however, almost as soon as the soil is packed around the vertical posts, the deterioration process begins. These structures were viewed as temporary buildings, even by those who owned them.

But little of English farming translated directly to the colonial experiences. Certainly the months-long heat and year-round humidity of the Chesa-peake were unlike any conditions back home. But Massachusetts posed its own set of problems. As the epochal glaciers receded from New England, they left behind a litter of large and small rocks on the undulating landscape. For any agriculture to take place, fields had to be cleared of the stones and the forest. Still worse, once the land was cleared, it seemed as though the topsoil was thin. It quickly lost its nutrients when the tree cover was removed or when livestock was allowed to range freely.

However, challenge was familiar to the Puritans and, with a few changes, English farming would adapt to New England. And despite the disease and Indians in the south, export trade flourished from Virginia and Maryland, enriching both the colonists and their backers in England. Optimism prevailed, and not simply because there was religious freedom and a certain level of independence in the New

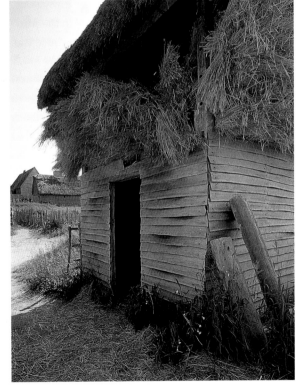

The small scale of these buildings reveals how temporary they were. As each shipload of Pilgrims arrived in the Massachusetts Bay Colony, each settler built accommodations for themselves and their livestock—usually one or two cows or oxen—and worked to survive their first cold, snowy winter. In 1620, a "wealthy" New England farmer had two cows; by the 1660s, families often had a dozen.

THE ENGLISH
BARN IN AMERICA

**McDougald barn,
Pennington, New Jersey**
From the outside, this New World German barn resembles the English barn with its main doorway along the long wall. Barns built in Germany frequently were constructed against hillsides. German banked barns, like the English counterparts, did not use the overhang, or forebay, which the Germans in Pennsylvania brought with them. On the upper side of the hill was the main—or wagon— entrance through which hay and grain was unloaded for storage and threshing.

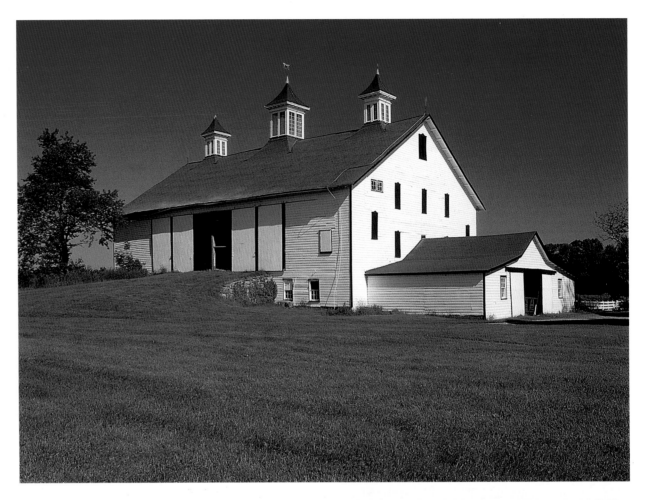

Ladders built into the framing are a common feature of German barns, and this was certainly carried over into those built in Pennsylvania as well as this one in New Jersey. In addition, the low walls—often called "breast boards"—separate the wagon and threshing floor from hay storage, and this is seen frequently in German barns.

lengths. The entire structure usually rested on a sill that effectively accepted whatever moisture crept up the stone foundation from the ground. Each bent, set on top of the sill, was connected to the next by horizontal beams around the perimeter called *girts* and by massive, load-bearing beams through the middle called *summer beams*. That name evolved from the old English expression for a pack animal that carried a heavy load, a *sumpter*.

Girts and summer beams provided stability and support midway up the barn structure. At the top, the girts were called *plates* while summer beams were simply labeled second summer beams. Obviously, front and rear girts and plates and summer beams had to be the same length, and barns of pleasing symmetry required that the three bays be of nearly equal dimension. Therefore, a three-bay barn required dozens of timbers of matched lengths. What's more, because of the loads these

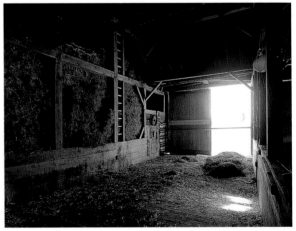

buildings carried, the vertical posts were frequently timbers hewn to 10x10 inches, while summer beams eventually were needed as large as 12 inches or even 18 inches wide by as much as 24 inches deep. At first, however, nearly all the timbers were hewn to 6x6-, 8x8-, or 10x10-inches. In large barns, girts and

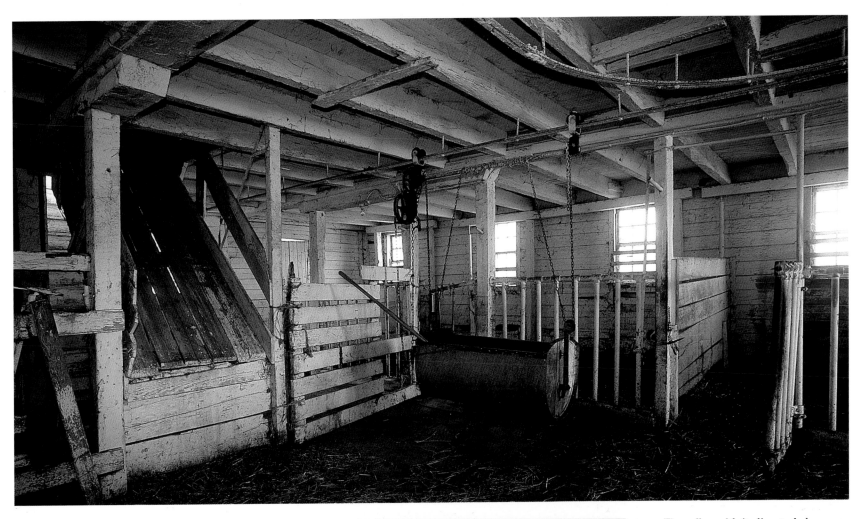

plates sometimes measured as long as 22 feet, though some individual beams stretched more than 60 or 70 feet. But the more-or-less standard length was 16-to-16 1/2 feet, a *rod* in classical measurement. In truth, the lengths varied between 14 and 17 feet. Therefore a three-bay barn was usually 42-to-51 feet long and half to two-thirds that in width.

However, the earliest barns in the New World were nowhere near so grand. Replica barns constructed at Plimoth Plantation, an early 17th-century living history museum an hour south of Boston, Massachusetts, and at Yorktown Victory Center, an 18th-century farm site/living history museum barely 12 miles from Colonial Williamsburg, are each one-bay structures and are much more representative of the scale of farming in the earliest days of the New World. The hay barn—actually, more like a rick—at Plimoth Plantation is 11 square feet and built of 8x8-inch hewn

timbers with a thatched roof whose height is adjustable to accommodate the amount of hay stored beneath it. The roof overhangs 32 inches all around to shed rain and snowfall. Inside the barn the small space is divided into two stalls for winter penning of two cows for dairy and beef production.

The cellar, with its livestock doors on the downhill side, was meant for housing and feeding the stock inside. A hay chute delivered feed to the animals. The manure trolley stands ready to remove their waste. This barn, built in 1901 at Roop's Mill Farm, originally was home to horses bred and trained for pulling carriages and taxis in New York City.

German barn builders allowed a great deal of ventilation to reach the harvested crops stored inside. Small gaps were left between each plank of siding and louvered vents were regularly spaced. On this barn, three cupolas with windows on all four sides brighten the interior. During the late 1920s, the barn was converted from horse stalls to dairy farming.

35

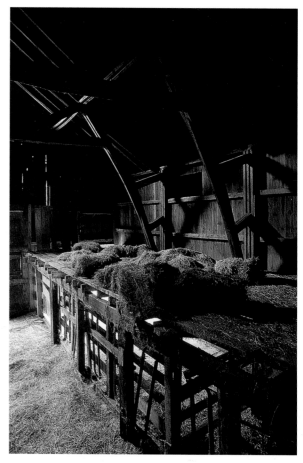

The milking parlor took great advantage of gravity, delivering hay from the mow overhead and removing manure through hinged planks on the floor.

Yankee frugality had greatly simplified timber-frame construction by the late 1800s as builders' knowledge of engineering increased over the 250 years of experience in the New World. Purlin posts rose only to tie beams that supported canted queen posts. These angled timbers supported an extremely simple log top plate and principal rafter system.

The barn fronts onto the road, a former farmer's path to the fields. The barn is 36 feet, 8 inches wide, and it's 75 feet, 8 inches to the end of the old barn, with a 31-foot, 3-inch addition on the rear. The barn is 27 feet, 4 inches tall, not including the large, original cupola.

THE
AMERICAN BARN

south of Baltimore. Two nearly identical barns are reconstructed there about 50 yards apart. They are both the same size—roughly 20x40 feet but the one farther from the road is incorporated into a setting that replicates a mid-17th-century farmstead with a two-story house nearby. It is constructed of white oak, erected in a series of bents that were built earthfast, the vertical posts of which were sunk directly into the ground without benefit of sills or foundation. Five-foot long white oak clapboards are nailed horizontally onto the downposts.

"The roof was built on the principal rafter system," Silas D. Hurry, archeological curator at Historic St. Mary's City, explained, "with main rafters atop each bent tied together with purlins, horizontal beams that served a similar purpose to the wall's girts. Roofing boards were attached vertically to the purlins, and the clapboards—shingles really didn't come along until the end of the century—were laid on top of the boards. The rafters were strengthened and stabilized with collar ties, horizontal beams to add rigidity to the roof structure against the winds. While its roof was white oak clapboard, it was similar in shape and effect to what a thatched roof would

have accomplished because of its tilted false plate, which caused the roof to kick out, sending rainfall farther out from the base of the building."

"It was," Henry Miller, Historic St. Mary's City director of research, said, "done to show how a barn would look if it was built by a first-generation immigrant English carpenter working in the easiest, quickest, and cheapest manner simply to meet an immediate need. The barn nearer the road is constructed as though it was the work of a carpenter three or four generations later—roughly early in the 18th century—but working with the same needs: easy, quick, and cheap."

Hurry continued. "The later barn also is built of white oak, but it is constructed with an *interrupted sill* even though the down posts are still set into the ground [the sill extends only between the posts, not underneath them]. The barn is assembled not in bents but by what's known as sidewall

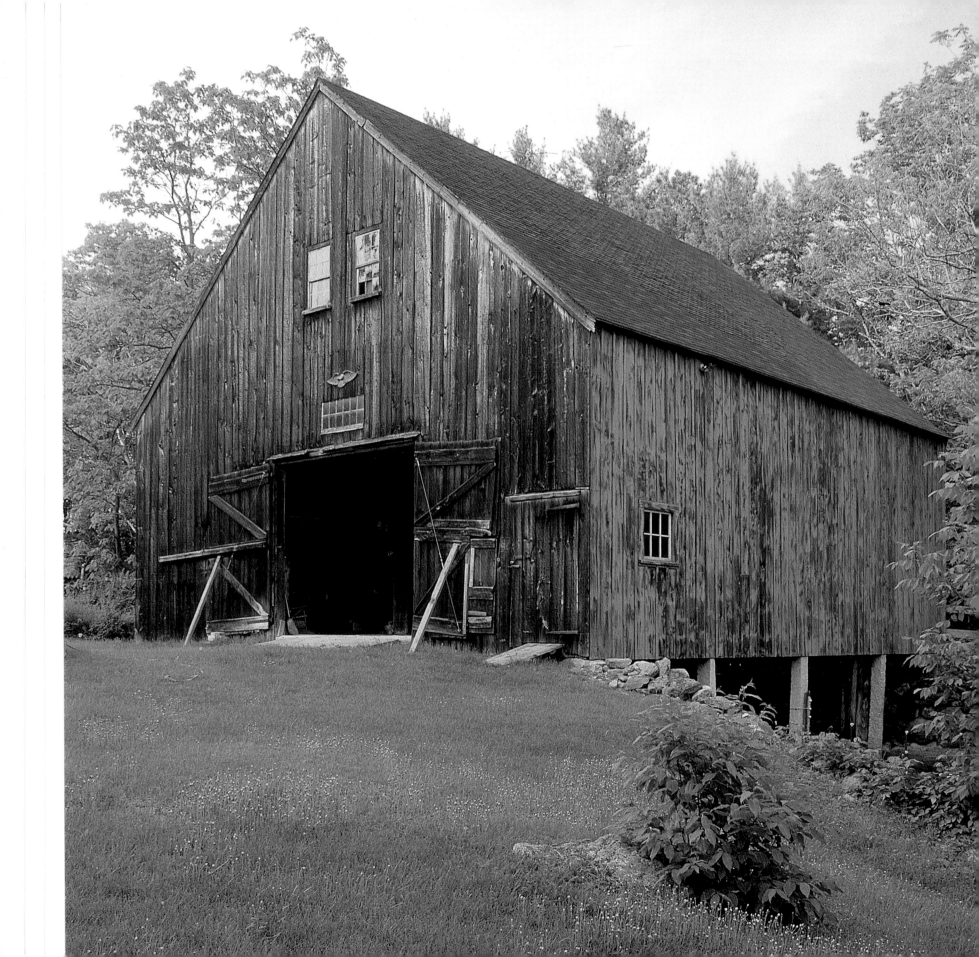

DUTCH, GERMAN, AND SWISS HERITAGE

*E*ven as immigration continued, migration began. The pattern of arrival, survival, settlement, betterment was repeated with each new ethnic group. The population of America was growing rapidly. New lands were needed for farms and villages because of the steady arrival of settlers not only from England but also now in greater numbers from northern and central European countries as well. The first Dutch arrived from Holland midway between the Jamestown colonists and the Massachusetts Bay Puritans. They established a trading post near present-day Albany, New York, in 1614 and founded New Amsterdam (now New York City) in 1625.

Farmers from the Netherlands brought with them a particular heritage that consolidated agriculture, animal husbandry, and their own home into a single structure. In the Old World, this rectangular building was known as a *loshoe*, with one large double doorway at one gable end. Unlike English barns that made no accommodation for sheltering livestock, the Dutch drove their animals into the barn through that doorway each night and back out each morning. Pigs lived nearest the door, with stalls for horses, cows and calves, and sheep lining the central aisle and leading away from the door. Animals faced into the center to facilitate feeding, and sometimes

Kimball-Savage Barn, Middleton, New Hampshire
The typical Dutch barn in the Netherlands was a rectangular structure with family living quarters at the end farthest from the main, gable-end door. In the New World, with its harsher, colder winters, immigrants separated the residence in order to heat it without the risk of burning down the hay-strewn barn. So Dutch barns such as this one in New Hampshire and others in New Jersey and New York are generally square. This one measures 40 feet, 5 inches on a side and stands 31 feet, 7 inches tall at the front door.

Dutch barn builders did many things to human scale, including inserting "man-doors" into the larger swinging barn doors. Main doors opened on both gable ends to allow wagons and wind to pass through. The livestock used separate doors near the outside wall to enter and leave the barn as well. Roof overhang is very slight.

This Dutch-style barn was built, ironically not by Dutch immigrants but by a Northern Irish family, the Colbaths, who first came to the New World around 1700. By 1780, they had reached the middle of New Hampshire and, as the family expanded, they built barns and homes. Ephraim Colbath wrote the date his barn was completed, May 11, 1834, on a southwest front girt.

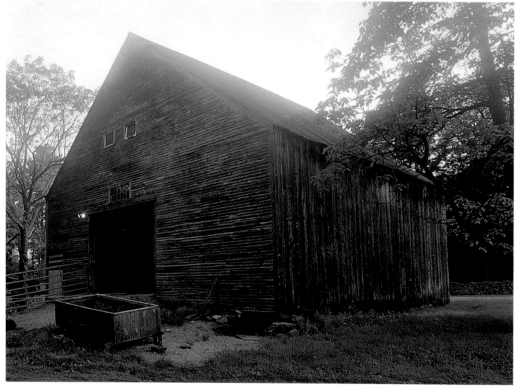

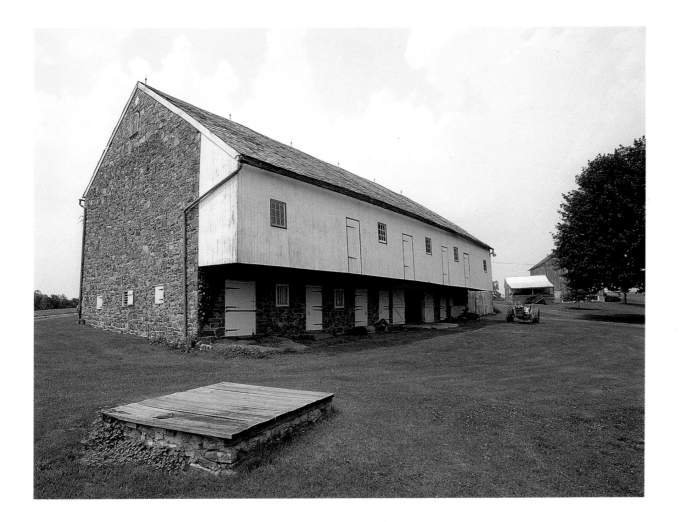

**Schryner barn,
Oregon, Pennsylvania**
In 1738, when Hans Adam Schryner
was 48, he and his four children
came to the colonies. He obtained a
grant of land from colonial governor
William Penn and began farming.
When he died, his oldest son, Philip,
and Philip's wife, Catherine,
inherited the farm, and then their
oldest son, Michael, inherited it from
them. About 1828, Michael
constructed the stone and wood
forebay barn.

Typical of Dutch-style barns, the
interior is slightly asymmetrical. The
owner and his family kept cows, and
the remains of stanchions still exist
behind the breast boards on the north
side of the 12 foot, 5 inch wide
central aisle. The stabling area is 12
feet wide, while across the center
aisle is a 15-foot, 6-inch-wide hay
storage. Above the center aisle is a
grain storage room, and on the door
and an adjoining wall one of the
owners began noting feed corn
harvest in 1851 (17 bushels) and
continued through the 1860s.

the ground level on which they stood was lower than
the central aisle and even banked away from it. The
central aisle also served as the threshing floor. The
gable-end doors provided access for wagons.

Two-thirds of the loshoe was home to the live-
stock and crops and it was built on a simple pounded
dirt floor. The last third, farthest from the main door
and insulated from winter cold by the heat of the
animals, was the family home. A doorway on each
side of the barn allowed access from the living quar-
ters to the yards. If a floor plan were drawn of a typ-
ical Netherlands loshoe, its resemblance to church
architecture would be apparent, from its long cen-
tral aisle entered by a doorway at the far end, to its
perpendicular aisles or transept, just before the
altar—or in this case, the hearth.

This residential area, generally built on a
"floor" of cobblestones, comprised several rooms.

There were tiny sleeping chambers—closet sized,
really—with doors to provide some privacy to the
sleepers and some further insulation from the
weather and the odors. There were public areas, a
kind of living room-dining area, and another room
set aside for such activities as weaving. Cooking was
done around an open hearth in the center of the
floor very near the sleeping rooms. Also near the
hearth was a room usually called the "best room."
This was literally the finest room in the house, a
place where visitors were entertained but which
the family seldom used otherwise. Above all of this
was the hayloft, which often extended the full
length of the barn and further insulated the inhabi-
tants. This hayloft provided sleeping quarters for
children and servants. In communities where life
was segregated by religious edict, all the men slept
in the hayloft.

Interior construction of the Pennsylvania Dutch barns was always heavy duty. Cross beams tied together the vertical posts several feet below the tie beams. Queen posts, angled at somewhere between 40 and 50 degrees and supported by smaller braces, carried the purlins, the horizontal beams on which rafters were laid and then to which roofing shingles were attached. This style was widespread by the mid-1800s.

Loshoes were built of timber frame. Eric Arthur and Dudley Whitney, authors of the 1972 book, *The Barn*, explained that this Dutch barn had "prototypes in iron-age Britain, when the barn took the form of an upturned ship. This was the barn of the fourth century B.C. It was rectangular and was formed by 'crucks' or the meeting of a pair of tree trunks roughly trimmed of their branches and so bent by nature that, when brought together they formed a curved 'A'. . . ." It was the Welsh and the Scottish Celts in Britain who devised the use of crucks separated by nearly equal spaces into bays, to support their early barns.

Walls of the loshoe were constructed of wattle and daub, wattle being a kind of intertwined weaving of sticks and twigs. Daub is a sort of clay plaster that forms a stucco to seal and strengthen the wattle. The barn's steeply-pitched—and usually hipped—roof was covered with thatch. Eaves drooped close to the ground but with a good overhang so rain run off did little damage to the sills and the bottoms of the walls.

The barn/home was nearly always built around a well and the hearth was placed as close to it as possible. In the Netherlands, farmers burned peat in their hearth; it provided enough heat for cooking and winter warming. A tiny vent hole was left in the roof peak for the smoke to escape. However, peat gave off little light. Lanterns—or torches—inside such a building were unthinkable; fire could take not only the farmers' harvest, produce, livestock, and home but perhaps also their lives. In the 17th century, long before glass windows would light and ventilate the interior, livestock aromas must have mixed heavily with the peat smoke in dark, damp gloominess in late winter.

In the New World, the Dutch learned that peat was unavailable. They also found that Eastern winters were much harder on them than the cold months in Holland. They knew that wood fires burned hotter, so the Dutch quickly adapted. They separated their homes from the barns. They modeled their residences after the wooden buildings they had seen in the towns and cities on market days. They viewed this new lifestyle as a great step up in their well-being. They modified their barn shape

slightly but predictably. The rectangular loshoe became a nearly square barn once the residence was removed. Locating thatch proved to be a challenge in some northern areas so roofs, while remaining steep and hipped, were covered with wood shingles. (Barns in some areas of Pennsylvania, however, used thatch even into the 19th century.) These New York and New Jersey farmers retained the big door in a gable end. However, they added another one at the opposite end (that was no longer blocked by living quarters). This eliminated the need to back the horses and wagon out after unloading the hay. Just as the English had done, the Dutch opened both doors on threshing days and let the wind do some of the work.

Within the next century, the Dutch made another improvement on their barns. Still feeding and tending livestock off the central aisle, inventive builders considered the desirability of animal doors at the sides of the gable ends, just inside the eaves.

As sizes of herds increased to such an extent that all the cows could not be milked at once, these livestock doors were added to both ends, just as the wagon doors had been. This allowed the animals to enter and exit the barn in one direction, without doubling back on incoming livestock.

*W*hile the earliest Pennsylvania Dutch immigrants had begun to arrive in the New World in the late 1600s, it was really during the first half of the 1700s that great numbers of German transplants settled in southeastern Pennsylvania. They were attracted to the peaceful organization of the region and to its religious tolerance fostered by founder William Penn and the Quakers beginning in 1680.

As Robert Ensminger characterized it in his 1992 book, *The Pennsylvania Barn, Its Origin, Evolution and Distribution in the United States*, these settlers "poured into an area of Pennsylvania beginning north of Philadelphia and extending west beyond the Susquehanna River. There they developed a successful agricultural economy based on the area's rich soils and easy access to urban markets via numerous early roads." A produce market was opened in Philadelphia by 1710. The Germans moved out into the gently rolling hills, following the well-established Indian trails. These paths connected not only the various tribal settlements, but they also came to be the roads between the German communities and the families that stretched between them.

The abundance of trees, unlike their homelands and in nowhere near such threatened existence as in Europe, made the area seem at once comfortable—even if not exactly familiar—to the Germans. (By the 18th century, most of the great forests of Europe had been harvested out. The New World's seemingly endless trees encouraged changes in building techniques. Labor-intensive wattle-and-daub walls were soon replaced by quick-and-easy wooden clapboard siding, for example.) Following the rapid completion of shelter for themselves and their families, the German farmers set out to construct larger, more permanent buildings for their livestock and grains.

Their first structures were built of logs from the

hardwood trees growing all around them. (Log cabins and barns probably arrived in the New World with the first Swedish settlers into Delaware in 1638.) Unlike the English who almost never built log barns, the earliest German barns in the New World were simple constructions, built of trees they felled for the purpose. They notched these at the ends in order to secure one log on top of and perpendicular to the next. Spaces between the logs were often left open to allow air to dry the harvest. Within a short time, however, the builders began to finish the logs on top and bottom for a closer fit; later they filled in the chinks between the logs to close up the barn against winter.

As family growth and continuing immigration swelled the German population, more workers were available to perform hand labor. Saw pits—in operation throughout Europe from the early 1600s—were established in the colonies, and the felled trees could be flattened on four sides. Elaborate notches and joinery were introduced to better and more tightly assemble and tie together the ever-growing barns.

The broad spread of countryside and the wealth of trees allowed landed settlers arriving in the New World in the early 1700s to dream of farms

This is what is known as a classic *Sweitzer* barn, or a *Swisser* barn, primarily due to the unsupported forebay that overhangs the cattle yard below it. These overhangs were built at the same time the barn was originally constructed and this area was frequently used for storing feed grain (the heavier hay was stored in the rest of the barn). Countless variations on this style exist. Some barns have trapdoors in the forebay through which grain can be shoveled down to the livestock below

The stone walls are 20 inches thick and the barn measures 40 feet, 7 inches deep including the 7-foot, 3-inch forebay and 88 feet, 8 inches long. It is built with four internal bents providing five bays. To the roof peak it stands 34 feet, 6 inches tall. Narrow slits in the stonework on the gable ends provide ventilation and a little light to the interior of the hay, wagon, and threshing floor.

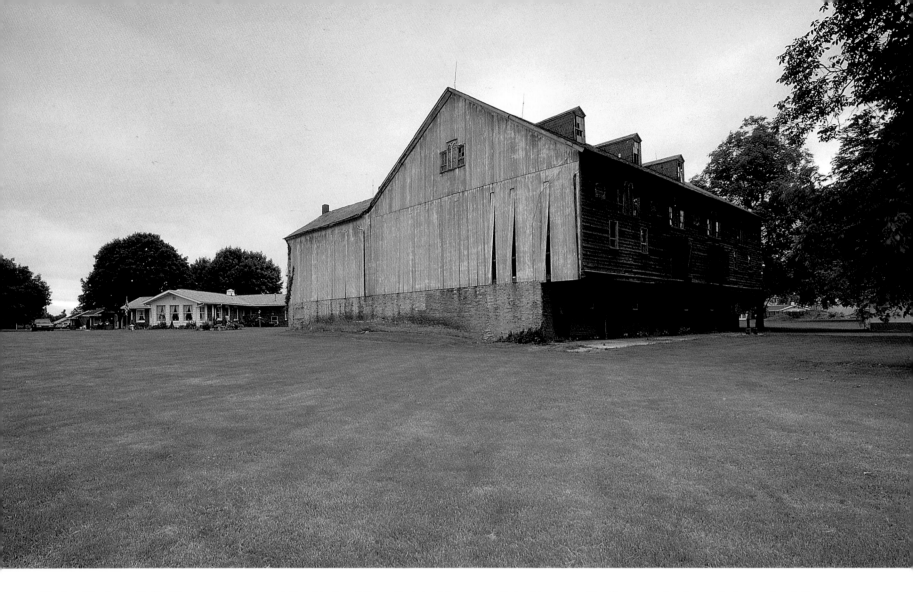

Hoober-Eby barn, Neffsville, Lancaster County, Pennsylvania
John and Matilda Eby acquired land from Matilda's father, George Hoober, near Neffsville in Lancaster County in 1859. A year later, John built a large—72 feet, 4 inches by 49 feet—brick-and-wood forebay barn. During the 1870s the Ebys divorced, and the farm was sold to Abraham Huber in 1882. For the next 75 years, his family worked the farm. Near the end of that time, developers built a retirement community on the farmland, expanding as more and more land was removed from active agriculture.

and the kinds of lives that had been unattainable back home. Europe had long since graduated from the tight, frightened living arrangements in walled compounds that characterized the Middle Ages and before. Certainly, this heritage proved adaptable to the colonies, and it was even necessary in the early 1600s in Jamestown and Massachusetts Bay to provide protection against uninvited visitors.

*B*y the time the central European immigrants arrived in William Penn's peaceable territory, even the English settlers in Massachusetts and Virginia had moved beyond the dark ages. The stockade walls of Plymouth Colony had been dismantled, the timbers turned into houses and barns. The Puritan fear of wilderness had been tamed out of necessity.

The farmers simply needed more land. Forests were burned, the demons of the superstitious were driven away, and villages and farms continued to grow.

When the great surges of Germanic colonists arrived, they found meadows laced with streams. These spread through the nearly limitless forests that rose and fell over long limestone ridges that ribbed Penn's colony. The Massachusetts idea of grazing commons had proven cumbersome and limiting, and for these central Europeans, the possibility of having one's own compound—a home and a barn—was the greatest motivation for hard work. They built structures familiar to them as their English neighbors had done a century before. Tall-roofed rectangular buildings appeared. But these differed from the Massachusetts barns and houses by the

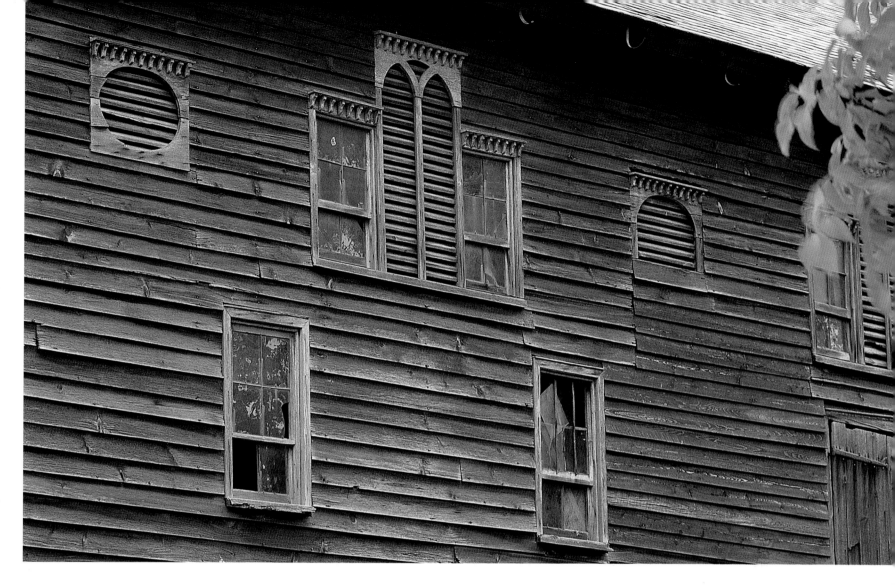

addition of a projection, a forebay, above the ground floor that was cantilevered out over the stockyard. This provided more floor space up in the haymow of the barn than in the stables down below. In the Swiss mountains it had served another function even more valuable during rainy and snowy seasons, conditions not unheard of in eastern Pennsylvania. As Robert Ensminger described it, "The overhang of the forebay prevents blockage of the stable doors by straw or snow and avoids splash erosion of foundation mortar near ground level during heavy rains."

Throughout middle Europe, in the crowded, walled towns in Britain, France, Switzerland, and Germany, this extension of the second floor expanded the living space of narrow, vertical houses in the only way possible: forward, out over the streets.

Most of the new settlers arriving from southern Germany and Switzerland were familiar with deep valleys, rolling hills, and mountains. The idea of a "bank" structure was an accepted design for a variety of building needs. These people had stored hay and grain in banked barns, but they also lived in houses and worshipped in churches and paid their taxes in buildings built out from hillsides. Among the early settlers were Mennonites, from a Christian Anabaptist sect that was founded in the Netherlands in the mid-1500s. Mennonites were often accomplished carpenters, and their talents were reflected in the innovative and well-built barns and homes.

The rolling terrain of Pennsylvania reminded these German and Swiss farmers of home. And so when they found land, they, like the English ahead of

The front was "decorated" with louvered ventilators. Double doors on the hay floor level allowed farmers to throw hay into the yard below and to further dry the harvest. German and Swiss farmers brought their architectural heritage: barns built against hillsides with stables below. The *vorbau*, or forebay, projected out a short distance over the farmyard below. This offered cattle some protection from falling rain and snow.

DUTCH, DEUTSCHE, AND GERMANS

The history of settlement in the early United States is often confusing because of the similarity of names of different ethnic groups. In the early 17th century, Dutch emigrants from the Netherlands settled in New York and New Jersey. They kept to the northeast, and their culture and architecture remained their own. Beginning in the late 17th century, German-language speakers arrived in the New World and gravitated to Pennsylvania. Some were trades people, but mostly they were farmers from southern Germany, Switzerland, and Czechoslovakia. They belonged primarily to the Lutheran or to the German Reformed Churches, with a small mix of Mennonites, Amish, and others. When they told the English their nationality—*Deutsche*—it was understood, and recorded, as Dutch.

These people, the Pennsylvania Dutch as they came to be known among themselves and outsiders as well, continued steady immigration to the New World into the early 19th century. Their offspring and their dialects evolved into the present-day Pennsylvania Dutch population and language. Then, beginning around 1840, the "modern" Germans began to arrive. These individuals included not only younger Lutherans and Reformed Church members but also Roman Catholics. They came from all over Germany as well as Austria and by large measure, they were mostly urban dwellers, better educated than those who had come before. These were trades people, some laborers and more professionals, and they spoke a language similar to today's high German.

them, built what they knew. They adopted Pennsylvania natural resources—and probably some English ideas—where they needed to do so. Throughout Switzerland and Bavaria, the barns were built perpendicular to the slope of the hill, that is, out from the hill. In many of them, entry was from the gable end; fewer it seemed, were entered from the long side. In Pennsylvania, right from the start, barns were set on the site to run along the hill and entry was on the sidewall.

In some areas in both Germany and Switzerland barns originally incorporated living quarters under the same roof, just as the Dutch loshoes had done. But these homes occupied two floors and behind them was the barn. Wagons drove the hay into storage on the same level as the upper story of the home, while animals were stabled down below behind the ground floor of the residence. Like the Dutch, the Germans and Swiss abandoned connected houses when they arrived in the New World and so, perhaps, they found other advantages to orienting the barn sideways to the hills.

For the next 200 years this hybrid building evolved. The changes were influenced by construction materials and by the methods available to process them. It was also affected by the amount of time and the quantity of workers available to build the structures. As with the English, the earliest houses and barns were uncomplicated rectangles. With abundant timber available, a careful selection from the farmers' own forests would yield fast, simple shelter for the family and the livestock.

A tax record of 1798 listed 15,490 barns in eastern Pennsylvania. The breakdown by building material offered a perspective on the evolution of construction styles up to that time. It also suggested the increasing stability of the settlers and their growing confidence in the agricultural economy of southeastern Pennsylvania. Wood structures, even those built with foundations and sill plates, were nowhere near so permanent as barns constructed of stone. Of the total, 6,818 were purely log barns; just 716 were identified as strictly timber-frame construction, while only 43 were listed as log-and-frame buildings. However, some 1,829 of the structures were described as

Hoober-Eby barn framing.

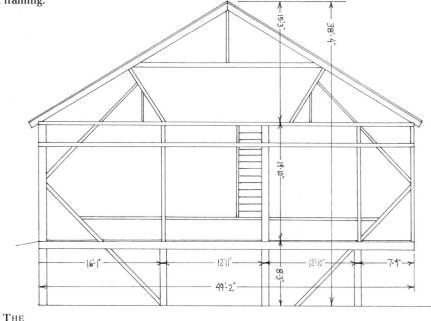

THE AMERICAN BARN

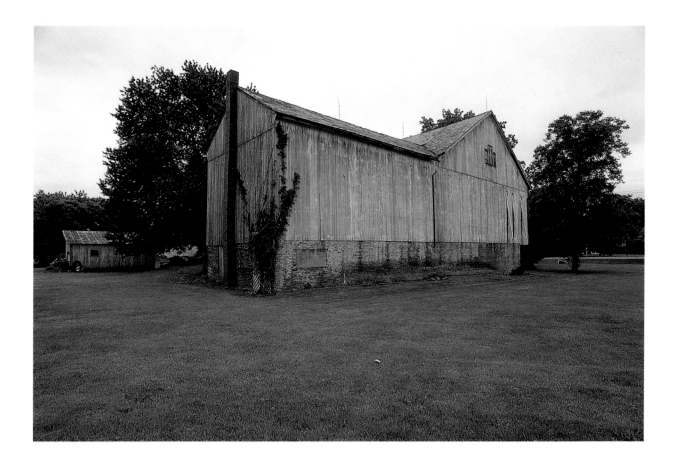

When tools were hand-powered, shortcuts were routine. Logs for floor beams were adzed on two sides when headroom was needed. Hewn major corner posts were 7x12s, and 6x10s were used for purlin posts. The forebay reached 7 feet out across an apron of grooved concrete. Barns very similar to this—but not identical—exist throughout Switzerland and southern Germany.

Sometime after the turn of the 20th century, Pennsylvania broadleaf or seedleaf variety tobacco became a profitable crop in Lancaster County. The barn owners began to raise it on their farm and the barn was modified to accommodate it. A new 22-foot, 6-inch-by-30-foot shed was built onto the rear of the barn, and tall vents that pivoted open from the top were cut into the new long wall to allow more efficient circulation to air dry the leaves.

exclusively stone barns while 685 were combinations of log and stone. What's more, one new material had yet to make a noticeable impact; in 1798, there were only 10 brick barns listed. (The same tax report listed 4,971 barns as "unclassified." This large number may have been the counts of lazy tax assessors simply unwilling to go have a closer look. Certainly, however, some of these were log barns that had been sided with vertical planks. From the outside, they would have resembled frame structures.)

Very few log barns still exist anywhere in the eastern United States. Because they were often the first building put up in the compound, they were usually superseded by a larger stone barn. The log structures slipped into secondary importance and finally into neglect. It didn't matter whether they were assembled from quickly felled trees or if the timbers were carefully finished on two or four sides, interlocked at the corners for strength and durability, and finally joined and sealed with lime mortar. Obsolete was obsolete.

Pennsylvania barn historian John K. Heyl has observed that these structures were often made up of two squares of log bays that flanked an open loft between them. Based on his own inspections and on a diligent study of the buildings by Chicago architect Charles Dornbusch, Heyl wrote the foreword to the Pennsylvania Folklore Society's 1956 volume devoted to Pennsylvania German barns.

"Sometimes additional bays were added at a later date," he theorized, "because of the increasing needs of storage for the increasing farm acreage. But the repetition of small units attached to each other also may be an indication of the continuing scarcity of manpower to erect a single larger structure. The log barn continued to be built, and its form developed along with other types of farm structures; as late as the early 19th century, this form of construction persisted in all the frontier areas." (In fact, Finnish and Swedish farmers continued to build log barns in Minnesota, Wisconsin, and Michigan's Upper Peninsula into the early 20th century.)

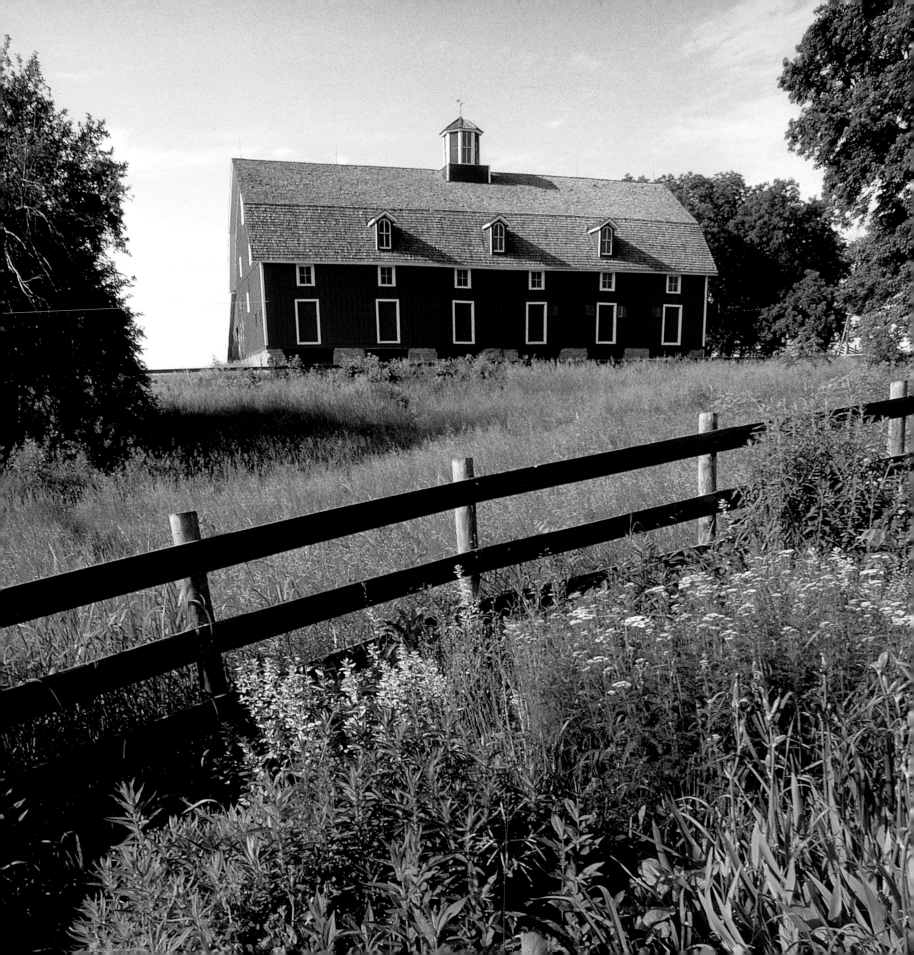

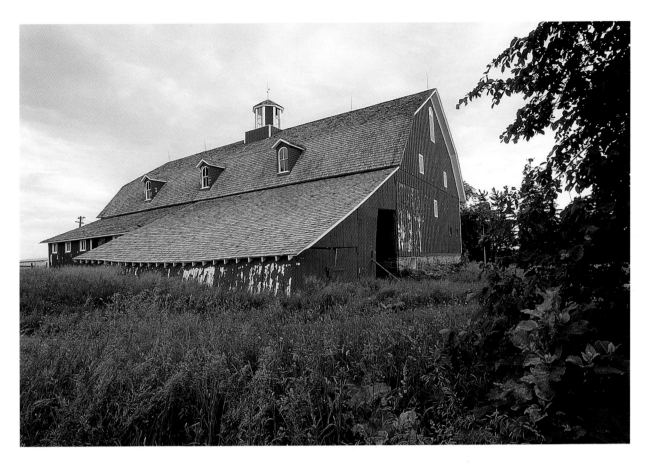

*V*ast numbers of Pennsylvania Dutch immigrants reached the New World in the first half of the 18th century. Penn's early colony of Quakers had experienced little trouble from the native population in the eastern part of his colony, and so immigrants selected their plots and cleared their lands in peace. Farms arose and grew rich as crops flourished and, in proximity to Philadelphia, an agricultural marketplace developed that encouraged farmers to enlarge their operations. This market economy fostered an almost self-perpetuating cycle of growth and expansion, of settlement and betterment. Later, swelling ambitions and real needs would enlarge the farms and barns even further.

Bigger barns were needed to accommodate greater quantities of crops and to hold them until markets seemed best. Granaries and threshing floors had to be enlarged. Farmers recognized that livestock that was fed and stabled grew more quickly and predictably than cattle that ranged freely and foraged for their food. The evolution from farming with oxen to using horses meant that farmers had to keep oats and other grains for feed as well as the earlier staple diet of hay.

The labor pool grew, and workers for hire were now available. More agricultural equipment and more livestock—and stabling and pens—were required. Bigger, more demanding construction could be undertaken. These were works requiring larger, more massive timbers. They utilized stout internal structures to support heavier loads inside and carry bigger roofs over them. This was no longer subsistence farming; it was yet another site for the steadily improving commercial farming business of America.

The Pennsylvania Dutch settlers moved out in search of more lands, following those trails the Indians had used for centuries. The immigrants passed by the towns and villages, leaving them to the English and Welsh settlers who had come before them and who felt more comfortable in organized habitation. This new expansion—to the west over the limestone hills and ridges across Penn's colony, to the

Interior framing is much streamlined over the southeastern Pennsylvania Dutch barns with elaborate bents and cross beams a few feet below tie beams. This barn is constructed with interior posts rising straight to roof purlin plates. The interior posts show evidence that the hayloft—now high above the main floor—originally was barely 7 feet up, allowing the barn a huge hay capacity. The roof structure did not allow running a single hay fork the length of the entire barn, so George Charles installed several shorter ones running the width of the barn.

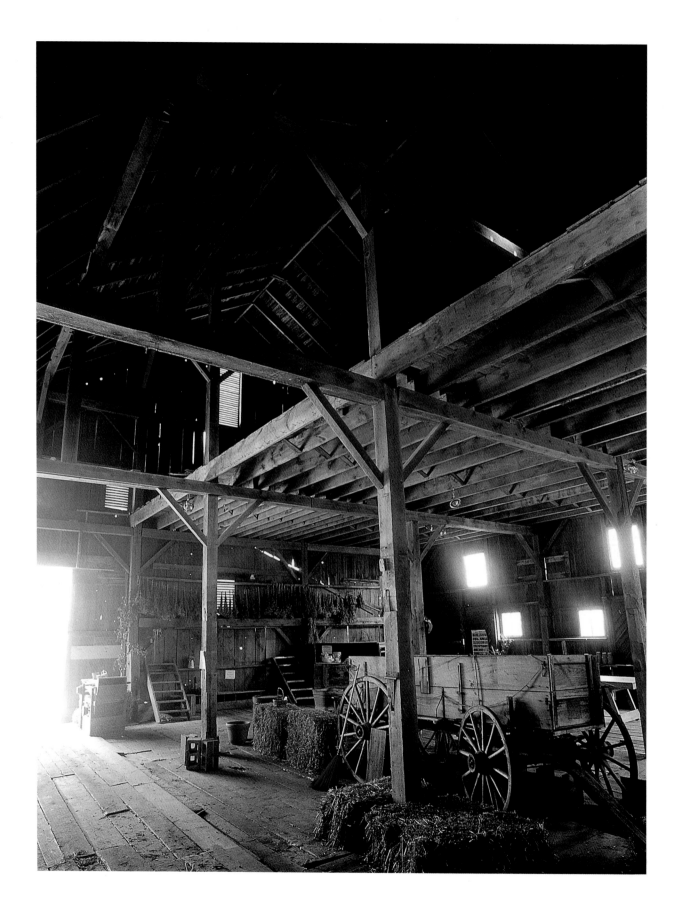

south over the wall-like Blue Ridge Mountains into Virginia, and even back east around the Potomac and Chesapeake into Maryland—moved the Germanic ideas and designs with them. (Later, when more of the Pennsylvania Dutch arrived to pursue the American dream, they spread their heritage further along the trails they followed. They set out to the north along the rivers through western New York, some continuing farther north into Ontario. They walked or rode west along paths that had become roads—and would, in the mid-20th century, eventually become interstate highways—leading them into Indiana, Illinois, and Wisconsin. Through the 19th century, their barn architecture was repeated hundreds of miles west and north of Pennsylvania.)

Dornbusch's and Heyl's studies revealed a pattern. The barns Dornbusch observed in the late 1940s and those Heyl reexamined in the early 1950s "show the evolution of a basic plan which continued to be followed. Already the use of an irregular site appears to be preferred." The comfortable familiarity with rolling hills and undulating terrain seemed to be a deciding factor for many farmers in their plot selection.

The barns with a cantilever or overhanging forebay reminded the two researchers of medieval structures—not just barns—in the hilly lands along the Rhine River and the borders near the Swiss Alps. Where there were no hills, farmers built them. Moving dirt into ramps to gain animal and wagon access to an upper level, they were adopting an idea from, of all things, military buildings and fortresses. Throughout Germany, England, and France, soldiers recognized the obvious defensive advantage of being above their attackers. Heyl carried the military analogy even further, suggesting that the long slots in the stone walls used for ventilation of the hay and grains in the Pennsylvania barns were all meant to reproduce the *balistratas*, the widened interior spaces in fortresses from which archers fired their arrows at invaders. In most forts, the funnel shape was outside the wall, while in barns for some reason, this was reversed. Even the use of light roofing materials such as straw thatch and hand-split wood shingles was carried over to Pennsylvania from the very tall, steep, gabled roofs at home.

As with the English structures, the framework of heavy but precisely measured, fitted, and pegged timbers provided the structural support. But the new geography—or more accurately geology—that met the westward migrants crossing Pennsylvania, offered to them an even more permanent building material to supplement the timber.

End walls were soon built of quarried limestone laid up in a lime mortar. Barns constructed with the cantilevered forebay (or *vorbau*) with sidewalls of stone have become known as "Sweitzer," or "Swisser," barns. Heyl wrote, "These barns on their natural or manmade ramped site recall the Swiss bridge-barn or house with its hayloft and inclined cartway; there is also the masonry walled stable area for stock below."

German builders generally constructed their barns with stone masonry up to the hayloft floor—even in structures where the rest of the primary construction was timber frame. Of course, countless other examples carried the masonry walls right to the peak of the gables, while interior and roof structure came from timber-frame bents supporting purlins. Still others, it seems, remodeled their wood frame buildings. Heyl wrote, "Some barns with stone gables completed to the roof ridge, show a complete change

Charles built the barn with the idea of going into cattle ranching. He did this quite successfully, and by the 1890s, he had several hundred head of polled Angus and Herefords on more than 1,200 acres. The sandstone foundation for the barn was quarried on the farm. The barn is 48 feet deep by 96 feet long and, from the yard level, stands 45 feet tall to the peak of the roof and another 12 feet for the cupola.

of type of stone and even of mason workmanship, indicating a later closure of a once wood-framed gable. Some barns, which outwardly seem to be wood-sheathed frame from the loft floor, in reality have a partially built masonry wall atop which is secured the heavy plate supporting the timbers above."

The heaviest of these hardwood timbers were usually oak and often the pegs were too, although hickory or even maple or ash were used for pegs in some instances. The heavy flooring planks were most often oak as well. Wood siding, both of the exterior and of the boards set tightly about the granary space and defining the stalls, was usually pine; pine or spruce was generally selected for some of the smaller braces. While sawn timbers first appeared in the early 19th century in New England and in the Chesapeake and Potomac regions, in Pennsylvania these were used only for lighter pieces of barn structure. The most massive pegged timbers of the structure were still formed by the ax and adze up to a decade or so before the Civil War. According

Hafer/Wren barn, Oley, Pennsylvania

Adorned with "hex" signs, this Berks County barn was built in 1880 by E. S. and A. Deturk, as is recorded on a stone set high in the gable end. This structure, with its symmetrical gables, is what is called a "closed forebay" barn. It was most recently repainted by sprayer, a highly efficient method of covering large expanses of old, dry wood siding.

The barn was sited on flat land, but the Deturks built an earthen ramp up to the large four-bent, five-bay barn. Property tax rates were revised in Berks County in the late 1800s, with the assessment rate higher for barns longer than 100 feet on any dimension. The building measures 42 feet, 3 inches deep and 97 feet, 10 inches long. Its forebay overhangs the yard by only 5 feet.

to Heyl, by the last quarter of the 19th century, "the overall size of these barns was so exactly established that in later years, when one structure burned, another barn, no longer in use, could be found, dismantled, and re-erected within the fire-scoured but intact masonry walls of the other."

Local fieldstone was used for each barn. As with great timbers, the convenience of backyard resources eliminated the difficulties of transporting heavy loads of stone or wood. Dornbusch and, later, Heyl counted barns built not only of the light gray, hard limestone, but they also noted buildings constructed of mottled green serpentine, beige sandstone, grayish granite, and striped gneiss, as well as of gray-green ledge slate and shale stones. Closer to Philadelphia, pudding stone and mica schist were quarried. And, while there were only 10 barns built of brick on the tax records of 1798, within the next century there were thousands constructed from home-fired brick. "The countryside has many scattered clay banks," Heyl reported, "which make a fine, hard, vari-hued red brick. Throughout the whole area, on almost every farm, there existed the bank-side, stone-arched lime kiln. The quarried limestone," he explained, "was dumped into this brick-lined hopper from above and a great wood fire burned this stone until it became the fragile, calcified lime that, slaked in water, made such a wonderful 'self-healing' mortar. Toward the close of the 18th century many stone masonry buildings had one or all walls coated with a lime stucco. This surface hardened into a light-colored impervious surface. It weatherproofed the surface of the masonry."

From the start, Pennsylvania barn builders used the *balistratas*, the fortress-like slits, for ventilation and circulation to dry the hay and grains. In later developments, builders made brick vents set into stone. Then came fixed wood louvers in frames. As time passed and the understanding of rising heat became clearer, ventilating cupolas appeared on roof ridges. In Lancaster County among others, there even seems to have been a belief among well-to-do farmers that if one cupola was good, two or three were better. Barns sprouted four or five or more, and once glass and glazed-wood frames were developed,

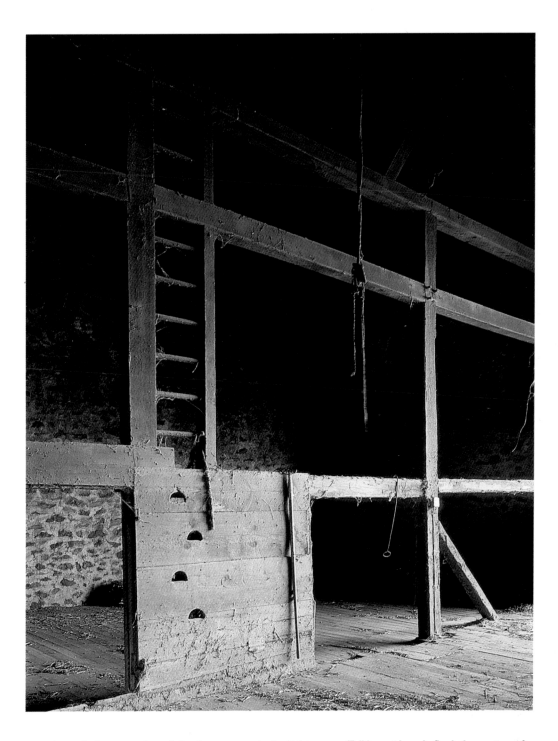

opening windows replaced the louvers to help light the barn interior as well as ventilate the heat.

Brick builders used the freedom their material allowed them to delete bricks from walls. They created designs that represented chalices, sheaves of wheat, diamonds, flowers, and even characterizations of the owner. This missing brickwork was a

Tall breast boards flank the centers of the two threshing floors and the ever-present ladders rise up toward the tie beams. The builders had a clever idea carving four footsteps into the 5-foot-tall side boards.

DUTCH, GERMAN,
AND SWISS HERITAGE

61

Kaufman barns, Oley, Pennsylvania

In Berks County, Pennsylvania, there are a pair of barns built in the late 1800s that characterize the *peilereck* forebay style. In these barns, the stone gable walls extend to the ground, and in fact, they wrap around slightly to form small alcoves at either end of the shallow forebay overhang. This style is one of many variations on the *Sweitzer* or *Swisser* barn.

technique that had first appeared in the 15th century in England as a method of ventilation, and it was elevated to an artistic form in Pennsylvania.

Following the Civil War, the small, individual louvers inspired additional creativity. They became tall, fanciful fixtures that punctuated the front and sides of frame barns. This decoration became a kind of functional ornamentation. Sometimes simple designs—six-pointed stars, crosses, and hearts—were sawn into the pine siding. Smaller, simpler cutouts had first appeared in the gables just below roof peaks in the 1700s.

Similar to English barns, the first steep-pitched German roofs were covered with the lightest materials available. In earlier construction, gables appeared to be off center. This was because, while builders extended the floor timbers out to support the forebay, it appears that they treated the sidewalls and the roof of these forebays as though they were added-on sheds. In later versions, generally regarded now as the "standard Pennsylvania barn," symmetry was the goal. The forebay was treated as part of the structure and was fully integrated into the gable end of the barn.

These roofs were built with principal rafter construction techniques that used wide-set, heavy supports. They were covered with either straw thatch or, later on, long, hand-split shingles of white cedar, pine, or oak. When the slate beds in eastern Pennsylvania were discovered and "mined," slate tile roofing—on lower (or flatter) roof slopes—became common. Dornbusch and Heyl discovered that in some areas, "early settlers had red clay tiles burned and these were used on their smaller buildings. Probably," Heyl mused, "this attractive roofing material, in such general use in the provinces of old Burgundy and the central Rhineland, proved much too heavy for the great, lofty roofs of the large barns." Tiles had been used on large barns and houses in Europe; however, in Pennsylvania some of the structures were growing to such a size where the weight, with added snows, would have been a problem.

The main cattle barn sits back from the road while nearer to the public access is the smaller sheep barn. It is 33 feet deep and 40 feet, 3 inches wide. The stone masonry walls of each barn are 20 inches thick. The *peilereck* forebay of the sheep barn overhangs barely 3 feet. The building stands 31 feet, 8 inches tall. Access to the upper level haymow is by ladder through a trapdoor. Other trapdoors in its floor allow hay to be dropped into feed troughs on the ground floor inside the barn.

Paint, however, weighed next to nothing. To protect the siding, early colonists smeared what was said to be a mix of iron-oxide and cows' milk onto their buildings. In Pennsylvania, once the prevailing deep red color had covered the wood-sided forebay, builders or owners trimmed the doorways, ventilators, and windows in lime whitewash or later, white lead paint. Sometime before the Civil War, the Pennsylvania Dutch began to paint decorations on their barns following traditional folk designs. The same six- and eight-pointed stars that earlier had been sawn into the wood were now painted on, floating in a circle of white. Spinning suns, hearts, tulips, and other flowers had appeared for decades on German furniture, pottery, embroidery, and textiles, even their documents. Like a secret handshake or a special greeting, these symbols, often outlined in black and generally—if erroneously—referred to now as "hex signs," became a means of identification to other Germans of the origins and heritage of the farm's owners.

The Pennsylvania Dutch barn builders learned that even an evolved building style could advance further. Some farmers who had built English-style barns eventually needed to enlarge their hay and grain storage capacity. At first, the solution had been to push the wall out over the stable, to make the forebay. These earliest settlers were simply doing—after the fact—what their countrymen who had arrived later would do right from the start. However, even those wiser, later arrivals learned that improvement was still possible.

When livestock populations increased on the farm, the amount of hay needed to feed the animals, of course, grew proportionately. Farmers stuffed barns with heavier and higher loads of feed. Forebays typically carried the granaries, and the rest of the space was used for general storage in the early days. Trapdoors in the floor and doors in the front wall opened to throw feed down to the livestock in the yard below. An exceptional harvest or several years of them displaced the tool storage and farmers

Architectural historians generally agree that the Pennsylvania Dutch forebay barn really was developed in Pennsylvania. But its roots go back to the architecture of homes and log barns in southeastern Switzerland and southern Germany. These evolved in the minds and imaginations of barn builders and their apprentices who, once they arrived in the New World, found the opportunity to experiment with new ideas.

DUTCH, GERMAN,
AND SWISS HERITAGE

The large barn measures 42 feet, 9 inches deep by 91 feet, 10 inches long. It is 40 feet, 8 inches to the roof peak from the cattle yard. On the bank side of the barn is an attached 11-foot, 9-inch-by-25-foot masonry granary, usually called an "out shed." As early as 1790, farming in eastern Pennsylvania began to shift from planting and harvesting grains to keeping livestock. Barns that previously only stored harvested materials had to be enlarged to keep animals and all their feed through the winter.

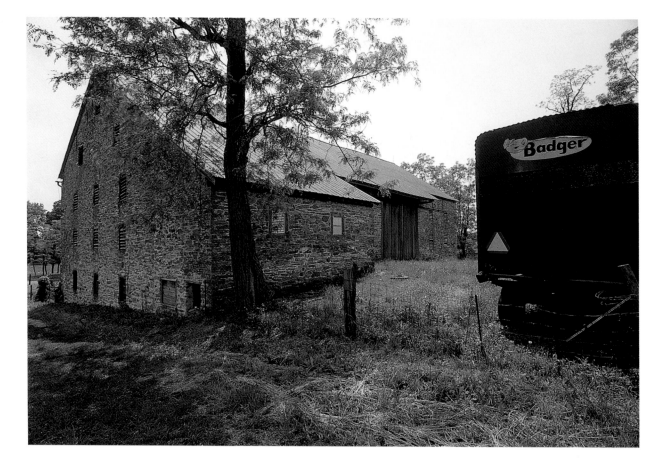

piled hay high against the front walls as well. This strained the 18th- and 19th-century forebay engineering technology. At first, farmers and builders fabricated masonry columns, *Eckpfeilern*, to support the ends. Eventually, builders saw a solution in sidewalls on the ground level, the stable level. Around 1800, stone masons simply began to build full gable walls down to the ground, without the notch below the forebay. Visually, this filled in the area under the ends of the cantilevered section. Structurally, these walls provided a kind of buttress that supported the forebay at the point where the weight of hay and of the corner of the roof had previously hung out in the air. This later style of forebay, with its gable end support walls that formed a kind of alcove on the stable level, was called *peilereck* forebays. Frequently wood posts or masonry pillars were inserted beneath the bent posts along the forebay to provide further support.

"At the stable level," Heyl wrote, "these extended masonry flanking walls not only provided shelter for the ends of the stable-door bay but, in many examples, (were) fitted out as harness storage cupboards or hand implement closets. That this addition to the structural stability of the cantilevered barn was a functional reply to a need, is plain. Many of the true 'Sweitzer' barns proved unstable enough that corner columns were later added; flanking supporting-walls of masonry, differing from the original fabric, were also sometimes constructed to carry the accumulated weight of the barn forebays after harvest."

But it was not only considerations of heavier hay loads that dictated these sidewalls or stone columns that began to appear beneath the forebay. The forests were being used up. Throughout the 18th century, summer beams, the massive load bearing timbers that supported the centers of haymow floors, could be cut to dimensions of 12x18 inches, in lengths of 50 or 60 feet. It was not uncommon to find cantilever beams running the entire width of a barn and stretching out into space 6, 8, or even 10 feet over the yard below. But these timbers were harvested out in the

The interior framing of this barn is typical of Pennsylvania Dutch barns throughout the region. With three bents and four large bays, the center two—originally as double threshing floors—are now parking and storage for farm implements. To either side are large loose-hay bins. As in other barns of this type, ladders lead up to tie beams, and high breast boards hold back the loose hay. It is 16 feet, 4 inches to the top of the tie beam.

DUTCH, GERMAN,
AND SWISS HERITAGE

CUSTOMS BECOME CULTURE, DIALECTS BECOME LANGUAGE

"I paint barns because I want to preserve the history," Jeff Marks said with obvious passion. "It's part of my heritage.

"Right now I'm kind of a struggling artist. I have a full-time job to support my family. But I paint because I love it. More than that, I paint because it's an obligation—to history."

Marks was born in 1959 in Mohnton, in Berks County, Pennsylvania. His father came from a long line of Pennsylvania Dutch and his mother was Polish. His heritage was spoken in two languages at the dinner table—one Sunday in German, the next in Polish.

"My interest in barns materialized, really, in the fourth grade—in art class," Marks said. "We were always drawing geometric shapes, and I always drew barns. I made a complete bank barn out of construction paper. Colored in all the stones. When most kids think of a barn, they draw a western barn, with cross doors. I did a bank barn.

Marks' interest and talent for art also emerged in the fourth grade. He started painting in oils before he was 12 years old, but the smell of the linseed oil gave him terrible headaches. So he switched to watercolor.

"As I progressed, I began to like watercolors much more. I know it's a harder medium, you can't correct your mistakes. You have to live with it. You don't have a second chance. You have to have very strong forethought. Your seeing becomes really critical."

What Marks began to see awakened him even more to his heritage and to the risk that, as Lancaster County and Berks County continued to grow, even more of their history would be lost to population growth and economic development. It is that concern that drives him to paint in two media—and on two vastly different scales. One scale is the watercolors he does for exhibitions, galleries, and for private collectors around Pennsylvania. The other scale is life-sized, accomplished on ladders. With oil-based paints, he creates or restores the symbols and signs of the Pennsylvania Dutch onto barn walls.

"Signs are part of our heritage, part of the Lutheran and the Reform Church, the mainstream of the Pennsylvania Germans. In the U.S., that artwork first appeared in southeastern Pennsylvania on birth certificates and baptismal certificates and on furniture like blanket chests in the late 1700s. About the time of the Civil War, even before, in the 1840s, as an art form, they began to lose their significance. Painting these decorations on the barn in the late 1800s was just like painting your fence. It was like finishing your property. It showed pride of ownership and care for the property. It said, 'Hey, I'm a Pennsylvania Dutchman, and I'm proud of it.' That's what the signs used to mean and that's why they painted them on their barns.

"Good 'hex signs'—I hesitate to use that name—just mimic the early

decorations you'd find on our chests," Marks continued. "The signs evolved from very simple geometric shapes in the beginning. Then through the Victorian period, they got fancy, with scallops and decoration. The symbols got more intricate.

"There were painters who made a good living decorating barns. With the onset of World War I, though, anything related to Germans was looked on badly. After World War I, it really died out and it wasn't until after World War II that the heritage again seemed acceptable. And as the economy boomed, during the early years of baby boomers, vacations became something common people could do. . . . Where could they go and what could they see?"

Marks said the vacation industry fostered the repainting of barns and decorating them with signs and symbols. "But the good thing about [the increased tourists] was it brought about a resurgence of who we are, Pennsylvania Germans. Beginning in the 1950s, the industry of middle-class vacationers [directed] some of the attention to barns and painting. At that time, too, serious writers and researchers began to look at the Pennsylvania Germans. Before it was just a custom, a dialect. Now it became a culture, a language.

"Doing my water colors—or when I repaint the signs and symbols on barns—is my way of reminding people that this is the end of an era. It's much more than a commercial thing that may bring me some money. I'm looking at this as capturing history so it doesn't get lost.

"I see a barn for years . . . and one day, I go past it and I see them covering the barn with aluminum siding. There are original signs on the barn, work done by painters 40 or 100 years ago. And they're covering it up. It's heartbreaking because these are locals, people who've grown up with this for so long that they don't even know what they've got. So they cover their history and don't even think anything of it."

Mass produced nails mix with mill-cut siding and hand-forged door hinges and latches on the back side of the sheep barn. With seemingly little upkeep and maintenance, these barns—and hundreds of others in Eastern Pennsylvania, vividly display the quality of eighteenth and nineteenth century craftsmanship.

1800s. Builders began to splice plates together to make up the length necessary to anchor the long forebay wall. Posts or columns were required to support the beams. The depletion of building materials forced architectural evolution. Ironically, a century earlier, those same materials existed in such abundance that timbers were split into clapboards cheaply and easily, accelerating the evolution from labor-intensive wattle-and-daub wall construction.

The evolution in New World agriculture was a kind of wattle-and-daub of its own. It was an intricately interwoven and bonded relationship of produce, product, and natural resources to labor, shelter, and geography. As farmers switched over from planting, cultivating, and harvesting wheat and other grains to managing livestock and its by-products, this change of emphasis dictated and directed the ongoing development of the German barns and of the Dutch and English buildings as well.

However, agriculture—and architecture—had only just begun to change. When settlers pressed farther west and reached the great plains—and the end of the endless forests—they found limitless horizons just as their parents and grandparents had discovered before them. Only now they no longer needed to exert great energy in clearing forests to plant their first crops.

Government policies by the mid-1800s encouraged acquisition of ever-larger tracts of land. The West was open. The ongoing development of canals, barges, and steamboats; the recent invention of the steam locomotive; and all of the wild rumors of a railway connecting the West made prairie farming seem lucrative despite its considerable challenges.

The farmers who remained in the traditional, historical agricultural sites of the East were now threatened. The popular farm journals of the day made their advice clear: adapt—to new crops, new ideas, new technology, even new farms in new states—or quit.

DUTCH, GERMAN,
AND SWISS HERITAGE

67

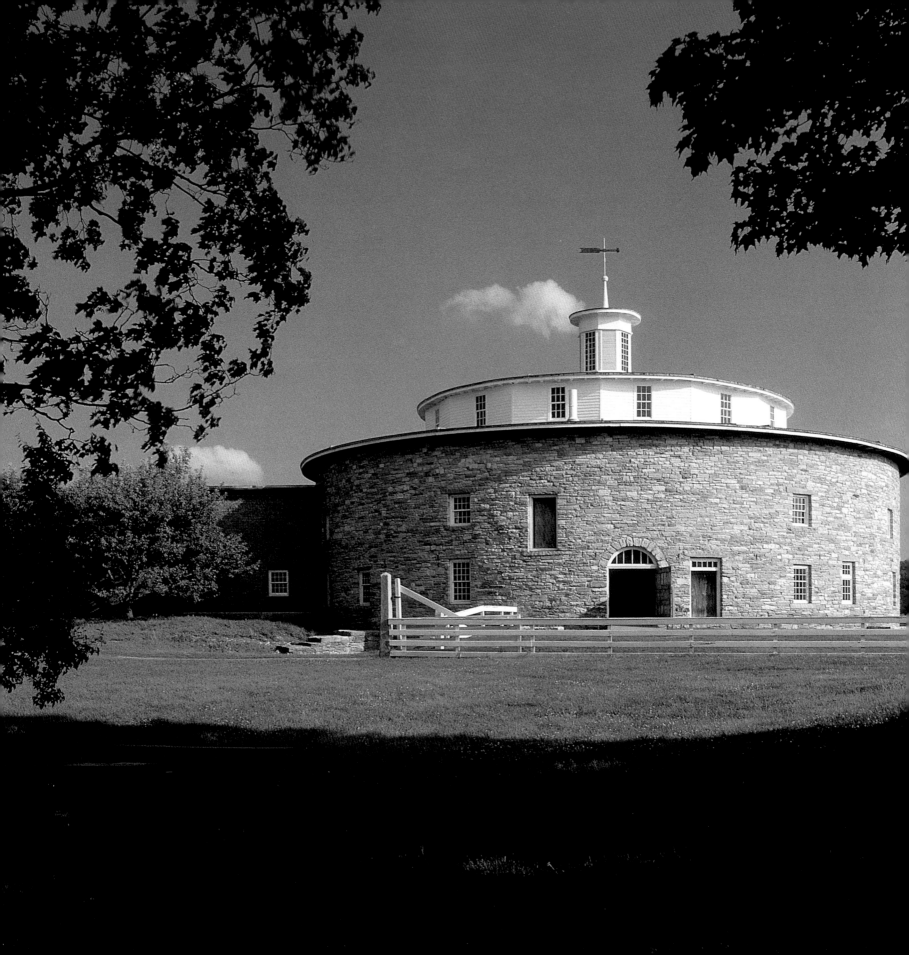

THE SHAPE
OF INNOVATION

B y 1801, the option for Americans to quit farming and find work in other trades was becoming a possibility. The population of the United States at that time was 5.3 million. Ninety-eight percent of those people lived within 150 miles of the Atlantic Ocean and 90 percent of the total were involved in agriculture in some way. Though the third president, Thomas Jefferson, was a farmer just like George Washington and John Adams before him had been, cities were growing. And they would continue to grow in relation to the population in farming. By 1850, only 80 percent of the population was agricultural. And it would continue to decline.

Fueling the young country's growth were fundamental economic changes. International trade had begun to make some colonials wealthy. Tobacco, furs, flour, wheat, and rum each comprised large export markets.

Emerging technologies also promised to change the complexion of agricultural life. In 1762, in Scotland, the Carron Ironworks improved its foundry techniques for casting iron. This produced a malleable metal that could be worked—by heat and hammer—into a variety of shapes including plows. Two years later, in 1764, Scottish inventor James Watt invented the steam condenser, a major step toward the steam engine and the impetus that would launch England's Industrial Revolution.

Hancock Shaker Village round dairy barn, Pittsfield, Massachusetts
While their religious interpretations were rigid and their rules and regulations were demanding, there was nothing small-minded about the United Society of Shaking Quakers, or Shakers as they were known. They reasonably considered ideas and innovations from the outside world and picked and chose what they believed would work best for them, their community, and their faith. One of those ideas was the round barn that they built at Hancock Village in western Massachusetts.

69

REBUILDING AMERICA'S PROTOTYPE ROUND BARN

G eorge Washington's round barn was a radical idea, one that proved to be nearly 100 years ahead of its time even when its time finally came to the Midwest in the late 1890s. The round threshing barn had predated even the Massachusetts Hancock Shaker Village barn by 30 years.

While Washington's barn was finished in 1794, it never completely met his expectations nor did it entirely succeed with his overseers and slaves. Still, the barn survived until the mid-1870s, by which time it had fallen into disrepair. Sometime between 1870 and 1875 the barn was dismantled. By that time, however, the Mount Vernon Ladies' Association of the Union had acquired Mount Vernon, having purchased it in 1858 from George Washington's great-grand-nephew John Augustine Washington. By then, the farm holdings were reduced to around 1,200 acres. The property purchased by the Ladies' Association was just 200 acres; it was, however, later supplemented by a 300-acre acquisition to ensure insulation of the property from subsequent development. Dogue Run Farm, where the barn was located, was no longer part of the property.

George Washington had first raised tobacco, as most of the Chesapeake region farmers had done. But while it had made others around him wealthy, he soon saw how ruinous the crop was to the soil. What's more, the plants required constant care which took large numbers of slaves. Prices, while rising rapidly in the early part of the 18th century, had stabilized, then fallen, and by the 1750s, they fluctuated unpredictably. A bright, curious man, Washington read books and journals and corresponded with agricultural theorists throughout the colonies and England. While still in his late 20s, after long thought, he switched crops.

"New Husbandry" was a movement in Britain that addressed the scarcity of land in the British Isles, and it set out to invent a kind of farming that did not deplete the soil, that was not so labor intensive, and that produced crops that could be raised again and again. Washington studied this philosophy, and then he planted wheat, corn, and potatoes. He raised buckwheat, various grasses, and rye as soil nutrients. He read about and adopted a crop-rotation plan. Fallow fields planted with grass and clover became cattle-grazing land, automatically enriching the soil through the manure. He plowed deeper than was common in those days, to mix topsoil with subsoil, and he harrowed the ground to keep it broken up. He experimented constantly. And he became successful. Each of his five farms had barns of the latest technology and thinking in which to shelter and process his produce.

Two hundred years after Washington sketched the designs for his 16-sided threshing barn, and 125 years after it came down, the Mount Vernon Ladies' Association and the directors of George Washington's Mount Vernon Estate and Gardens decided to rebuild the structure as the centerpiece of a new exhibition entitled, "George Washington: Pioneer Farmer."

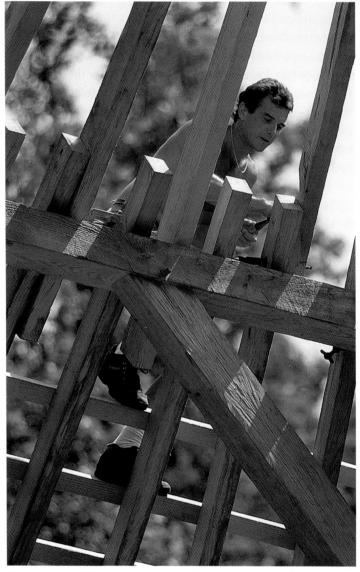

Fred Asplen and Berkeley Robertson of Accokeek, Maryland, were two of six primary carpenters hired to re-create the banked barn. In addition, about half-a-dozen assistants worked full time and a large number of interns assisted as well. Robertson (shown here) fits rafters to the circular purlins to form the barn roof. Most of the framing wood was pine while the massive vertical posts were oak. Some 10,000 cypress shingles were split in 3-foot lengths. The roof pitch is 43 degrees, fairly standard for the times.

Photograph, c. 1870, of Washington's round wheat-threshing barn. It was demolished around 1875. *Mount Vernon Ladies' Association*

Generous grants from the W. K. Kellogg Foundation of Battle Creek, Michigan, have helped fund the accurate re-creation of the building. Grants totaling $2.5 million will establish educational programs, an internship program, and complete construction of the barn and outbuildings (their cost being $1.8 million). Washington's initial plans called for 30,820 bricks to build the first floor and foundation walls, and allowing for breakage, he fired 40,000 of them. Archaeologists excavated original bricks from the site and these were used as models—for size, shape, and color—for new bricks. Some of these new bricks were made from local clay and were fired on the premises. One difficulty in building the barn came from the challenge of accurately reproducing what the old growth timber had allowed, that is, long timber. Locating logs in the lengths and densities that Washington had specified and that were also somewhere near the age of timbers his men would have used to build the barn proved vexing.

But when the call went out to the American Forest and Paper Association (AF&PA) members for the kind of timbers to support the weight of two or three horses trampling wheat, there was great concern about finding harvestable timber that was large enough. Heads were scratched, maps were consulted, and a few ideas came to the surface—literally, in some cases.

One suggestion was to locate suppliers of "sinker logs," timbers and trees that were floated downstream to mills a century ago or longer but had sunk. Specialists eventually located more than seven truckloads of these logs,

wood so densely grown that 50 growth rings per inch is not uncommon; some of the logs counted more than 1,000 rings.

John O'Rourke, construction manager on the re-creation, worked with six carpenters and another half-dozen assistants. They all set out to reproduce the structure not only to accurate scale but to do so using historically correct technologies. Hundreds of logs were broadaxed and pit-sawed from September 1995 through March 1996, hewn down to 12x12-inch timbers. "I broadaxed a foot wide for three miles," Fred Asplen of Irvine, Kentucky, explained, giving scale to some of the work done by backs, arms, and hands. "Most all the framing and wood was pine," he continued. "The octagon [center] post the eight surrounding posts, and treading floor were oak. The roof shingles, all ten thousand of them, were Louisiana cypress. We split these three feet long by anywhere from three to six inches wide. And on the cone-shaped roof, we had to taper them to fit."

Georgia Pacific's forest research department located some old oak in North Carolina. The cypress was a bit more challenging.

"Some of the cypress our suppliers came up with," John O'Rourke explained, "were heartwood, as much as six feet in diameter. Most of them were originally harvested before 1840. And they sunk in Louisiana bayous soon after. They were logged this time by helicopters." A number of other companies and donors stepped up to help, providing additional logs and funding.

In all, 400 logs have gone into the reconstruction of the barn and the corn house and stables that flank it. Asplen, Robertson, O'Rourke, and a constant stream of summer interns worked on the buildings using period-correct tools and techniques, including wrestling timbers mostly by hand and block-and-tackle (a 20-foot-long, 12x12-inch beam of green pine weighs 850 pounds). About 10,000 mostly hand-forged nails will be used to attach the siding and floors. Throughout the rest of the barn, pegs, mortises, and tenons connect the beams and posts. In addition, other concealed structural supports have been added and a very much modern-day foundation supports the 41-foot-tall barn. The original ramp for horses or oxen to enter the barn was quite steep. In the modern version, it has been made flatter to ease the climb for visitors, and wheelchair access has been discretely designed into the re-created barn. Even electric lights will subtly illuminate joinery and interior framing, all modern conventions to bring a unique and certainly influential 18th-century barn up and into the 21st century.

"When George Washington designed this barn," John O'Rourke observed, "he didn't have to deal with thousands of visitors every day and the modern safety laws to protect them. But this is being done so carefully that when it's finished, no one'll ever know we paid attention to all these little details.

"What visitors will see here is something as close as humanly possible in 1996 to what George Washington had 200 years ago. And it's beautiful."

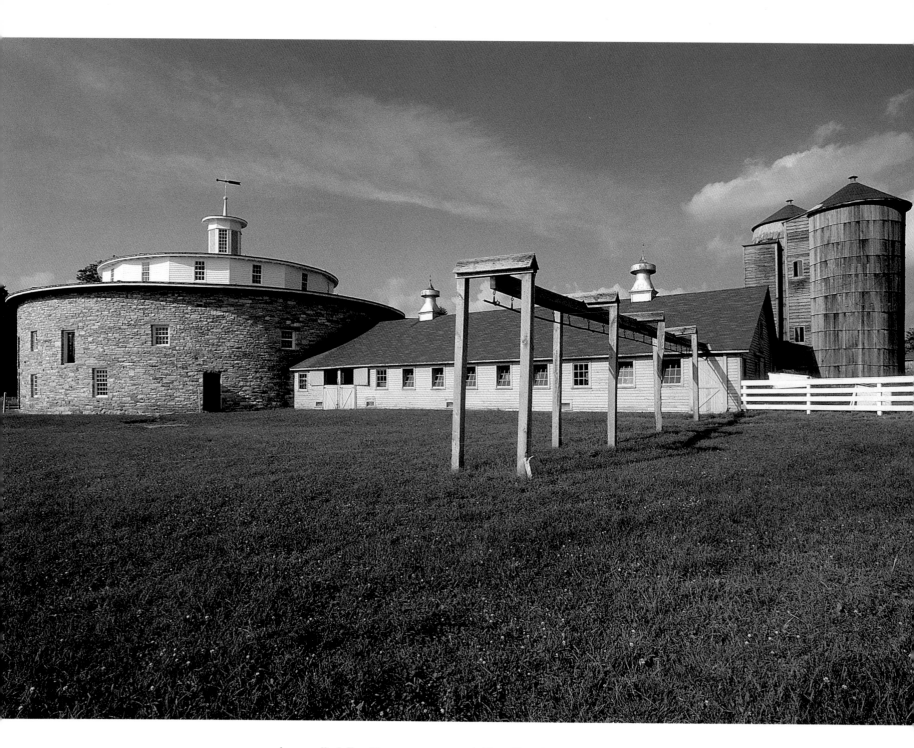

orders, called Families, were created. The Church Family was the highest and they required that their members give up everything they had—wealth, belongings, property, even family ties—to the Society for community ownership.

Throughout the next 35 years, new members joined the Society and the population grew. Living quarters, segregating women from the men, were expanded, and new barns, sheds, meeting houses, and other buildings were constructed to meet the needs of a community of nearly 250 inhabitants. Their architecture was always rectangular, often perfectly symmetrical. It was unadorned and yet elegant in its simplicity and extraordinary in its craftsmanship.

THE
AMERICAN BARN

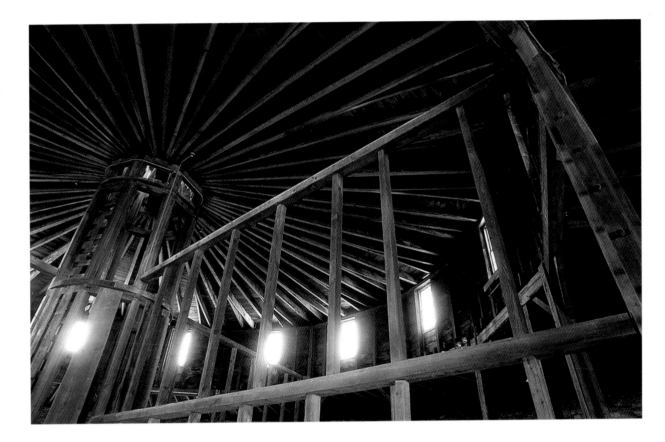

**Hancock Shaker Village
round dairy barn,
Pittsfield, Massachusetts**
Deming and Goodrich designed a
barn 85 feet, 10 inches in diameter
with the capacity for 52 cows. The
central octagonal ventilating shaft is
53 feet tall. The interior haymow
stretches some 46 feet across, and
the barn's structure allowed hay to
pile as high as 30 feet. Community
carpenters did the interior structure
and finishing. Most of the framing
was of American chestnut while the
flooring was either pine or chestnut.
Construction took nearly a year to
complete. Wood for this building was
harvested primarily from trees on
community land.

It is impossible to say where the idea
of a round dairy barn came from.
Prior to building this structure, all
the Shaker buildings had been
rectangular and marked by a near
perfect symmetry that greatly pleased
their eye. However, a fire in 1825
destroyed the Hancock community's
large dairy barn, and elders William
Deming and Daniel Goodrich planned
a large, round stone building to
replace it. While it was neither
rectangular nor exactly symmetrical,
it was simple and extremely efficient,
two other hallmarks of Shaker
architecture and design.

Shaker enterprise supported the community.
Their industry and efficiency had provided for them in
ways far beyond those necessities that were fulfilled
by farming and raising livestock. The Shakers traveled
from town to town selling these items directly to
merchants throughout the New England states.

In 1825, a fire destroyed the largest cow barn,
located near the center of the Church Family settle-
ment. When Elder William Deming and Elder Daniel
Goodrich—in whose home Mother Ann had held the
first worship service in Hancock—began to think
about replacing the structure, they devised a plan
unprecedented in Shaker architecture: they designed
a round barn capped with a low conical roof.

Because of its rules about celibacy, no one was
born into the Shaker faith. Everyone who joined the
Society came from a previous lifetime of outside
contact and activities. Each new convert brought
skills, talents, and ideas, and while the religion was
strict in itself, it did not forbid further outside con-
tact. The Believers were known to be progressive
farmers and intelligent, imaginative individuals will-

ing to think and experiment. The ideas that they
picked up along the roads as they sold their goods
they brought back to the village, and they absorbed
or adopted those ideas to fit their own needs and
lives. Whether, however, any of them ever reached
Mount Vernon and saw firsthand George Washing-
ton's barn is unknown. If in their travels, they
encountered others who traded with Washington is
equally uncertain. At Hancock Village today, there is
no record anywhere of the inspiration for the round
barn that Elders Goodrich and Deming designed.
But its similarities to the Virginia structure are curi-
ously coincidental.

Goodrich and Deming designed a banked barn
with a conical roof topped by a round cupola. The
purpose of their barn was not for threshing grain but
for storing feed for their large herd of dairy and beef
cattle. Both Washington and the Shakers utilized the
tall center area of their barns for storage. This cav-
ity was filled by driving a wagon up into the barn and
unloading hay or grain down into the center. Both
barns used gravity to good advantage, Washington's

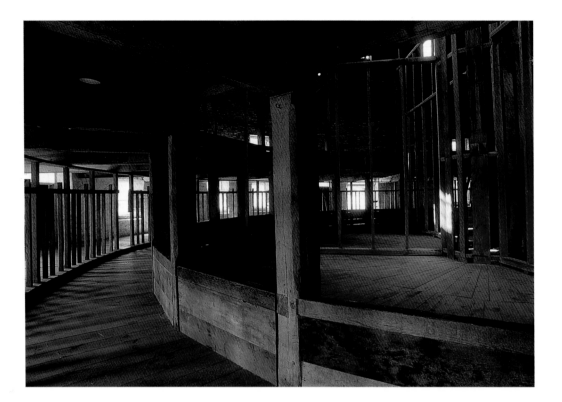

low grade marble, were quarried locally, some of it even coming from pits on Shaker land. Construction took nearly a year.

The Shakers devised a number of interesting safety features in the barn. Even with stone walls that ranged in thickness from 3 feet at the base to 2 feet at the eaves, fire was a great risk. Draft horses that hauled in the heavily loaded hay wagons were fitted with forged-steel horseshoes. The haymow wagon floor was supported by 30 chestnut 8x12-inch floor beams, each 16 feet, 3 inches long. (These radiated out from the plates atop the 10x12-inch cattle-level floor posts.) On top of the 8x12s, 5x8 "sleepers" were pegged in, equally spaced from the outside stone wall to the haymow low wall. Onto these, the carpenters nailed pine subfloor planks. However, because of the risk of a horseshoe striking a nail head and causing a spark, Deming and Goodrich ordered a second pine plank floor laid on top of the subfloor. It was not secured with nails. Basically, it floated. Its nearly 16-foot width allowed for horses and wagons to circle around the open haymow. The full circle, like Washington's structure, eliminated the need to back horses and wagons out of the barn.

A central, octagonal-shaped open column was formed by 6x8-inch 53-foot-tall vertical beams that extended up to the roof peak. This allowed ventilation to the middle of the hay pile. At the bottom, the entire mound of hay sat on another false floor, this one built nearly a foot above the pounded dirt (much like Washington's false floor on his granary level). This also allowed air to circulate to the bottom of the hay pile. Below the cattle level, around the perimeter of the barn, was a manure sink; the milkers and barn attendants shoveled the animal waste down through trapdoors spaced around the outside of the milking parlor. (In the common practice of the day, this was allowed to build up through the winter to insulate the ground from frosts. In the spring the accumulated manure was hauled out and spread over the fields as fertilizer.)

The barn was completed in 1826. Its cost, listed in Shaker record books, was a stunning $10,000. And for almost 40 years, the barn performed as intended. Then, on December 1, 1864, a fire caused

There are curious similarities between the Shakers' barn and the structure George Washington built. Both were banked barns, but more significantly, horse- or oxen-drawn wagons entered the upper level to unload their cargo into a vast center haymow. As with Washington's barn, the Shakers used gravity to help them. Hay unloaded from wagons fell to the ground floor where attendants pitchforked it from the center to as many as 50 dairy cows around the perimeter of the ground floor.

to deliver the trod-out grain to storage bins below, the Shakers' to deliver hay to cattle feeding and being milked below. The 85-foot, 10-inch outside diameter of the Massachusetts barn dwarfed Washington's 52-foot scale, but the Shakers needed space to milk as many as 50 cows at a time. The central hay location meant that one individual could feed the entire milking herd with few wasted steps. Stanchions and head guards separated and secured the cows, and milking began and ended in the same place around the circle every day.

Goodrich and Deming made use not only of experienced stone masons, carpenters, and cabinetmakers among the Church's Believers but also of outsiders from nearby Pittsfield and the surrounding area. Records showed that the outside stone masons together were paid $500 and they were fed and housed for the duration of construction. The large barn was framed mostly of chestnut while the hay wagon level flooring and the roof was of either pine, chestnut, or other local woods. All the wood was cut from forests on Shaker family properties, which by this time covered more than 3,000 acres. The stone walls, a mix of limestone, fieldstone, and

by a carelessly handled lantern destroyed the conical roof, its structural support members, and much of the timber framework within the barn. Records at the time report the loss at $15,000 because even though the outer walls remained standing, wagons and other equipment, some livestock, and nearly 100 tons of hay were lost as well.

There was no question but to rebuild. The barn had functioned well, its efficiency was demonstrated daily, and the village herd had not outgrown it. Within a year, the barn was cleaned out, reframed, and the roof was rebuilt. Its new roof was nearly flat, but it was crowned by a 15-foot-tall cupola in the center, similar to what had been at the point of the cone before this. A decade later, the roof was modified once more. A 14-sided 51-foot, 10-inch diameter structure was built. This added nearly 9 feet to the height of the barn and was fitted with double-hung windows to allow not only for additional ventilation but also to provide greater daytime illumination. The 15-foot-tall cupola was replaced on the roof of the clerestory structure at its center.

Throughout the life of the round barn, change came right to the doorstep of the Shakers' world from outside sources. The Believers accepted and adapted to some of it, but their strict beliefs and rigid adherence to certain behaviors ultimately doomed them to extinction. In 1838 the Western Railway Corporation purchased a right-of-way from the Hancock Shaker Society, and by 1847, the Shaker village had become a tourist attraction as well as a shopping destination. A guidebook at the time described the outbuildings and the round barn, the people and their beliefs, and the very high quality of their products. Everything from brooms to boxes to furniture and buildings was made to high standards incorporating efficiency of design, absence of decoration, and dedication to achieving perfection in their lives and work.

Where the Shaker population at Hancock had been 247 in 1829, it had slipped to 217 by 1846, and then to 193 by 1853. The various Families were consolidated more tightly surrounding the central Church Family. A decade later, the U.S. government, desperate for able bodies, refused to accept the

Shaker's claims of pacifism and threatened the community throughout the Civil War. Shakers were drafted, but immediately furloughed.

In Hancock, the round barn continued to serve its purpose. But when the next opportunity to build a barn came to the diminishing numbers of Shakers, their previous willingness to innovate and to adapt outsider ideas faded. The United Society allowed only one round barn. The long-standing preference for right angles and pleasing rectangles prevailed. Subsequent dairy barns and stables were all rectangular.

*J*ust as quitting farming was a possibility for residents of communities from Maine to Virginia and beyond, leaving the Society was an option for Shakers as well. Young adults, brought into the Society as infants, faced the rigors of the Shaker religion that attracted virtually no new converts during the first half of the 20th century. The elders—many quite elderly by this time—required more care than the farm, making active farming difficult. The introduction of income and property taxes affected the Shaker community whose income had decreased dramatically. The shrinking Families consolidated

Outside stone masons were hired to complete the walls of the barn. All the stone—limestone, fieldstone, and some low-grade marble—was quarried locally. Stone walls ranged from 3 feet thick at the base to 2 feet at the eaves, 21 feet above the ground. During the time their work was required, the workers were housed and fed by the community, and at the end, they were paid $500.

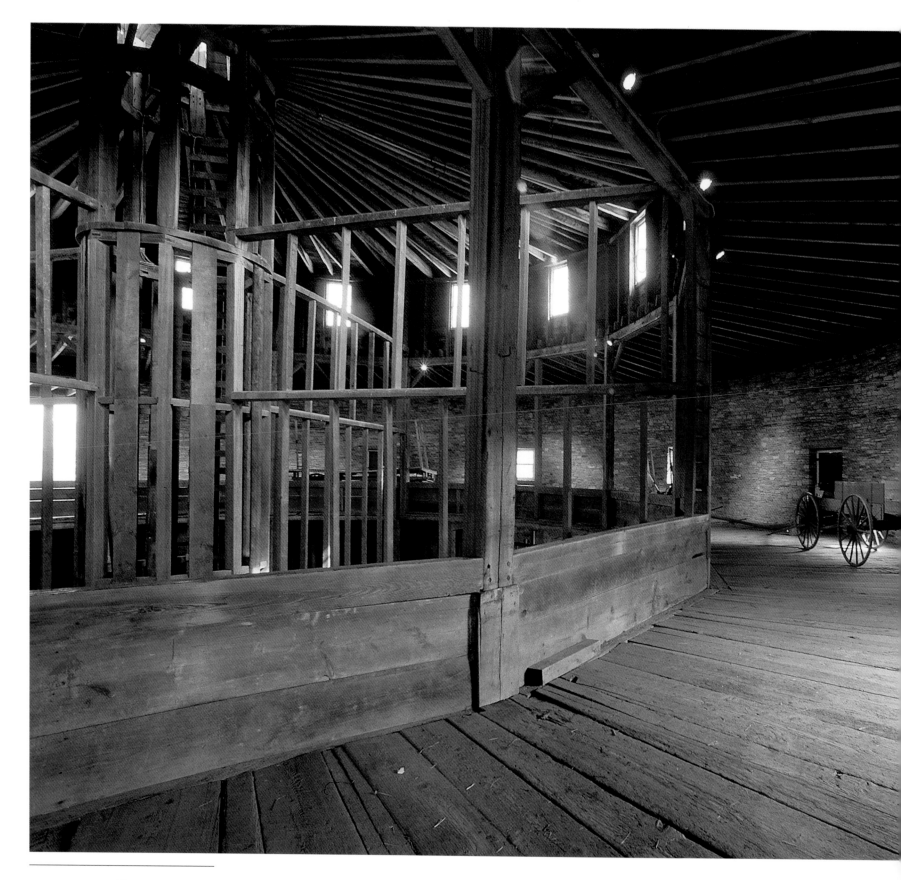

and sold off farmland. In 1959, with only three elderly sisters surviving at Hancock, the Central Ministry located in Canterbury, New Hampshire, decided to close the Massachusetts village. On October 15, 1960, the remaining 900 acres and 17 buildings still standing were sold for $125,000, and restoration of the village that had long been neglected began soon after.

Once the active dairy farming ceased and no new manure insulated the shallow foundation, frost heaved and unsettled the round stone building. Walls cracked. In February 1968, workers began a near-complete renovation of the round barn. All of the existing stonework was dismantled, leaving only the concentric roofs supported by timber-frame skeletons. Some of the stone was exchanged for new material quarried expressly for the restoration. Window and door lintels were replaced.

In Stephen J. Stein's excellent book, *The Shaker Experience in America*, he pointed out that the Shaker society ran into difficulty as it tried to maintain its strong, singular religious beliefs in the face of a drastically changing world. As Stein wrote, "The sectarian principle of separation from the world had been abandoned for the alternative strategy of becoming a vanguard of reform, leading the world toward a better tomorrow. The work ethic, once sanctioned as the highest form of worship, became simply a necessity for survival."

It would not be until near the turn of the 20th century, in the capitals of Wisconsin and Illinois, that one of the Shaker vanguards of reform would be recognized. Outsiders at the University of Wisconsin and Illinois would write enthusiastically about the efficiency of round barns. And within a quarter century of that, there would be more round barns on earth than there were Shakers.

To lessen fire risk, the elders conceived a clever plan for the wagon floor. Worried that the horses' shoes or wagons' wheel rims might spark on a nail head, and thereby ignite the entire barn's highly flammable contents, Deming and Goodrich laid a false floor on top of the nailed one. This rested in place only by gravity, but it kept nail heads from being underfoot.

THE REVOLUTION OF INDUSTRY

T he Revolutionary War did more than allow the colonies to gain their independence from Great Britain. The call to battle also pulled men and boys away from their homes and towns, took them out of their regions, and exposed them to what lay over the horizon. It showed New England farmers that the entire land was not just heavily forested, hilly, and rock strewn, whetting appetites for what could be.

At the beginning of the 19th century, the new United States extended as far as the Mississippi River. Throughout the 1800s, through purchases, treaties, and annexations, the Louisiana Territory gave to America the land from the Mississippi River west.

When the first settlers reached the Midwest and discovered the end of the seemingly endless forests, they found plains and grasslands extending on to the next horizon. This land was meant for wheat and corn. As the 19th century unfolded, settlers continued to push west.

The flatboats and canoes that had floated settlers down rivers in the 1820s gave way to steamboats that could propel them up rivers as well. And by 1860, freight—except for what was moved along the great rivers—came ashore to move along by steam locomotives. In 1830 there had not been even 100 miles of rails throughout the United States. In the next decade, this stretched out to 3,000 miles, and by 1860, farmers and

Rundlet-May house and carriage barn, Portsmouth, New Hampshire
Writers in mid-1800s New England agricultural journals advised readers to attach their barn to the home to make the farming/home industry relationship more convenient for the farm family. As farmers traveled into the cities to market their produce, they observed just this kind of residence with its attached carriage house; if it worked in the city it might work on a farm, too.

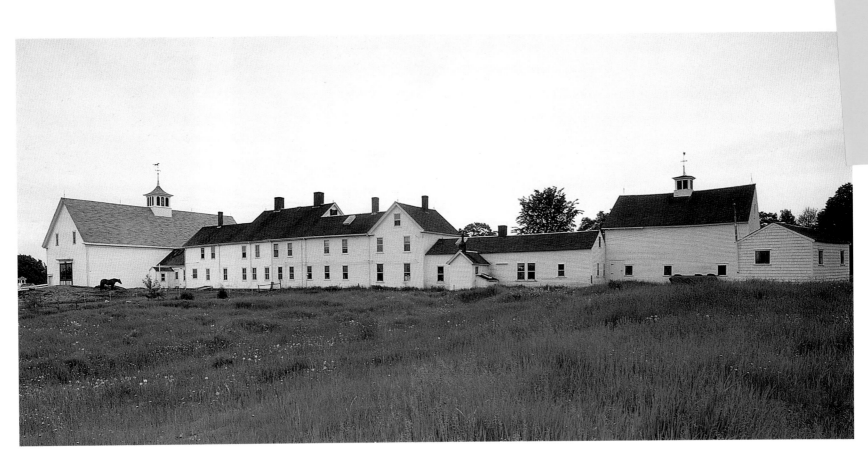

Skolfield connected double barn, Harpswell Neck, Maine

If the James Rundlet mansion inspired New Hampshire farmers to build their own city-like connected structures, the massive Skolfield complex, seen from the rear, near Brunswick, Maine, must have humbled others. Its very scale is overwhelming. Within its confines are four homes, two summer kitchens, a shed, and two barns. It spans 287 feet, 7 inches from the far edges of the small barn at right to its opposite large barn. It straddles a town line, paying taxes to two communities.

builders working in the New World colonies and then the early United States developed and simplified their building techniques. Their goal was to use less labor even if it took no less timber. The bent system of internal structure allowed this. Roofing changed as well from the English major-rafter/minor purlin style to the major-purlin/common rafter technique of the New England barns. Roof pitch rose, as well, from a flatter 6-feet-in-12 rise to an 8- or even 12-foot rise in 12 feet after the 1830s—the better to shed heavy winter snows.

One curious development influenced this change from the English to the New England style for a short while. Each of these barns was still basically a three-bay-by-three-aisle design. The center aisle in the English barns had been the threshing floor. But by the early 1830s, threshing machines began to replace hand threshing and the center floor became equipment storage. In addition, because machine threshing—and horse-drawn farming—was more efficient, more productive with greater yield, farmers discovered the need for more

room in the haymow and granary. (Many of the earliest New England barns were built slightly asymmetrical, with more space devoted to the hay storage—generally on the north side of the barn to insulate the livestock against the predominant winter winds—and a smaller cow and horse stabling area on the south side. By the 1850s, however, this returned to symmetrical spacing as more sophisticated breeding increased the size of the livestock.)

Between the 1830s and the 1850s, another development spread widely throughout New England. Barns built from scratch were constructed on top of a cellar, and those already existing had one dug out from underneath. This provided storage areas both for the livestock manure—no longer hauled out of the barn but simply shoveled through trapdoors into the cellar below—as well as for some of the crops meant for consumption or shipping at a later date.

All of these improvements in barn design and construction set the stage for the next, most significant step in the evolution of the New England barn: its connection to the farmer's house.

The idea of connecting house to barn was not original to the New England farmers faced with the goal of economizing their labors and their footsteps especially in harsh winter conditions. The progressive farm journal writers who proposed such a scheme had simply done their homework and knew their history. Farming compounds existed throughout Europe in the dark ages as ways to keep out uninvited animals and humans alike. The Dutch and Germans lived in connected barns for centuries before they came to the New World. And perhaps 1,500 years before the first Maine farmer jacked up his barn and moved it into a loosely formed line behind his house, summer kitchen, tool shed, and wagon shed, the Roman farm complex had probably inspired them all.

The Roman farmhouse and its diverse connected structures served as the center of life as well as of agricultural production. These compounds

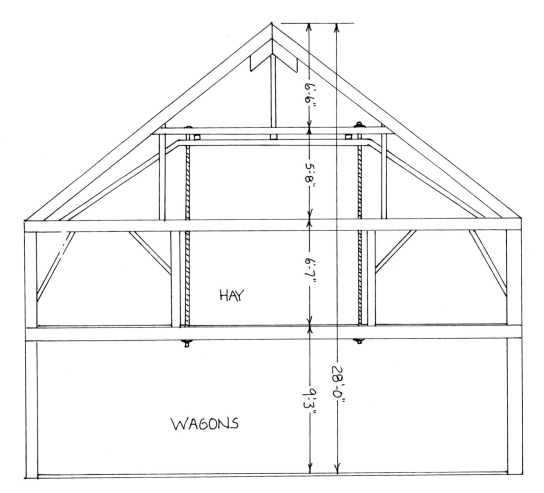

In the haymow of the smaller barn, a clever system was invented to support the hay floor above the now-clear-span barn floor. The hay floor was hung by 7/8-inch-diameter iron rods that were attached to supplemental tie beams spanning the two interior bents. These supplemental beams were fitted below the collar ties but above the existing cross beams. This system became common around the turn of the 20th century, and it continued to hold up the hay floor—with a decreased load, and the roof, no matter how severe the winter snowfall.

Skolfield barn framing

THE SKOLFIELDS OF MAINE: HOME FROM THE SEA TO FARM

"**W**hen Thomas Skolfield arrived in Boston from Ireland in 1725, he was twenty-five years old, alone, independent, and ambitious. For the first few years he worked all sorts of odd jobs around Boston before heading out for what he thought was better opportunity in Maine." His great great grandson, John Skolfield, now an attorney in Winter Park, Florida, continued telling the story with obvious pride, "By 1734, Thomas had made his way up to Brunswick. There he found work harvesting timber on Birch Island, which was very close by. But there was a dispute over who owned the island and the timber he was harvesting, so that put an end to his enterprise. Still, he'd been a hard worker, industrious. In nine years in America, he had married and saved enough money to buy a large property out on Harpswell Neck. Ironically, from the site there, they could see Birch Island. He built a small, New England-style, three-bay barn and a house for his wife, Mary, and himself."

Shipbuilding had begun in Brunswick, Maine, as early as 1717, but Skolfield and his growing family farmed for a living. However, as the seven sons grew, the second-generation Skolfields watched the local shipyards with increasing fascination and envy.

"Thomas wasn't too keen on the idea of shipping," John explained. "So when his oldest boy, George R., decided he wanted to go into the business, he had to get his money elsewhere to get started. He borrowed a dollar to buy his first broadax, and with that he started to build his first ship." Just before the turn of the 19th century, George R. founded his own shipyard barely 200 yards from the family house. The next oldest brother, Clement, joined him while the other brothers continued farming with their father and mother across the road. Thomas and Mary gradually increased their landholdings to 200 acres.

In 1802, the first of the Skolfield tall-ship square-riggers was launched. It displaced 400 tons, large at the time, and the shipyards sold the vessel for $75,000. In those days, shipping was so profitable that an investment like that could be paid off in its first year. And frequently it had to be. The average life for a trade ship was less than five years; most were lost to pirates or violent storms.

Through the next 90 years—and two generations—Skolfield's ship-building—and shipping—business expanded. And so did their house across the road. Thomas and Mary's oldest sons, George R. and Clement, had gone to sea, earning their master's ratings and sailing the Far East trade routes. When they returned to Harpswell Neck as retired sea captains, they built two new houses onto either side of Thomas and Mary's first main house. George R.'s home expanded the structure to the east and Clement pushed the outer walls westward. In 1834, Master George and another brother, Robert, built a 32x36-foot barn onto Clement's end of the growing structure to accommodate the agricultural undertakings of the land-bound Skolfields.

Merrucoonegan is an Indian word for "carrying place across the neck." The Skolfield land at one time occupied both sides of the road and extended from one shore to another, from Middle Bay Cove to Harpswell Cove. Indians portaged their canoes across the neck and gave the land its name. Irishman Thomas Skolfield arrived in Brunswick, Maine, in 1734. Eventually he and his wife, Mary, bought land and began farming. But shipbuilding was already going on in Brunswick by the time the Skolfields arrived, and ships and the sea would become a way of living for five of their seven sons.

Throughout this time, ships grew and, with George R. and his son Daniel T. now running the business, the shipyards and shipping operations moved into their third generation. Toward the end of the era, Daniel T. took over managing the shipyards as the Skolfields produced ships that measured 200 to 235 feet in overall length, displacing from 1,250 to 1,750 tons. Their last

tall ship, Skolfield Shipyards' 65th, was launched in 1885. It was a 232-footer that displaced 1,731 tons. They named it the Master George R. Skolfield after the shipyard founder. Daniel T.'s sons, John and George, sailed the ship, continuing to work the Far East trade routes until 1899 when they sold it. (The ship's career ended in the winter of 1920 when, during a fierce storm, it was washed ashore in New Jersey.)

As sons and grandsons returned from the sea, houses and L-shaped summer kitchens were added to the elongated structure across from the shipyards.

"Daniel T. erected a tall windmill behind the barn, near the summer kitchen," John recalled. "It came down in the hurricane of 1936. Until it was knocked down, it serviced a cistern under the pantry. Daniel T. had a large black pump in the summer kitchen, and with it and the windmill, he pumped water up to two large copper tanks in the attic. His system provided running water for all the houses, for the entire structure."

The fourth house to join the assembly was built to the east, extending the entire connected barn-shed-kitchen-house-house-house-house-kitchen across the Brunswick County line. The Skolfields had fought a tax battle with the town of Harpswell (on the west, where the rest of the house and the shipyards were located). The town levied an assessment on an unfinished ship hull. Harpswell previously had fully taxed only vessels that were completed and on the water. But the city, needing additional funds, changed the rules. So Daniel T. Skolfield's new home was built across the county line, to be taxed by Brunswick instead. And when he added the large barn in 1897, it pushed the structures further into Brunswick. Skolfield enjoyed the taxpayer's last laugh, depriving Harpswell of fees not only on the defunct shipyard but also on two new structures.

Daniel T. had come home from the sea to farm. His nephew, George, returned home from the Navy and chose not to go to college. So the two of them became full-time farmers, establishing an apple orchard and dairy farm out of their large new barn at the east end of the house in Brunswick. Timbers originally intended for the hulls of future square-riggers were used to build the massive 40x85-foot barn and Merrucoonegan Farm—named after an old Indian expression for "carrying place across the neck"—was born.

"George was my uncle, and I can remember my father, John, and Uncle George and my grandfather, Daniel T., in the winter," John said. "They'd harness up horses and go to one of the surrounding ponds with long saws. They'd cut ice blocks and store them in sawdust down in our icehouse through the year. When the winter was cold enough, they could saddle up horses and travel by horseback across the bay as far as Birch Island."

After nearly a century of shipbuilding and seafaring, the Skolfields knew how to read the weather. By the 1870s, in the skies overhead they saw not storm clouds rising but *steam* clouds closing in around them. By the time Daniel closed the shipyard in 1892, there were railways through Brunswick. Sailing ships had stretched their lives more than half a century, living on borrowed time from as early as 1840 when the steamship *Sirius* crossed the Atlantic in 18 days without benefit of sail.

"Daniel T. returned to the land that his grandfather had bought. He put all the property back into one piece over a period of time," John said. "He died in 1945 at age 86, and he divided the farm between his sons, John, my father, and George, my uncle. George got the half with the big barn, where he'd been farming for a couple of years. My father got the small barn down to the shore and a small cottage on Middle Bay."

George's daughter Barbara and John's son John, the attorney, share ownership of the farm now. There is talk of Barbara's daughter moving her large-animal veterinary practice into the large barn, bringing the sixth generation home to Harpswell Neck. By the time the three generations of shipbuilders finished with Thomas and Mary's first home, it far outstretched the shipyard's biggest square-rigger. From the west wall of the small barn to the east wall of the large one, the Merrucoonegan measures 288 feet. There's no guessing what it displaces.

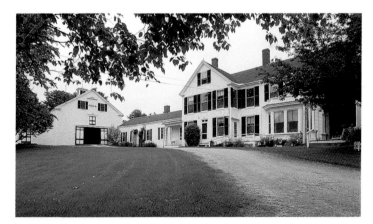

In 1802, Thomas and Mary Skolfield's oldest son, George R., founded Skolfield Shipyards barely 200 yards from the small barn he and his brothers would build 32 years later. As the older brothers retired from the sea, they came home to Thomas and Mary's house, building additions on for themselves. The small barn measures 32 feet, 2 inches wide, 35 feet, 8 inches deep, with a 14-foot, 5-inch-by-46-foot stable added on to the south (front) wall.

Five generations of Skolfields have lived in these houses and farmed this land. Across the road, two generations of them built tall ships during the height of the square-rigger ocean sailing ship period of American history. Skolfields built 65 ships from 1802 until 1885, when the last one, a 232-foot vessel displacing 1,731 tons, was launched. Still, by any accounting, their finest construction was their connected home. The last residence and the large barn were framed from timbers left over when the Skolfields closed the shipyard.

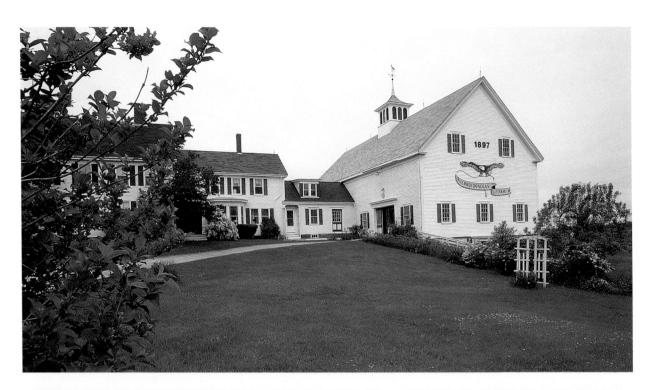

Merrucoonegan Farm's large barn was completed in 1897 and measures 39 feet, 8 inches wide by 84 feet, 10 inches long. Built with six bents making seven bays and three aisles, the barn was originally used for dairy farming after the Skolfields retired from shipbuilding and seafaring. An apple orchard was planted as well. After the farm ceased active agriculture, the barn—including the cellar shown here—became, as many are, storage. There are some plans being discussed to reactivate the barn as a large-animal veterinary facility.

probably inspired the tribal villages of the Dark Ages where the entire population lived in houses clustered around a threshing floor, granary pits, and the community's water supply. These were all surrounded and protected by tall walls or stockades. However, the purpose of all these versions was the safety and security of the inhabitants, their livestock, and harvested crops, not economy of production.

Architectural historian Thomas Hubka has spent years studying New England connected barns. He is the author of an engaging and enlightening history of these buildings called *Big House, Little House, Back House, Barn*. His study goes far toward explaining the truths and myths of these uniquely New England structures.

From the earliest days of farmhouses in New England, summer kitchens were joined to the rear of the house in a kind of L-shaped addition, often called the "little house." This kept the heat of cooking out of the rest of the house in the summer months. Beginning in the late 1700s, any home industry was accommodated in a further addition to the structure that was strung off the back of the kitchen little house. This housed the farmer's workshop, and the candle making, leather tanning, or cabinetmaking was done in here as well. While the English farm would have separated each function into a distant building, writers in farming magazines in the mid-1800s began to stress saving steps, centralizing all the farm's activities closer to the main house. And so the "back house"—the shops—joined the little house.

The final step in this evolution was complicated. It involved turning over a great number of prejudices and historical practices. It involved convincing vast numbers of conservative farmers that this was not ostentation but efficiency. And this involved adaptation of town and city styles of architecture to the country.

The English heritage not only dictated a separate structure for each function. The English also looked with slight disdain at the idea of living among the livestock. And there was finally the great risk that a fire that began in one structure would not stop until it had destroyed everything else connected to it.

Around 1800, an architectural style emerged in U.S. cities that harked back to the elaborate colonial manner houses of Williamsburg, Baltimore, and Philadelphia. These grand residences were connected by symmetrical wings to servants' quarters, kitchens, stables, and carriage houses. This style was called "Palladian," named after the 16th-century Italian architect Andrea Palladio whose designs strongly influenced American farmer/architect/politicians such as George Washington and Thomas Jefferson. Resurrecting this architectural influence for use in the established commercial centers of the industrial Northeast set another precedent. For the farmers who traveled into the cities to sell produce and products, these connected homes established a kind of acceptability. Townsfolk did it for convenience and to further a style. The farmer could certainly do his own adaptation for economy of operation.

Magazine writers stressed the efficiency available to farmers and families from connecting barn to carriage house to workshop to kitchen to main house. There was never a suggestion, however, of interior doorways connecting the smells of the barn to the interior of the kitchen or home. Still, it made

**Timmons barn,
Barrington, New Hampshire**
The small barn (24 feet, 7 inches by 30 feet, 6 inches) and the large connected house near Barrington, New Hampshire, were built around 1830 by Dr. John Fernald from Kittery, Maine. While a state highway now passes in front of the house, the original road ran right behind the structures as early as 1756, to connect Barrington to nearby Dover. Both house and barn are built of white oak, their major timbers hand-hewn more than 9-inches thick. This early New England connected barn is separated from the house and its wagon sheds by the *porte-cochere*,, or breezeway, that gave the house and carriage yard access to the old road.

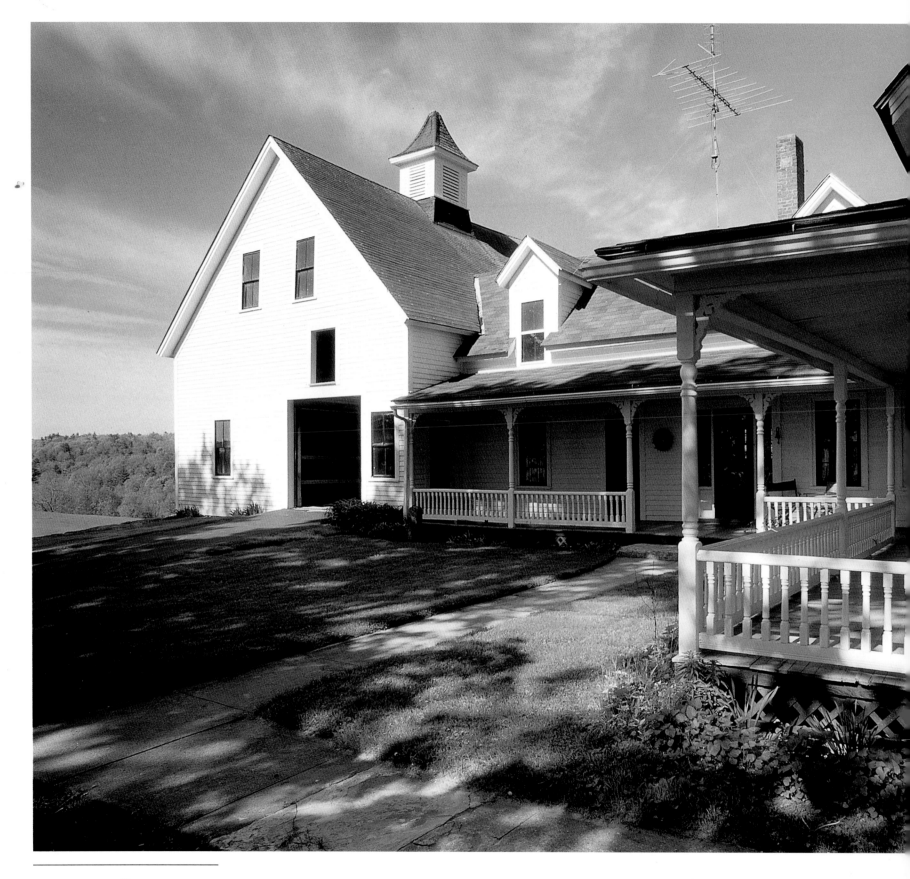

much more sense when performing the wide variety of home industries if commuting time was reduced.

The traditional argument for barns connected-to-the-homes is that this configuration made the farmer's chores much easier during the brutal New England winters. The farmer could walk from his warm home through the kitchen and on through other structures protected from the wind (at least) to feed and tend his livestock. He never had to go outside. But this simply wasn't the case.

The barns that farmers attached to their string of other structures were not connected except by common walls. These barns were often simply moved from somewhere else in the farmyard to join the house. Or else a barn was torn down and its pieces used to construct a new barn connected to the carriage house or work shed. (This was easier, of course, because barns prior to 1850 simply rested on—but were not usually attached to—excavated cellars or rudimentary foundations of stone.)

As Thomas Hubka discovered, "This tradition of moving buildings was absolutely essential to the widespread popularity of the connected farm concept. The total record of change in New England building traditions presents a graphic picture of people committed to the idea of physically tinkering, retooling and altering the buildings in order to improve their physical surroundings. This is not the record of people unwilling or unable to change, but the manifest imprint of a modern experimenting people well in keeping with the optimistic predictions of Thomas Jefferson and Alexis de Tocqueville in regard to the potential of the masses for individual improvement." The Puritan ethic that brought them to the New World existed more than 200 years later when they again risked dramatic change in order to improve their lives. In the end, however, it came to little good.

"In some nearly tragic ways," Hubka wrote, "New England farmers had created the outlines of a system that was beginning to put increased labor into increasingly uneconomical tasks. Their mixed-farming, home industry system was an inherently labor-intensive system . . . and home industry activities such as logging and clothes making diverted

Wheeler connected barn, Hardwick, Massachusetts
This is a nearly archetypal connected barn configuration, one that is common throughout New England. The main farmhouse is connected by interior doorways to a small addition and then to the large kitchen. Beyond that, on many farms, there might be another smaller structure that served the purposes of tool shed, workshop, or general storage. Next to that would be the barn. This barn was built as a carriage house and stable because the farm also has a very large dairy barn up the road a short distance.

considerable energy away from agricultural activities." The magazines of the time wrote that New England farmers, faced with poor soil and a variety of crops and animals requiring an ever wider variety of tools and machines, must continue to diversify or die. "New England farmers," Hubka concluded, "had little alternative but to maintain these methods if they were to continue farming. Gradually, however, these factors made it more and more difficult for them to compete with more specialized producers in other parts of the country."

Farmers in New England continued to build barns connected to their homes all the way into the early 1900s. But the style never moved west too far beyond Massachusetts. This idea of mixing farming with manufacturing was necessary only in New England.

In fact, the preponderance of these wonderful buildings were built and are still found in Maine, in

Typical of connected New England barns, there is no entry into the barn directly from inside the house or connected sheds or kitchens. This was done to keep barn odors and sanitation problems out of the house. Still, the motive for connecting barns to houses was convenience—to save the farmer steps. The advantage in winter was considerable.

The barn measures 30 feet, 5 inches wide and 37 feet, 2 inches deep. This was a banked horse barn/carriage house; the cellar was not used for livestock. At the front, it stands 31 feet, 6 inches tall, while at the rear its height adds another 10 feet, 1 inch. The entire building is 81 feet, 4 inches long. Its gable-end front door is off center to allow storage for wagons and stables for horses.

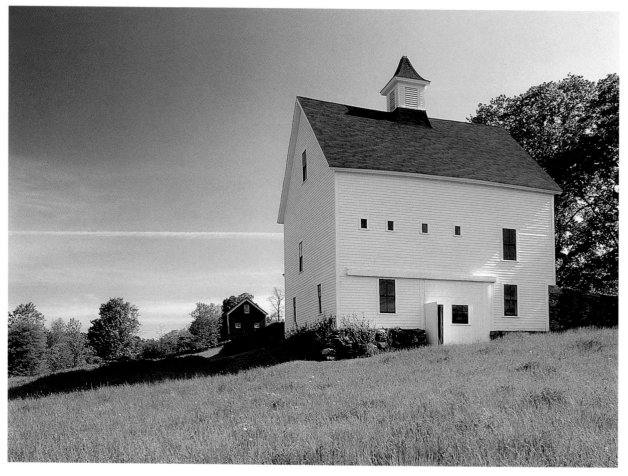

southern New Hampshire, southeastern Vermont, and eastern and central Massachusetts.

"In retrospect," Thomas Hubka summed up, "this nineteenth century New England farm reform movement only helped to prolong old fashioned methods of agriculture into the twentieth century. . . . Connected farm buildings were the manifestation of a powerful will to succeed by farming, and in that goal, New England farmers were extremely successful, for a while."

That this style was never adopted in Minnesota or in the Dakotas and Montana where winters are far more severe explains in itself why the connected barn was not a weatherwise development. These connected barns came to exist as a result of—and to improve the results of—home industry.

It was, in effect, a kind of fad. It provided one more futile attempt to make a challenging farming condition into something more successful than it was. Agriculture alone could no longer provide an income that would support New England farmers. In the face of an economically threatening challenge from the open prairies of the Midwest, almost no industry or idea seemed too radical to open-minded farmers bent on survival.

The home was constructed around 1850 by Marshall Nye for his children. Both the house and barn are among the earliest examples of balloon-frame construction in central Massachusetts. This style of building, also known as "stick construction," originated in the Midwest in 1830. Once commercial lumber mills could produce lumber of consistent dimensions, builders began experimenting with dividing the loads formerly carried by massive timbers into "sticks."

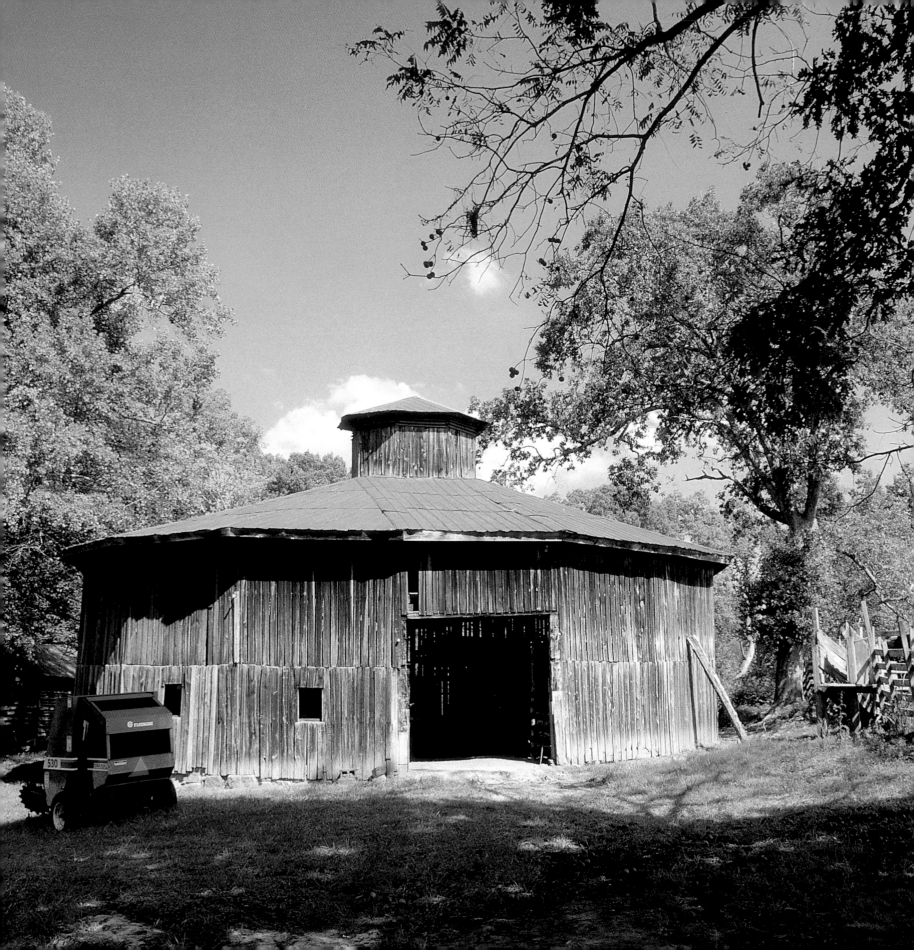

ANOTHER FAD, ANOTHER FASHION

*C*onnected farm buildings were not the only "fad"—to put it less than charitably—that farmers adopted in the interest of efficiency and increased productivity. The innovation that may have begun with George Washington in 1793 was certainly advanced far along the way by the Hancock Village Shakers in 1826. But then it was picked up and vigorously promoted in a paper published in 1890 in the *Seventh Annual Report of the Agricultural Experiment Station* at the University of Wisconsin by an extension researcher, Franklin Hiram King.

King, a professor of agricultural physics at the University of Wisconsin-Madison, had been asked in 1889 by his brother "to suggest a plan of a barn for a dairy farm which would accommodate eighty cows and ten horses and which would permit driving behind the cattle in cleaning, and in front of them in feeding green fodder. A silo, granary and storage space for dry fodder was to be covered by the same roof, to be conveniently accessible to all its parts, but not very expensive."

King wrote further that "the reasonableness of the demands could not be questioned, but to meet them with any of the usual styles of barn architecture the writer found impracticable when everything was considered."

Without acknowledging the origins of his design, Franklin King devised something very similar to the Hancock Shaker barn, which he enlarged slightly. He proposed that his brother, C. E. King, build this new

Clark 16-sided mule barn, Denver, North Carolina
In 1895, when the future North Carolina commissioner of agriculture Alexander Graham was still a young man, the original 1835 corn crib and house barn on his family's farm burned. His father, a progressive man who farmed with mules, was aware of the most current thinking in barn design. He had likely read about Lorenzo Coffin and Elliot Stewart and their octagonal barns built with a conventional center aisle.

Few woods are harder than aged oak. Carpenters say they can bend four out of every five nails they try to sink into dried, cured oak. In the century since the Grahams built their barn, the mortar that held its foundation stones together has long since dissolved. The structure was divided into 13 stalls, each wedge shaped 10 feet, 8 inches deep, 7 feet, 4 inches inside the barn and averaging 12 feet, 6 inches on the outside wall. On the south face there is a corn crib 11 by 12 feet.

circular barn out of wood on a stone foundation. King even reproduced the George Washington/Hancock Village conical roof with its attached center cupola. In his plan for his brother, Franklin replaced the center haymow of the Shaker barn with a round silo, which was his own innovation; before King, silos were square and separated from the barn. This internal silo was 34 feet tall with a 28-foot outside diameter. C. E. King's circular barn was completed in 1891 on his farm in Whitewater, southeast of Madison, by a Rome, Wisconsin, builder, A. McFarlan.

The King barn was 92 feet in diameter and it stood 28 feet from the ground to the eaves. The bottom floor was configured in three concentric circles. Cows faced out from the innermost ring to a middle aisle from which they were fed. Cows also occupied the outer ring, facing back into the middle one. The animals stood on a raised wood floor for milking; to their rear was a 6-foot-wide wagon path for manure cleanup. On the second level, above the cows and the feed aisle, was a hay floor extending out 18 feet from the edge of the silo. This held the loose hay, which could be forked down to the livestock below through a series of trapdoors. Around the outside wall of the second floor, above the outer milking ring and its wagon path, was the hay wagon floor. Here, just as in the Hancock barn, horse-drawn wagons entered by a ramp and unloaded while moving around the circle. The horses then walked out without having to back up.

The barn foundation was also a series of concentric circles. The innermost one supported the silo, while the outside ring carried the walls. "The laying of walls to a circle and leveling them was a simple matter," Franklin King wrote, "and accomplished with the aim of a straight-edge, one end of which was fixed to a post in the center. . . . The movable end of the straight edge rested on a ring of boards tacked to stakes driven into the ground outside the wall being built."

In addition to looking into silos, King had been concerned for some time with barn ventilation. "When it is known," he wrote in the same paper, "that air once breathed, unless diluted with that which is fresh, cannot support higher animal life;

that one-fifth of the weight of materials taken into our bodies daily is oxygen from the air, and that we must breathe 346 cubic feet of air to get it; that on the average our livestock consume more air per capita than we do, and that horses have died from suffocation while being shipped in box cars, it should be evident that, coupled with our efforts to secure warm barns, there should also be those to provide ample ventilation."

While his writing style was convoluted, his idea was direct and fairly simple. His design allowed the heat of drying hay and silage to escape through the cupola. As the heat rose, it drew in fresh, cool air from holes drilled through from the outside at the sills.

His brother built the barn for $2,400. This was another of his selling points. His 92-foot-diameter barn was capable of housing 98 cattle and 10 horses with its silo inside. King calculated that it pushed 16,048 square feet of wall space out into the air, in a shape that the winds slipped past more easily. The nearest match in outside surface in his comparison—at 15,789 square feet—was a 40x50-foot rectangular cattle barn. But this structure would accommodate only 37 cattle, no horses, and it contained no silo. King determined that in order to house 94 cattle in a traditional rectangular barn, he needed a structure 56x28 feet. Its exterior wall space was 20,210 square feet—much greater resistance against winter winds—yet it fell short on interior space at 5,048 square feet. This was 8,000 square feet smaller than his brother's round barn with 13,300 square feet. King's design offered one more benefit. Ensilage stored inside the center silo was insulated from outside freezing temperatures by the large air space surrounding it and by the considerable body heat generated by the livestock wintering inside the barn.

"By combining everything under the single roof," King concluded, "by adopting the cylindrical form which requires the smallest amount of siding, roofing and paint, and which admits the cheapest and least lumber for the frame and by distributing the lumber so as to make it perform two or more functions" one achieved the greatest economy.

Unfortunately for the brothers King, Franklin's roof did not hold up well on C. E.'s barn. In an

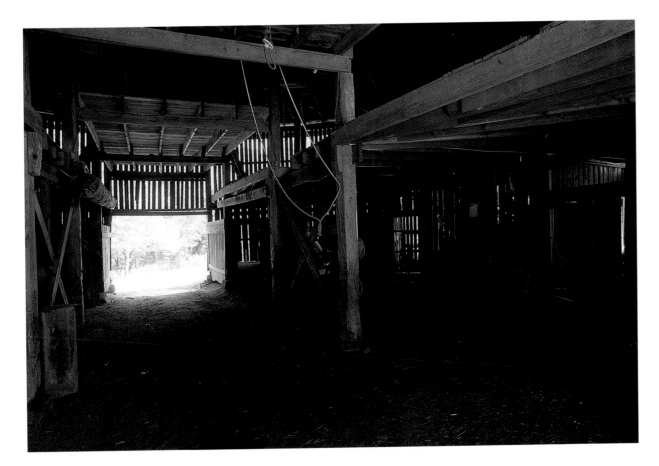

The barn is 58 feet, 6 inches across, 183 feet, 10 inches in circumference. A haymow was built above each semicircular set of stalls, and additional 11-foot, 6-inch-by-26-foot haylofts are suspended above the central 11-foot drive aisle. Eight central posts are sawn 8x10s reaching up 25 feet, 10 inches to the base of the cupola and ventilation tower. All posts and load-bearing beams are 8x8s.

The Graham family built their 16-sided barn along the same style as Lorenzo Coffin and Elliot Stewart had done, with central aisles. Both Coffin and Stewart retained a more ordinary arrangement for box stalls and milking stanchions off either side of the aisle. However, by this time Wisconsin researcher Franklin King had published his description of round dairy barns with milking done around the circumference. The Grahams may have adopted ideas from each source. Alexander was commissioner of agriculture from 1908 through 1923, when his son took over the position.

attempt to provide a clear span throughout the haymow, King put no supports under his diagonal roof rafters forming the cone. Over time, the weight of the cupola—coupled with the strain regularly put on the roof rafters by the heavily loaded hay fork—began to put the entire roof in jeopardy of collapsing. Designers who followed King's invention quickly adopted supported gambrel roofs and later trussed gambrels and arches.

*J*t seems that round—or at least multisided—barns have historical roots that predate Washington's own efforts. Larry Jost, a round-barn enthusiast in St. Louis, Missouri, authored and published in 1982 a small history of these structures, *The Round and Five-or-More Equal Sided Barns of Wisconsin*. Jost suggested that the earliest circular structures in the United States were probably octagonal churches built by the Dutch Reform Church in the Hudson River Valley. Some 20 of them were known to exist between 1680 and

1750. These, Jost hinted, may have come from round hay *ricks* in use throughout Holland even before the 16th century. "In Holland," Jost learned, "the hay rick took the form of a structure with a first level enclosed by a wood frame with a partial stationary roof above which would be a cone-shaped central roof which could be raised or lowered as the level of stored hay varied."

With a little imagination, the reconstructed hay rick at Plimoth Plantation Living History Museum in Plymouth, Massachusetts, offers a hint of round barn development. If that structure were enlarged to house not just two but four or more cows or oxen, its straw-thatched roof would fill out. From a distance, it would look like a round barn. But that's hypothetical. Other round buildings did appear elsewhere.

In England, with the widespread adoption of cotton gins in the late 1700s came gin-gangs, which Jost described as "a small and often round or octagonal building found near the barn which housed a threshing machine's driving gear and the horse

**Jost potato barn,
Sagaponack, New York**

Potatoes are harvested ripe in mid-October on the east end of Long Island, New York, but they are stored until the market is ready. Because potatoes cannot be frozen, their storage barns are half-submerged where the ground heat protects them from Long Island's winters. From the front door, the barn appeared 24 feet, 2 inches tall; from the banked sides or back, it looked less than 12 feet high. Nearly every barn has a fireplace, wood-fed in the early days, gas-fired in modern times, to maintain a temperature above freezing no matter what the weather outside.

Potato farmers store their crops, watching the markets carefully. If every grower delivered his crop in October, the huge glut would collapse prices. On Long Island, however, there is greater risk to potato prices than frozen crops or a market glut destroying prices. Real estate development is consuming potato farms the way the blight consumed potatoes in Ireland in the 1800s. This barn, photographed in September 1995, was taken down in the spring of 1996.

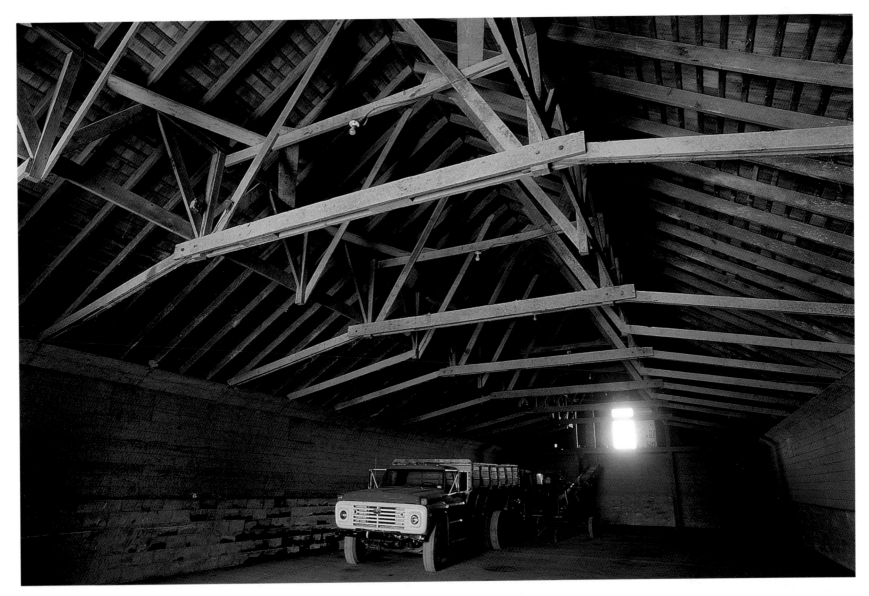

Thirty years before Fowler's house was blown to so much debris, Lorenzo Coffin, an influential stock breeder in Iowa, completed a 68-foot-diameter octagon-shaped barn. Coffin's own farm, Willow Edge, outside of Fort Dodge, provided some of the raw materials. He and a crew hewed framing timbers and shingles. They hauled in the rest of what they needed by wagon. Built against a gentle rise, his bank barn carried an unusual modified hip-roof that was supported by elaborate braces, struts, and purlins. The drawback of Coffin's design was its supporting posts which cluttered the interior of the haymow. Still, the overall plan began to have some appeal to open-minded and innovative farmers throughout Iowa. While he did little to publicize or promote his idea, variations of Coffin's octagonal barn with its modified hip-roof began to appear in other parts of the state in the early 1870s.

In the East, where the passion for octagonal houses had cooled, excitement was suddenly rekindled for octagonal barns in 1874. It happened in Lake View, New York, on Lake Erie, 400 miles west of Fowler's Fishkill home. Lake View is near enough to Buffalo that it is now a suburb. Elliott Stewart, the editor of the monthly Buffalo *Live-Stock Journal,* and a sometime lecturer on agriculture at Cornell University, built an 80-foot-diameter octagonal barn. Stewart was a well-known farmer who, until

The barn was built with a kind of modified principal roof rafter system. The roof trusses, spanning 38 feet, 6 inches inside, carried a pair of queen posts supporting purlins, anchored with tie beams. The trusses, all built of 2x8 modern dimension lumber, were set 12 feet on center. At the center, ground clearance was 13 feet, 6 inches to the bottom of the horizontal truss member. The structure measured 90 feet, 9 inches long. A foundation supported the poured concrete floor and 10-foot tall concrete block walls with earthen banks built up outside to the roof eaves.

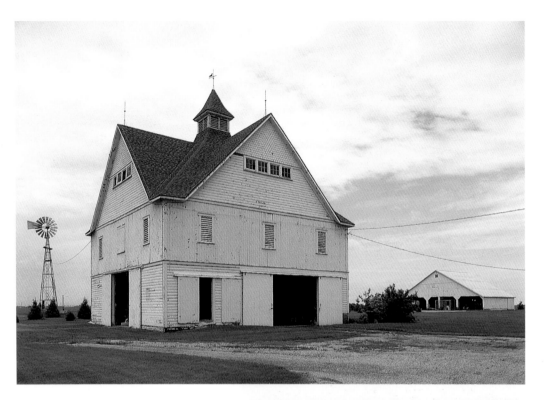

completion of his new barn, had done his farming in the traditional English manner with separate buildings for different functions. When the octagon was finished, he burned to the ground four older buildings.

Frequently throughout the next decade, Stewart wrote articles about his barn that were widely published and broadly reprinted in a variety of newspapers, magazines, and books. By 1884, he knew of at least 30 farmers who had built octagonal barns based on his design and experiences. Stewart's barn introduced the octagonal "cone" roof style, which was entirely self-supporting. This was made up of eight wedge-shaped sections that allowed a clear span because they required no internal support. While Stewart built his new barn on flat land, he incorporated a manmade embankment to provide access to his upper-level haymow.

Stewart's philosophy of consolidating all farm functions under one roof—albeit octagonal—was enthusiastically advanced by other writers as well.

Flack cross-gable barn, McComb, Illinois

The goal of the cross-gable barn was to provide the largest usable space possible without any obstruction from vertical posts, braces, or struts. The cross-gabled roof is basically a modified hip roof with four identical gables on top of a square building. Cross-gable barns were first described in a carpenter's pocket manual published in Philadelphia in the late 1700s, and the earliest known cross-gabled building was a meeting house in Massachusetts in 1702.

Timber was prepared in nearby Adair and driven by horse and wagon to the barn site. The underside of the four-gabled roof is as intricate as any "painted lady" house of the era. This barn is 40 feet, 4 inches wide, 40 feet, 6 inches deep. It is 52 feet, 1 inch to the top of the cupola.

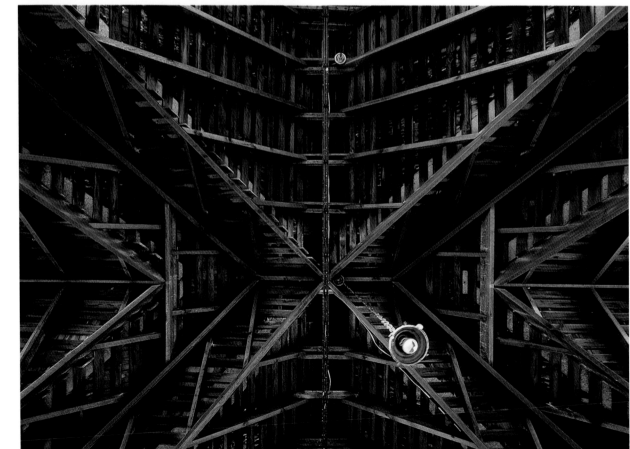

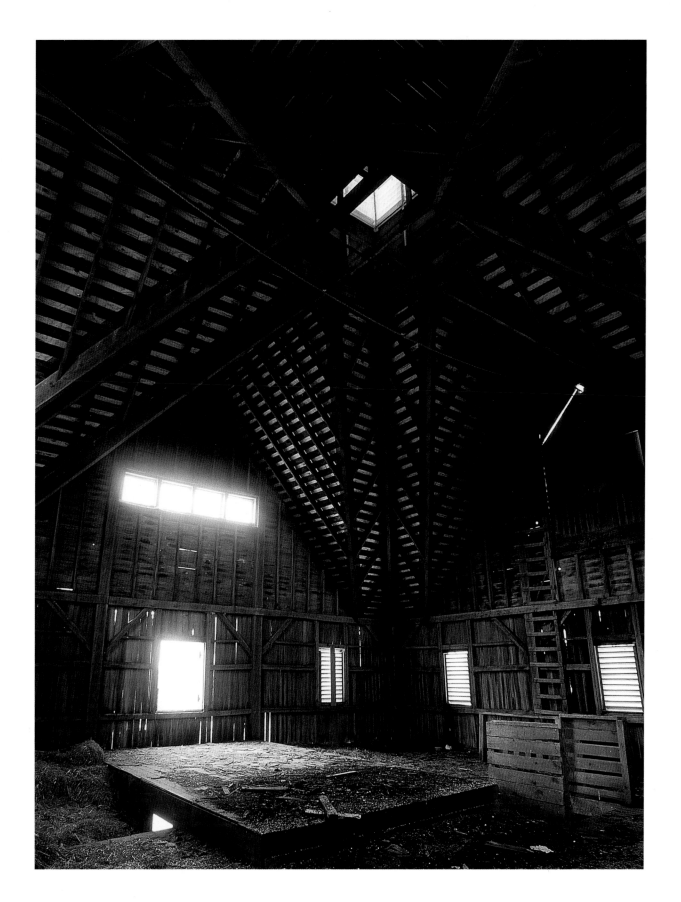

The area around McComb, in McDonough County, Illinois, is home to about 25 of these interesting barns. Two builders in the area were responsible for most of them. Nick Breasaw built a more ornate, decorative version, while Isaac Newton Willis built this and another dozen or so. Wood was precut and the joinery work was carved during the winters. Beginning in the spring, the builders and their crews fanned out over the area, building square barns. The crew earned $1 a day plus room and board for each of the five and a half days required for construction.

ANOTHER FAD,
ANOTHER FASHION

Cina tile round barn, Viroqua, Wisconsin

Albert and Mary Cunningham acquired their farmland just outside Viroqua, Wisconsin, in 1914. The land included an existing rectangular barn and a round silo, inspired by Wisconsin researcher Franklin King's writings in 1890. Wisconsin was in the throes of a building frenzy during the 30 years that followed the publication of King's ideas, and as many as 215 round barns may have been constructed in Wisconsin alone.

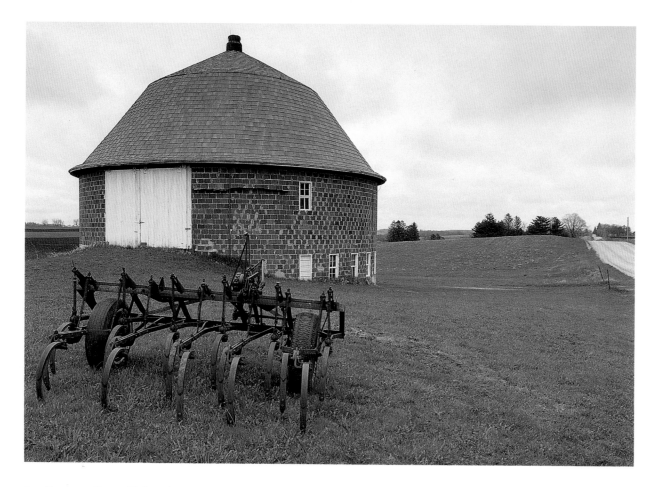

A colleague, Byron Halsted, compiled a book in 1881 called *Barn Plans and Outbuildings*, and on his first page he considered the trend.

"With the increase of wealth," Halsted began, "and we may add of good sense and enlarged ideas, among the farmers of this country, there is a gradual but very decided improvement in farm architecture. The old custom was to build small barns, to add others on three sides of a yard, perhaps of several yards, and to construct sheds, pigpens, corn houses, and such minor structures as might seem desirable. In the course of a few years, the group of roofs, big and little, span and lean-to . . . would present the appearance of a small crowded village. Compared with a well arranged barn, a group of small buildings is inconvenient and extremely expensive to keep in good repair."

Despite this, Halsted followed a very traditional approach to farm architecture, and he avoided any mention of octagonal or round barns anywhere in his book. Because of Orson Fowler's slip from the limelight, Halsted may have been wary of what he saw as a similar passing fancy. In any event, octagonal barns, while radical in their exterior shape, were very traditional in their interior layout. Cow and horse stalls were arranged in parallel ranks just like those in rectangular barns. To many farmers and to a growing number of writers, it was simply a novelty.

Yet, a decade later, Franklin King would give everyone something more to think about. His own design, grown out of his research into round silos, did restore popular attention to octagonal and round barns in the United States. It provoked a real spurt of building. Estimates suggest that as many as 215 round or polygonal barns were constructed in Wisconsin. Another 170 were built in Minnesota and 160 in Iowa. King's design appeared not only in the extension service report, but it was also reproduced in all six editions of a very popular agricultural sciences textbook he authored. Eventually, King's cause was taken up by others. A professional colleague at the

University of Illinois at Champaign-Urbana, Wilbur J. Frazer, published an article called "Economy of the Round Dairy Barn." This appeared in the University of Illinois Agricultural Experiment Station Bulletin No. 143 in February 1910. It was Frazer's enthusiasm before and after his publication that spread the popularity of round barns not only throughout Illinois but on to Indiana as well. Between 250 and 300 were constructed in Indiana, and that state claims that it is the round barn capital of America.

Round barns offered farmers different farming techniques from traditional rectangular or even octagonal barns. The incorporation of a silo within the barn mandated that interior arrangements be reconfigured. Straight rows would be interrupted by the silo; stalls, feeding, and cleaning alleys all curved around it. The top of the silo often became the center support for the barn roof, alleviating the need for all other interior posts and opening up all but the center of the barn to free span.

The next development to affect Franklin King's round silo also benefited the round barn. At Iowa State University, Professor J. B. Davidson and Iowa Experiment Station researcher Matt King worked with a local tile manufacturer to produce the first clay tiles for round silos in 1908. From that success, they developed hollow curved tiles, which they then promoted for barn construction as a fire-safe and less expensive alternative to wood. (This also allowed the invention of the "Iowa Silo." This placed a 100-or-more gallon hollow-curved tile water reservoir on top of the fodder silo inside the barn.)

Owners saw other alternatives for their farms because of the round barn. Before the turn of the 20th century, farmers had begun to specialize. Barns strictly intended for dairy operations—and not only round—started to appear. Others were being designed to house specific stock such as beef cattle, sheep, or hogs. Some structures were being constructed as show barns for the display and sales of livestock brought in only for that purpose.

Round barn plans could be ordered by mail. A Chicago architect William Radford, who had produced barn plans beginning in the 1890s, sold round barn plans for $20 and blueprints for an octagonal

barn for $15 as early as 1909. William Louden, the Fairfield, Iowa, barn equipment manufacturer, produced and sold round barn blueprints for $5 in 1915. Matt King, the agricultural engineer who had helped develop the curved hollow tiles, began to provide his own plans through the Permanent Building Society of Des Moines. Davenport, Iowa, prefabricated house manufacturer Gordon-Van Time Company, offered pre-cut, ready-to-assemble round barn kits in their 1917 catalog. Chicago mail-order houses Montgomery Ward and Sears, Roebuck each offered kits. Sears customers could even finance the barn and arrange its assembly by Sears carpenters through the catalog.

In southeastern Wisconsin, Alga Shivers, a carpenter/builder, earned quite a reputation building round barns. Shivers was one of a group of blacks who settled into Cheyenne Valley near Ontario, Wisconsin, following the Civil War. He constructed nearly a dozen barns throughout the small area.

In late 1916, Cunningham hired a crew to build a round barn where a rectangular one had been. The workers built the new barn around the silo. They had to increase the height of the silo to support the new round roof. Round barns remained popular into the 1920s and even mail-order giants such as Sears, Roebuck and Company marketed round and octagonal barns in their mail-order catalogs.

In 1908, University researchers in Iowa developed rounded clay tiles for silo and barn construction. Cunningham planned to concrete skin the entire tile portion, but he died before he could complete the work. His daughter, Helen, had married a local farmer, Nunce Cina, and they took over operating the farm and its 36-foot-diameter round barn. The Cinas kept 15 cows, a bull, and two horses.

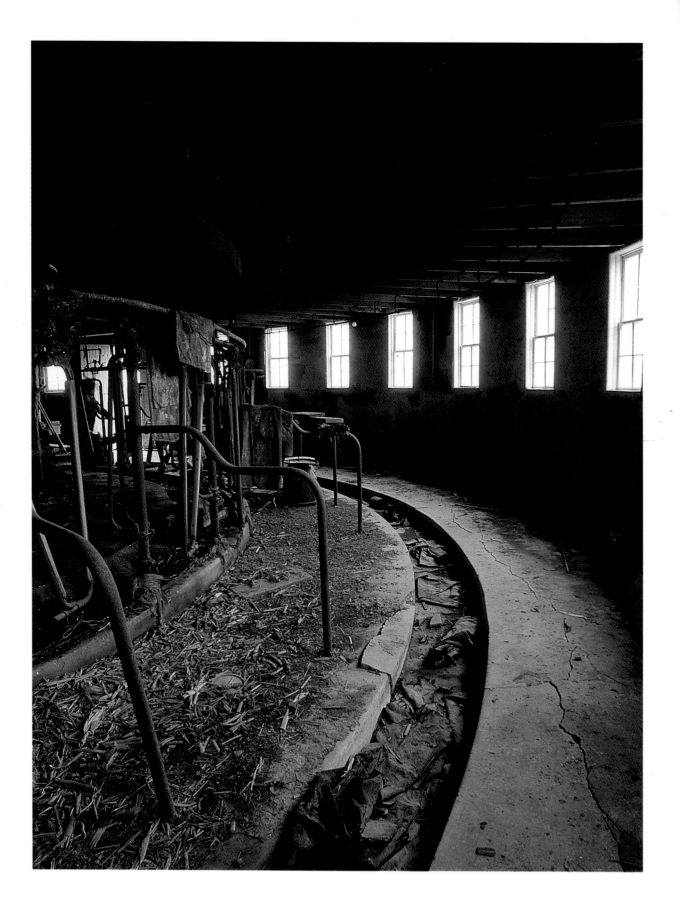

Already known as a barn builder, Shivers began to receive orders for round barns in the late 1890s from farmers inspired by King's writings. Shivers and his small crew harvested wood from the farmer's own forest and left the wood to cure. A year or so later, he and two or three assistants would arrive in their wagons and begin construction. The work usually took Shivers and his crew about three months to complete.

The popularity of the style failed abruptly in the late 1920s. Many reasons contributed to what appeared to be an almost overnight collapse. Technology was partly to blame. Loose hay was baled more often than not by then, and putting up bales into a round mow was difficult. Barn cleaners and hay trolleys were widely marketed by companies such as Louden, Janesway, and others. Their systems were available to fit their barns. However, structures built by independents such as Shivers in Wisconsin or Benton Steele (who worked in Iowa, Nebraska, and Kansas) generally conformed to their customers' needs, not equipment manufacturers' specifications. Since no two independent round barns had the same diameter, "standard" curves could not be adapted to individual circular gutters and walls. A similar problem arose with the adoption of milking machines. The pipes at first were not easily bent into gradual arcs. But these were problems that the various manufacturers eventually solved.

An element of greed played a role as well. Horace Duncan, a midwestern architect, succeeded in obtaining a patent for a round barn design in the early 1920s. He demanded a royalty and took to suing for patent infringement anyone who copied the *idea* of the round barn, let alone his own version of it. Word spread quickly.

The real causes of the death of the round barns, however, were deeper. The success and growth of some farms was one influence. While builders like Alga Shivers always counseled their customers to build a bigger barn than they needed at that moment, many did not, and built instead only what they could afford. Later, when they wanted or needed to expand their herd, the round barn couldn't grow longer or wider. It couldn't grow up or out. As George Washington discovered, it could only be supplemented—or replaced—with another round, or more likely, rectangular barn.

However, the lack of success of farms was a greater cause. Lowell Soike, a historian with the Iowa State Historical Department and author of *Without Right Angles—The Round Barns of Iowa*, thoughtfully and in great detail examined the history of Iowa's 160 round and polygonal barns.

"Hard times sealed the fate of the round barn," he wrote. "The financially difficult 1920s sharply reduced farmer demands for buildings and dampened further experimental ventures. . . . The Great Depression halted almost all farm construction, and by the time farmers could afford to build again (after World War II), round barns—and traditional barns generally—had ceased to be practical.

"The round barn fit the time of horse farming," Soike concluded. "The farm tractor and its impressive accompaniment of large implements changed all that. Even the largest round barn seldom has enough alley space to allow entry of the tractor with its front-end loader, which cut short the onerous chore of hauling manure. . . . So today these barns, along with many of their rectangular cousins, find their use limited. . . . As often as not, they stand empty, wasting from neglect."

Round barns spread sporadically east and west. Perhaps fewer than two dozen may have been built in Vermont; only a few more than that were constructed in California. As part of the start of the age of specialized farming, most of the round and polygonal barns were built for dairy cows. However, three unusual round barns were built in Oregon's high desert.

On a ranch in the shadow of Steens Mountain in southeast Oregon, a 5-foot, 5-inch tall, 135-pound Missouri-born Californian would eventually control 2,100 square miles of some of the most beautiful grazing land in America. He figured that round barns best did what he wanted done.

WAY OUT WEST

Agriculture in the American West benefited and suffered from its location. By the time settlers understood the arid prairies and had gotten beyond the barest subsistence farming, they had made sense of the scale of the land and what was required of them to work it.

From the 1840s through the 1890s, eastern and midwestern farmers moved to the West and became ranchers. Traditional row crops needed too much water to survive in the West, at least until irrigation techniques were developed. Once that occurred, areas such as California's central valleys along the San Joaquin and Sacramento rivers became America's wheat belt. Ranches were established that stretched over dozens of miles and covered thousands of acres. Harvests were measured in millions of bushels.

Without irrigation, there was grass enough to feed cows but scarcely enough per acre to maintain a viable dairy operation the likes of which were beginning back East. This was land to let the stock range free, loosely tended. Herds were driven up mountains by cowboys and Mexican *vaqueros* to spend summers grazing in higher altitude pastures. In the fall, the herds were rounded up to winter in lower valleys. The West was

**Western barn,
New Pine Creek, Oregon**
Framed of oak and sided with redwood, this southwestern Oregon horse barn shows the effects of age. Its south wall with its low eaves has been bleached dry by the sun and blasted by prevailing winds. Its west wall has been cured, burned, and bronzed by long sunsets. This style of roof is called "gable on hip roof" because the gable—set back from the end of the barn—protrudes through the hip. It is a method of providing slightly more hay storage space while retaining the wind-bending properties of a hip roof. It is somewhat challenging to frame.

Peter French round horse-breaking barn, near Frenchglen, Oregon
Looking more like a stealth flying saucer than a barn, Peter French's round horse-breaking barn is built of native materials from a land with few building resources to spare. French managed an enormous cattle ranch for Californian Hugh Glenn. He steadily acquired land during a 26-year period, building the P Ranch into a property of 100,000 acres with nearly 45,000 head of cattle. French's crew caught wild horses on the plains and broke them—year round—in the barn.

THE
AMERICAN BARN

territory to raise animals for slaughter as food and whatever by-products might be useful—sheep and beef cattle country that produced wool and cowhide and dinner.

These animals required larger and larger ranches but because this "crop" generally walked to market on its own four feet, few of these ranches had need for barns, until specific uses dictated otherwise. While dairy farms in the East and Midwest wintered their herds inside barns, this was impossible in the West. Instead, ranchers risked everything each winter, relying on their steers to forage for grass beneath the lighter snows of lower elevations. However, this risk was self-perpetuating: even small herds needed a lot of range. But small herds were subsistence ranching; it was large herds that made

money, and they required vast lands. Any profit from the stock sale would be squandered in the expense of building a barn large enough to house them all *and* their winter's feed. Instead, smaller structures held feed that was ridden out daily to widespread herds.

It would be half a century before feedlots would prove the economic benefit of pampered beef cattle. Until then, western barns were rare and specialized. In California, Oregon, Washington, and Idaho, they were home to the large horse herds needed to harvest wheat. Elsewhere—Montana, Wyoming, and Colorado, for example—they stored feed to supplement winter grazing. Many of the structures were built out of local indigenous materials. Most were low to the ground, cowering beneath winter jet streams that blasted hard winds down from the Arctic Circle.

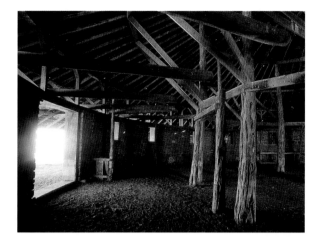

Those winds slapped too hard against the tall, traditional Yankee barns of New England, and builders' first efforts at bringing eastern and midwestern traditions to the windswept West found their barns collapsed under January blizzards.

In the West, the needs for barns were simpler, but the conditions much more difficult.

*J*ohn William French was born in April 1849 in Callaway County, Missouri, 15 months after gold was discovered in California. When French was one year old, his parents moved the family west but they found all the land around Sacramento tied up in land grants that a wheat farmer named Hugh Glenn was busily acquiring. The Frenches turned north and they tried shepherding. French grew up ranching. He worked for his father, and he came to know all kinds of livestock and what it meant to work for someone else. The more he learned about Hugh Glenn's vast operations, the more interested he became in what the man seemed to be doing.

Hugh James Glenn was born in Virginia in 1824. He had a medical degree and was a doctor during the Mexican War, but when he was just 24, miners in California discovered gold at Sutter's Mill east of Sacramento. A year later, in March 1849, he married Nancy Abernathy, and they started west from Virginia with big ambitions but few plans. They bought some livestock in Missouri and drove them all the way to gold country where the market, hungry for beef, bought whatever was available and paid—in gold—whatever the seller asked.

Glenn made a dozen trips back to Missouri. He returned with cattle, horses, and sheep, each time taking from hungry miners their hard-found gold. By 1867, Glenn had acquired a 7,000-acre land grant in northern Colusa County, north of Sacramento. He paid $1.60 an acre—a total of $11,200—for a plot of nearly level land along the Sacramento River. He began to expand his landholdings, and in 1879, he was nicknamed the Wheat King when his 45,000 acres of ranches yielded one million bushels of threshable gold. Within four years, he and Nancy owned 65,000 acres. But Glenn was also a builder—some 27 new barns, 38 houses, and 14 blacksmith shops appeared on their ranches.

Glenn's vast wheat acreage put him in conflict with the cattlemen who needed land to graze. In 1872, California's legislature had passed a law allowing landowners to keep—and charge a boarding fee for—animals found trespassing on their land. It doomed open grazing land in California, and cattlemen began moving north to Oregon for open range. Glenn knew that was where he must look as well. But he also knew that he needed help.

French designed the barn himself. His inspiration is unknown. The center is a 60-foot diameter horse-breaking corral, surrounded by lava rock. French's crew hauled something like 170 cubic yards, about 250 tons, from a site 8 miles from this location. They used juniper trees for all the wood framing and rafters and cedar for shingles. Much of the lumber was milled at Burns, about 55 miles to the north.

Surrounding the 2-foot-thick stone corral wall is a 14-foot-wide exercise track. French's vaqueros saddle broke the horses within the corral and then began to train them walking laps around the barn. The P Ranch had huge requirements for horses, needing some 200 to tend its vast landholdings and huge cattle herds. The vaqueros broke a horse a day; the excess animals were sold to neighboring ranchers and settlers.

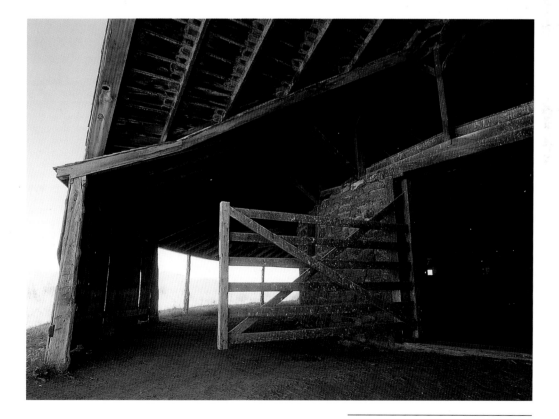

The side walls are only 8 feet high. This is another example of western barns designed with as much concern to wind resistance as to interior capacity. This was one of three identical round barns French built for breaking horses on the P Ranch. Above the inner stone corral wall was a circular haymow about 20 feet wide that ran the entire circle.

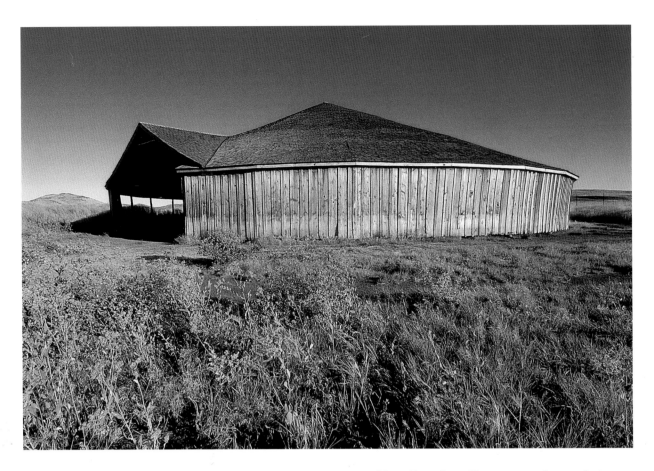

Hugh Glenn, then 46, typically hired Mexican vaqueros and Chinese cooks for his ranches. However, all of his foremen were whites, and he saw in the 21-year-old John French an able manager; Glenn hired him in 1870. French learned to speak Spanish and, for reasons never really known, it seems his men—Glenn's men—came to call him Peter. It was a name French adopted and used for the rest of his life.

In 1872, Glenn sent Peter French north with a select herd of 1,200 shorthorn cows, a few bulls, about 20 saddle horses, half a dozen vaqueros, and a Chinese cook. With no exact destination in mind, French encountered a disillusioned gold miner working the Donner and Blitzen Valley in southeast Oregon. The man went by the name of Porter. He owned a dozen cows and he readily sold them and his branding iron, the "P," to French. This conferred to French the right to every other steer with a P on its hip. More important, it conveyed the grazing rights in the valley where P cattle had fed.

Giles French, a Vermonter of no relation to Peter French, wrote *Cattle Country of Peter French* in 1962. In this fine history, French, the writer, explained the intertwined history of French and Hugh Glenn, a relationship that had great impact on cattle ranching and land use in the West. He explained what grazing rights meant in 1870s terms.

"The fact that there was no other brand on that range made the land technically his, under existing rules of possession," French wrote. "'First come, first served' decided the range rights of much of the West in the days of the big spreads. If a man moved into a territory and used the grass, he was entitled to continue using it and to expand until he came to the border of another cattleman's range. Usage, rather than outright ownership of the land itself, determined the right to control—but grass was all a cattleman wanted anyway.

"In 1872," Giles French explained, "land was not considered valuable; grass was the important asset, and then only when used in the year it grew. If a steer ate the grass and waxed fat and was sold and

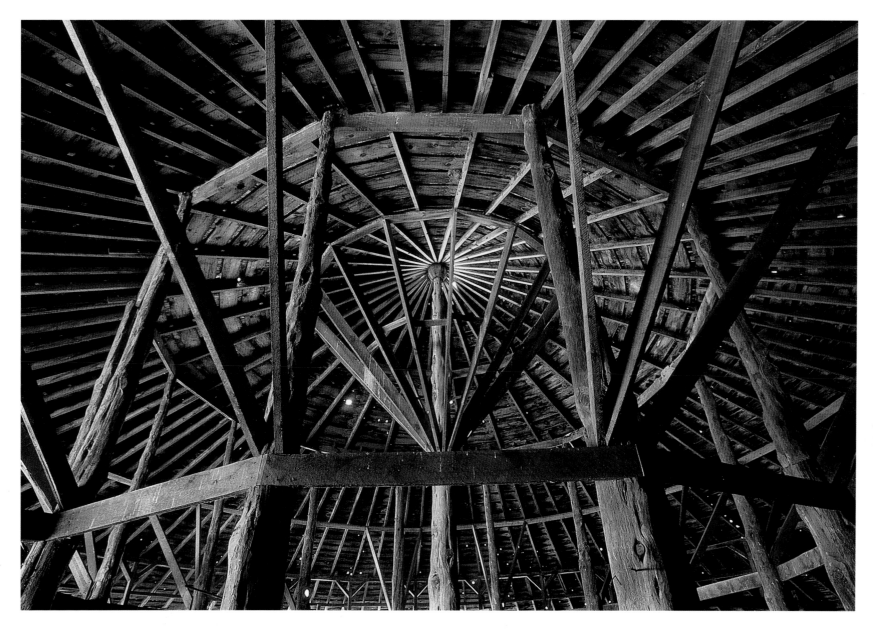

butchered to feed hungry people, a service was performed jointly by grass and steer and man. Ownership of the land made no difference."

The valley Porter occupied had enjoyed unusual rain during the previous 15 years. Some of the valley floor had returned to a kind of prehistoric swamp. Other ranchers feared leaving cattle untended in these areas, worrying they might be trapped and drown. Porter had the entire valley to himself, grazing in the shadow of the 50-mile-long, 9,354-foot high Steens Mountain. When French and his crew and the 1,212 head of cattle walked down

into the valley, they met grass up to their saddle stirrups. For French it was love at first sight. He decided to own it as far as he could see.

French quickly built a camp, the P Ranch, for his seven men. He had to transport lumber from Fort Harney, 70 miles away, to build a house for all of them. From a lower valley they found willows and fabricated a corral. They constructed a 50x150-foot calving and dairy barn. They began to capture and break wild horses that ran free through his big, remote valley. Over time, French and his crew built 500 miles of arrow-straight fences using smooth wire, replacing it

Such involved engineering and intricate joinery and craftsmanship are even more remarkable since Peter French grew up as a rancher and had no architectural training other than what he read in the variety of popular magazines of the late 1800s. The central juniper is 35 feet long, set 6 feet into the soil. The barn is 96 feet across and 29 feet, 6 inches to the center peak.

WAY
OUT WEST

Hamel/Rust horse barn, Davis, California

Like a scene out of history, Michael Carson, a blacksmith from Woodland, California, works on shoes for a young Arabian horse, tended by Lorry Dunning, an agricultural historian from nearby Davis. The 101-foot-long barn is 40 feet, 4 inches wide and has a 14-foot, 2-inch stable shed added to the east side. The front of the New England-style barn, facing north, is streaked with green moss.

The barn frame was formed of eastern hemlock and pine. In 1860 it was all gathered together by the George S. Lincoln Company, a machine-toolmaker at Phoenix Iron Works in Hartford, Connecticut. Lincoln and Phoenix had, in effect, produced a kit barn. It shipped the frame around South America to San Francisco, arriving in the spring of 1861. The landowner, Frederick Werner, transported the Phoenix kit to his 1,200-acre horse ranch in Davis where it was assembled and then sided with California redwood.

The barn was divided into 26 horse stalls, with an office, tack room, bunk room, and a quarantine stall. Loose grain, stored in the haymow, was delivered down two wooden chutes into feed boxes such as this one. In 1867 Werner sold his operation to Henry Hamel, who continued the horse operation even more successfully. Raising Clydesdales and Percherons, Hamel sold his big draught horses to San Francisco trolley car companies and waterfront shipping firms.

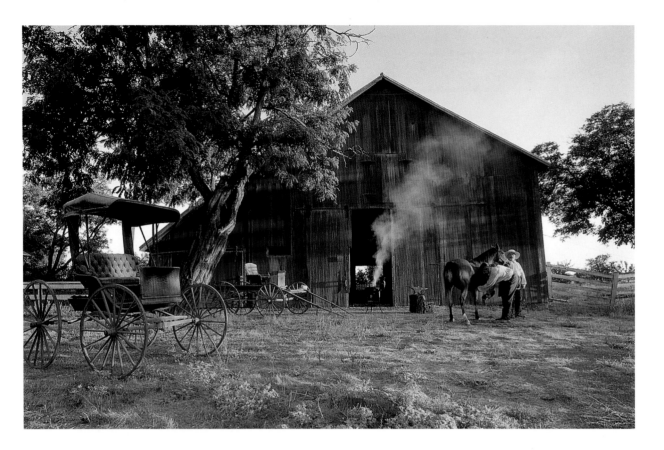

with good, reliable barbed-wire when that became available in 1877. They planted an orchard and a vegetable garden. They caught trout from the river, hunted deer and antelope from the valley, and got big horn sheep from Steens Mountain.

Eventually French built a large white house for himself and surrounded it with poplars to turn back the wind. He established a store at the ranch because by 1877, the P had grown so large—and was so distant from any town—that not only were food

This redwood-sided barn proves the old wisdom that moss grows on the north side. The Werner/Hamel barn was assembled from its "kit" with pegs in mortise-and-tenon joinery and handmade square nails for flooring, siding, and roofing. This barn, surely one of the first kit barns produced, is a curious blend of East and West Coast building styles and materials. The barn remains in the Hamel family to this day.

staples needed for his ranch hands but so were replacement supplies such as trousers and boots. As his—Glenn's—lands and herd grew, so did his crew grow, and his vaqueros often sent for their families to join them.

He paid his experienced men $30 to $35 a month. French was a compassionate and generous boss, capable of the same hard work as any of his men. He was known as an honest businessman, and he was well respected, well liked and, of course, envied for his success.

When neighboring rancher Bill Barton retired, French bought his Barton Lake Ranch which included a vast gentle hilltop that was dry year round even in wet years. On that rise, French built the first of his new barns, round ones, meant for horse breaking.

French reasoned that his men had little to do during the deep winter months. Yet horse breaking was just not practical in the snow. So he conceived a large round barn supported in the center by a single, 35-foot-tall, 1-foot-diameter juniper tree. A ring of 13 similar junipers circled the center post 14 feet out,

and another 14 feet beyond that a 24-inch thick volcanic stone wall marked the edge of the circular breaking corral. French's men hauled 170 cubic yards of the rock—about 250 tons—8 miles by wagon from the river. Fourteen windows—simple wood-framed holes, 2-by-3 feet, left in the stone walls actually—allowed light into the corral. Outside the stone wall was another 14-foot-wide dirt track surrounded by the 8-foot-tall wood-plank outer wall that held up the roof rafters. Lumber for the two gates, the rafters, and siding was milled in Burns, 55 miles north. The entire barn was 96 feet in diameter.

"French's theory," Giles French wrote, "was that, in this barn, colts could be broken in winter and be ready for riding when spring came, but his theory did not always work out. A horse could be ridden several days around the track inside the barn and seem gentle, yet might buck like a wild horse when mounted outside—a peculiarity of equine psychology that had to be learned from experience." It must have taken some peculiar psychology on French's part to get grown-and-otherwise-sensible men to

Werner "bought" the barn to house horses he trained for racing. He had a training track on his land just south of the barn. In the mid-1860s, his horses won first premiums "for Imported Stallions" from the California State Fair. The haymow runs the entire length of the barn with glory holes for a Jackson fork near the front and rear. In addition, two grain storage bins were located in the mow, providing gravity feed to smaller grain bins on the main floor.

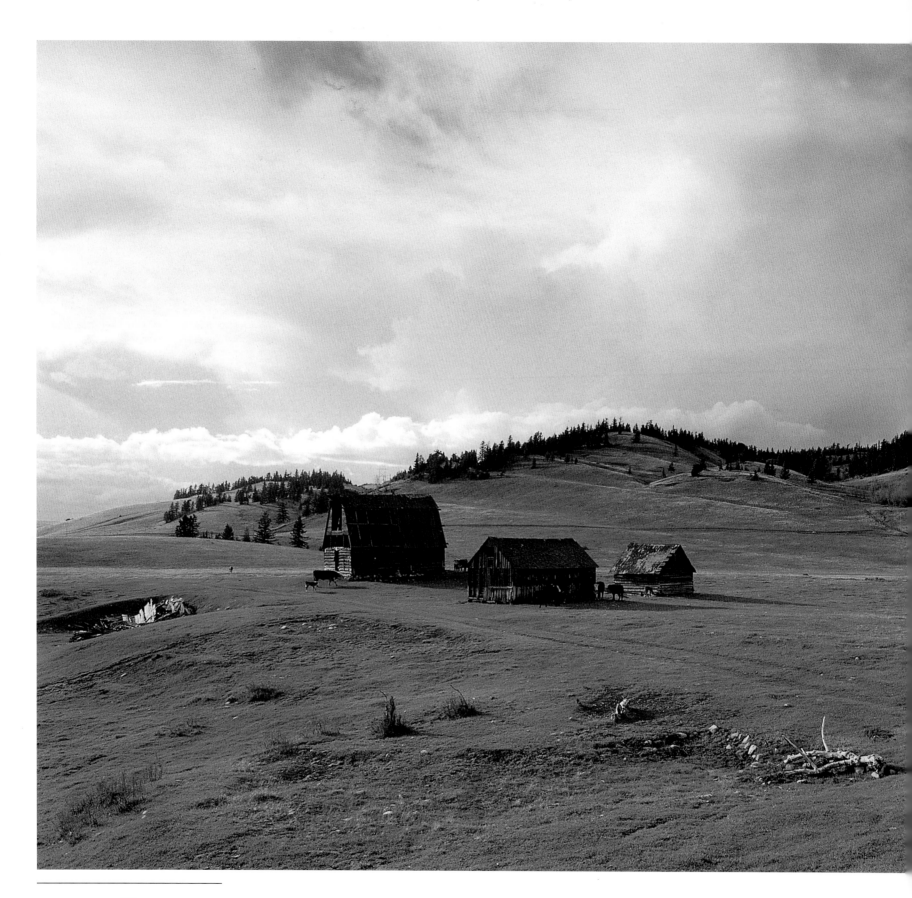

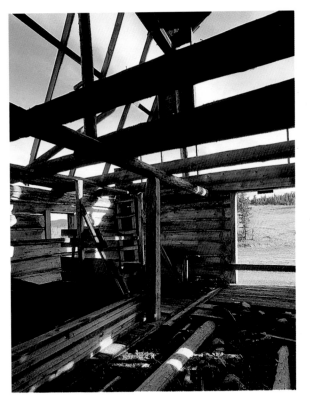

Giacomuzi log barn, Beresford, British Columbia

In the early 1920s, dairy farming regulations changed in British Columbia, dictating that cows could no longer be milked on dirt floors. So Joseph Giacomuzi abandoned his old banked barn and built a new dairy barn out of fir logs to the north. The old barn eventually fell onto itself on top of the cellar. Cream and milk were stored in the small log shed to the northwest of the barn, just past the granary.

Joseph Giacomuzi died in 1944 and by 1946, with the onset of yet another set of regulations requiring dairy cows to be milked only on concrete floors, his family retired the barn from active farming. The entire structure—log walls, floor, stanchions, and roofing—was made of fir, the most plentiful wood in the interior of British Columbia. Fir lasts a long time if its bark is peeled.

climb on wild horses bucking around inside a round stone building. Still, it worked so well that French built two more. One went up at the P ranch and the other was at Three Mile Ranch, some distance from the P. The French-Glenn operation reached a point where it raised about 300 head of horses and mule colts each year as well. French's men broke even more wild horses—some stories say as many as 1,000 each year—that the men captured running free. Beyond the 200 to 300 that the P needed to operate, French sold the rest.

Exact dates of the round barn construction are uncertain. Educated guesses suggest that they were built before 1880. Unlike Glenn's operations in California where more than two dozen barns stabled draft horses and stored planting and harvesting equipment, cattle ranching, especially in the West, had limited uses for barns. Herds were much too large to stable through the winters. With the exception of structures already existing on the ranches Peter French bought, there were few barns. It appears he and his men built only the one rectangular barn and the three round ones.

No one knows where Peter French got the idea to enclose a horse-breaking corral within a riding track, all under one roof. He was an extremely intelligent man, and he was a reader. It's likely that the popular journals that publicized Orson Fowler, Elliott Stewart, Franklin King, and Wilbur Frazer also reached the West and found their way into Peter French's saddle bags and on up to the P ranch.

French worked hard to acquire the entire valley for his boss. The U.S. government Homestead Act of 1862 acknowledged the land rights of squatters as long as they stayed on the land they had taken. Swampland—wet some years, dry others—fell into the cracks in existing legislation: states could sell swampland that had been claimed for $1 per acre, with no limit. French burst that loophole wide open in 1877 with a purchase of 42,300 acres of the Diamond Swamp. Transactions that large were not unusual at the P. In 1878, French sold a large herd for $125,665. By 1880, French was running more than 20,000 head on

Barn building in the West—in Canada and the United States—utilized different woods from what the continent has grown in the East. Further north, Swedish and Norwegian farmers and timber framers built with spruce and, using a broadax and adze into the early 20th century, finished floors as smooth as if the wood had been milled and sanded. Out on the coast, builders used cedar for framing, siding, floors, and roofs. Inland, and as far south as Californias Sierra Nevada mountains, Douglas fir was used.

The barn is built of 12-inch diameter fir logs. It is a gable-end entry structure, measuring 26 feet across the end and 31 feet, 8 inches long. The windows are 2-feet square holes left in the walls. In the mid-1960s, after the barn had been unused for nearly 20 years, vandals found the remote structure and began to dismantle it.

THE
AMERICAN BARN

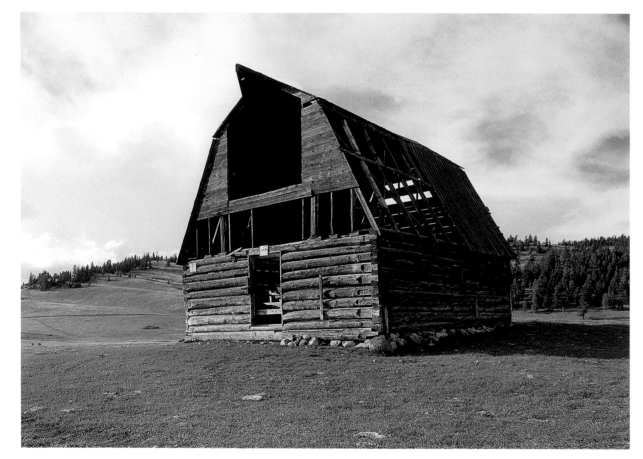

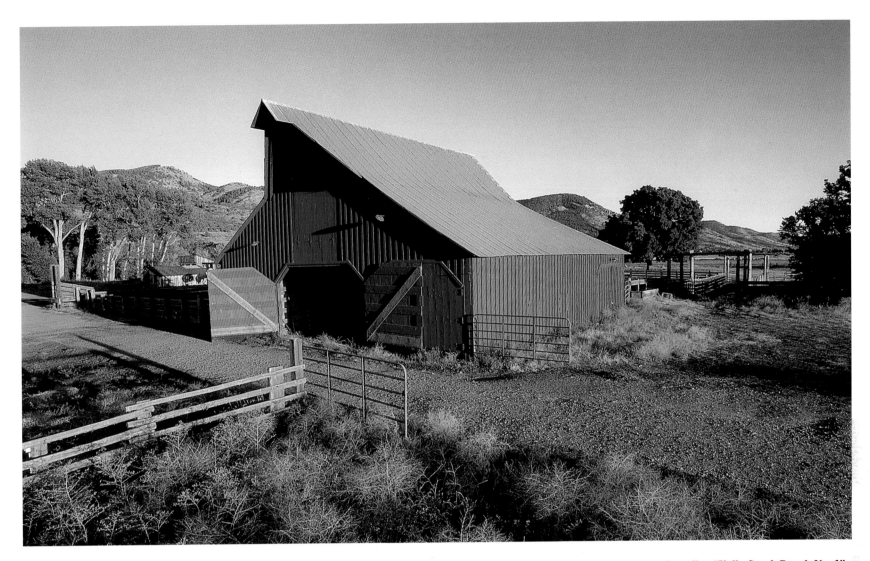

the P and he had begun a lucrative business in providing horses and mules—broken in the round barns—for the steady stream of homesteaders who swerved off the Oregon trail into southeastern Oregon or down to northern California.

In February 1883, Peter French married Hugh Glenn's daughter Ella. Just 16 days after the wedding, 58-year old Hugh Glenn was shot in the head by his former bookkeeper. His estate was valued at $1.23 million, including 30,000 head of cattle on the 70,000-acre ranch that French had built for him in Oregon.

Ella elected to stay with her mother in Oakland while French returned to Oregon to work and manage his crews, herds, and lands. Horse breaking continued at about one a day per barn. He continued to acquire lands.

Part of this land expansion came courtesy of the Homestead Act of 1862 that provided French with "swampland." It also offered 160 acres of public domain for a dollar or two an acre to anyone willing to settle on it. This was a better deal in some parts of the country than it was in Oregon's high desert. Scarce water made traditional crop farming impossible. Even cattle ranching was a challenge on a plot of only a quarter section. Most of these homesteads were established after the last great Indian battles in 1878 ultimately relocated the Paiutes and other tribes to distant reservations. When migrants heard it was safe to move to Oregon, many wanted to try what that rancher French had done. Most of them failed, and French bought up many of those homesteads.

Lewallen "Kelly Creek Ranch No. 1" horse barn, New Pine Creek, Oregon
Barns in the West evolved from the same thinking that put frontier settler families in sod homes hunkered down against the hard prairie winds. Western barns turn their backs and sides to prevailing winds, offering low eaves and low profiles instead of tall, hard flat walls. Hay hoods, the beak-like projection of the roof peak, are common. Large hay doors were built high up the front wall, and the essential Jackson, Louden, or other hay forks picked up the material off a wagon outside the barn and, like a crane, carried it into the barn to drop it.

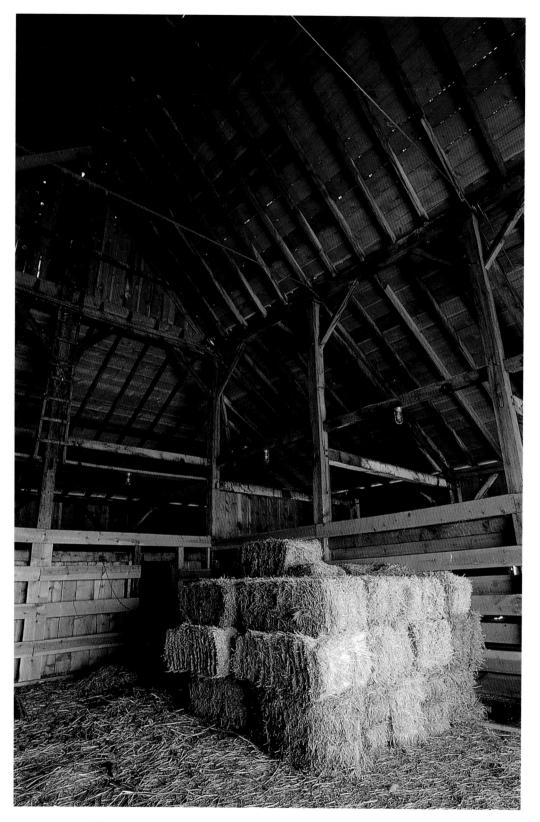

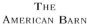

For years French had irrigated his acreage and provided water for his herds by draining off Malheur Lake, which constituted one of his ranch boundaries. The lake was extremely large, but it was very shallow. A 1-foot drop in water level exposed thousands of acres between the new and old shoreline. Through the 1880s, diminished rainfall had not replenished the lake. Settlers moved onto these newly opened lands to homestead. French, too busy and too kind, never protested or filed claims under riparian or shoreline rights. In late 1894, a Supreme Court ruling over a similar situation forced French to write letters. He told all his neighbors that he, not they, owned the land on which they lived. During the next three years, friendships unraveled as French was forced to file lawsuits to get any response from his neighbors.

Peter French turned 49. The family, directing the corporation, took control of the ranch and began reversing his orders. The Glenns constantly demanded more money even as cattle prices dropped. (The railroad, one of the ranch's best customers, had reached the Pacific Ocean. It no longer needed French's cattle to eat or his horses to work.)

The day after Christmas 1898, French helped his men to move a herd, working in place of one of his sick foremen. The group watched as neighboring rancher Ed Oliver rode out of a hollow at full gallop, charging them. Within moments, he shot French in the face with a pistol. Peter French died immediately. A jury trial found Oliver not guilty.

Within a few years, however, it became obvious to everyone that it took a man like John William "Peter" French, someone strong, courageous, and patient, to make that huge cattle operation work. The executor of his estate and of the French-Glenn Livestock Company sold all the land. One company after another tried and failed. The property and buildings fell into disrepair; the round barns at the P and at Three Mile Ranch came down. The Eastern Oregon Livestock Company, part of Swift and Company, gave it a try. Even they couldn't make it work.

They found a new buyer for the land Peter French had patiently and diligently acquired for Hugh Glenn. In 1935, Swift sold 64,717 acres to the

Slick metal roofs have gone a long way to save century-old barns from destruction by heavy snow. The barn, framed of fir and sided with spruce, is nearly square, at 53 feet, 4 inches wide by 57 feet, 4 inches deep. It was assembled with mill-sawed modern dimension lumber. The style of barn is also known as the "Mormon cattle barn."

Western barns were not meant for the same threshing purposes that English, New England, and early Pennsylvania Dutch barns had to accommodate. By the time settlers reached the West, threshing was mechanized. Barns sometimes stabled the horses ranchers used to tend their cattle, and the buildings stored feed for beef cattle that wintered outside. In this barn, pens surrounding the central hay storage were used for calving and foaling operations, and now, for equipment storage.

U.S. Department of the Interior for $675,000. It was added to land that President Theodore Roosevelt had designated as part of the Malheur National Wildlife Refuge back in 1908.

The Barton Lake Ranch and its round barn, however, was not included in those dealings. It remained in private hands, finally used for storing hay and grain for longtime local ranchers Richard and T. E. Jenkins. In 1969, they turned it over to the Oregon State Historical Society. Their gift included the cost of replacing the roof, around $14,000 for the crew to repair timbers, boards, and nail down some 50,000 new cedar shingles.

The cowboy violence of the West that ended the lives of Hugh Glenn and Peter French was a far cry from the experiences of the peaceable Mennonites in their lives in North America. But the culture and the architecture these deeply religious people brought with them to this continent had been directly influenced by the violence of those around them.

By the time the Mennonites arrived in Manitoba in the 1870s, they'd been pushed around Western and Eastern Europe for nearly 300 years. Their story began in the Netherlands and Switzerland during the Reformation, where the religious sect was founded by followers of a Dutch priest called Menno Simons. They wanted a clear separation between church and state. Membership in their church, acceptance of their beliefs, was demonstrated by adult baptism. Believers were Anabaptists, *ana* from the Latin for "again." They practiced Christian brotherly love and mutual aid. The emerging governments in the 16th century, however, seemed to them to exist solely to make war, and Menno Simons' followers refused to support them. These new governments demanded the churches support—even sanctify—their activities, no matter what they did. In exchange, the governments supported the churches financially. However, the Mennonites refused to swear loyalty or to fight, and they could not support the state-approved churches. To the governments, then, the Mennonites were a new enemy.

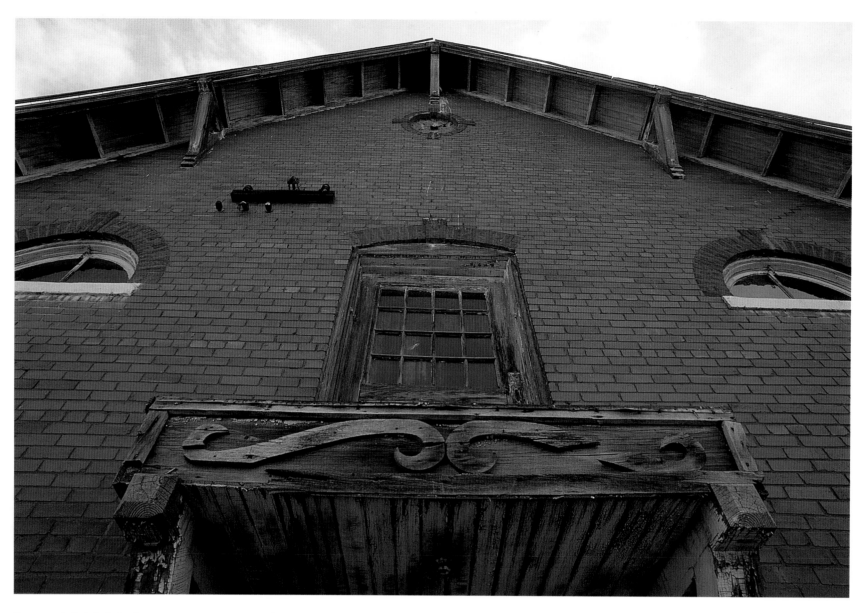

Petramala brick dairy barn, Trinidad, Colorado

The soil—clay really—in Trinidad, Colorado, produced better bricks than trees. Streets and buildings were built of bricks from the Trinidad Brick Company. Harry and Mary Bowman owned a general mercantile store in town. Mary ran a small dairy to sell milk in 5-gallon cans in the store. A large farm homesteaded in 1881 by two sisters came available around 1910, and Mary—fascinated by dairy farming— bought it, bought 50 cows, and built the large brick barn and other buildings.

Their strong beliefs resulted in their expulsion from many cities throughout Western Europe during the late 1500s. They were welcomed in Poland where the royalty recognized the value of a peaceful nature and an industrious work ethic. Offered the lowlands and swamplands of central Poland, the Mennonites accepted. Their farming traditions and architecture from the Netherlands suited this new homeland. Their homes and barns were the typical connected timber-frame, thatched-roof structures that protected livestock, harvest, and family under one rectangular roof.

In Poland, they were free to hold their beliefs, practice their religion, and keep their language. There were limits, however. They were neither allowed to mingle nor intermarry with the predominantly Roman Catholic population. Nor were they allowed to build their own houses of worship. This forced them to begin holding religious services in their barns.

Their refusal to bear arms, to serve a state, or to declare loyalty to any government made them unwelcome in 1772, when Prussia took over the Vitsula Delta lowlands that the Mennonites had inhabited peaceably for nearly 200 years. Prussians introduced mandatory conscription and taxes supporting the Protestant church and the military; the Polish Mennonites again prepared to move.

Between 1789 and 1830, most of the nearly 3,700 families living in Poland went on to southern Russia, invited by Catherine the Great. During this period, the Mennonites settled along the Dnieper River and then migrated farther, along the Molotschna River north of Crimea and the Black Sea. They established the same style of open farm villages as in Poland and in their original homelands. Again, they built traditional Dutch connected house-barn structures. But invading Tartars, intent on taking the lands themselves, forced the Mennonites to modify their farming—and their architecture—in a way that would have a long-standing impact.

Partially for reasons of security, but also for the purposes of equality, the Mennonite farmers gave all their fields to the village. All the land was redivided equally among the families. Each was given a long, narrow plot that extended back from the river. Houses were built—or moved—to be near the river or around a common grazing pasture, and cultivation took place in these long rows out the rear. The connected house-barns ended up side-by-side, with an equal distance between them. This offered much better protection as a united community.

By the mid-18th century, rules existed that described the placement and construction of buildings. Calm returned and prosperity soon followed. Brick began to replace wood as the primary building material for all structures. The architecture conformed closely from one farm to another, reflecting the Mennonite respect for simplicity and their desire to limit the possibilities for one farmer's personal wealth to outshine the others.

The Mennonites prospered, many of them became very successful in agriculture and in industry. From Altona in the southwest to Bergthal in the far east, to the Chortitza settlements north along the Dnieper River, some 85 Mennonite communities flourished in Russia. But again, politics interfered.

In the 1870s, neighboring German nations flexed their muscle. Russia reacted by seeking to make all its inhabitants "Russian." Their language became a mandatory study in schools and only

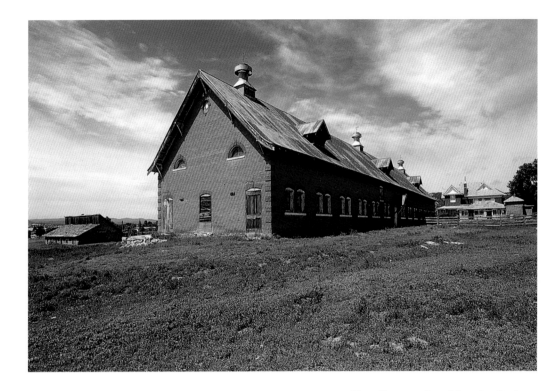

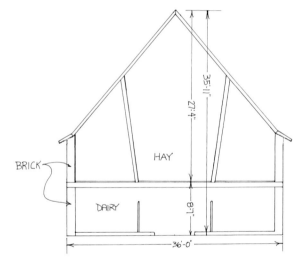

Petramala barn framing.

Mary Bowman found the plan for her barn from a blueprint of one in Pennsylvania. She adapted the design to flat terrain and changed the building material from wood to brick. Bowman sold all the milk in Trinidad, and her crew delivered milk to the coal camps in the area where coke was mined for steel manufacture. The barn is 36 feet wide by 171 feet, 9 inches long.

Russian was accepted for official correspondence. A Universal Military Service Act in 1874 reminded many Mennonites of Prussian requirements 100 years before. They resolved to move once again. Throughout the next 10 years, some 18,000 Mennonites emigrated to North America. Eight thousand of them headed to Canada, to the new province of Manitoba. The rest scattered into Minnesota, South Dakota, Nebraska, and Kansas.

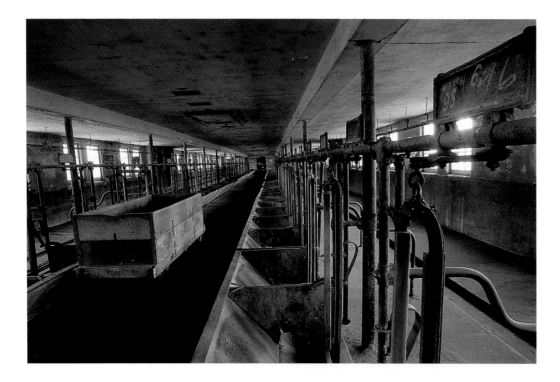

Mennonite architecture, particularly the homes and barns that they would build in southern Manitoba, were carefully studied in the late 1970s. The provincial government was organizing a master plan for regional development. Historians David Butterfield and Edward Ledohowski spent five years preparing an illuminating study for the Department of Culture, Heritage and Recreation, Historic Resources Branch, of the province of Manitoba. The result, a work titled *Architectural Heritage*, was published in 1984. It explored Mennonite travels and travails that had already established the kind of lives and architecture they brought with them to the province.

The first Mennonites into Canada had negotiated reserves of land starting in Steinbach, southeast of Winnipeg. Families began to arrive in 1874. By 1875, they expanded into the Western Reserve of lands held for them. They named their new communities

On March 1, 1945, Colorado adopted pasteurization laws. Cows could no longer be fed hay nor be milked on wood. Albert and Madeline Petramala had just acquired the farm from Mary Bowman, and they were given 90 days to cover the interior. The Petramalas used plaster of Paris. The modifications allowed room to accommodate 82 cows. Milking all 440 Guernseys and Holsteins at 12:30 A.M. and 12:30 P.M. took Albert Petramala and six hired men four hours for each milking.

The biggest job Albert Petramala had during his first 90 days was cleaning out the huge haymow. The 5x7-inch, 15-foot-long canted purlin posts are 12 feet on center. Those posts, the side wall braces, and the floor are all fir, the only wood available from nearby mountains. Before 1945, it could be dropped down through three trapdoors into the center aisle of the milking barn.

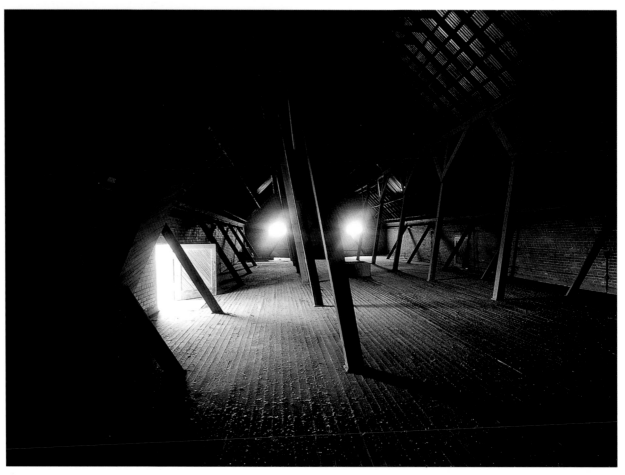

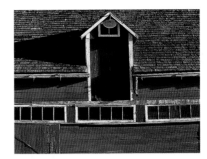

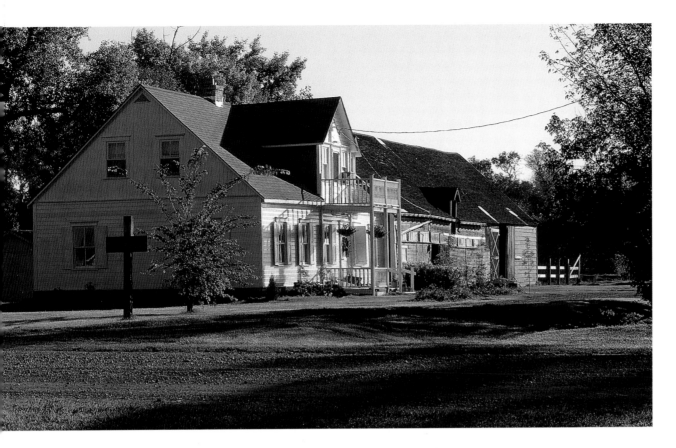

Traditionally, cows and horses were kept in the barns attached to the home. These animals needed regular attention whereas, the chickens and pigs could get by for a day or two when the temperature dropped. Cow pens were placed beneath the windows for light while milking. Horse stables filled out the end of the barn farthest from the house. The haymow, filled by its own outside door, ran the length of the barn.

Hamm house/barn,
Altona, Manitoba, Canada
Sunrise washes the south face of the Russian-Mennonite-style connected house and barn in southern Manitoba. The house, 24 feet wide and 38 feet deep, shares a common wall with the 33-by-83-foot livestock barn. Unlike New England connected barns, access to the Manitoba barns is directly from inside the house. In a frigid Canadian prairie winter (usually several days of -40 degrees F), the farmer need not go outside.

Altona, Neubergthal, and Chortitz, and other names carried over from Ukraine. The village design established in southern Russia was also carried over to this new homeland. Farms were laid out long and narrow. Each house was set 60 meters from the next, each one set back 30 meters from the road. A portion of land was set aside for nonfarmers and another for community buildings such as stores, the post office, schools, a blacksmith shop. From the first arrivals in 1875 until the railroad reached the area in 1882, most of the buildings were temporary log structures, quickly assembled, and covered with mud or sod. These were half submerged into the ground and consisted of two "rooms," the larger for the family, the smaller for the livestock. Called *semlins*, these roughly 15x35-foot structures were relatively warm throughout Manitoba's brutal winter due to the shared body heat of the inhabitants.

After their first winter, most residents set out priorities: plant, and then establish a more permanent home. As in Russia, the Mennonites in Manitoba set their connected house-barn buildings perpendicular to the road and always facing either east or south. These early houses originally comprised only four rooms in front of the barns.

By the time this generation left Russia for North America, brick had been used for building for all their lives. Neighboring settlers had to show the newcomers how to build with logs. The post-and-fill technique was widely adopted. Carpenters squared the timbers by adze or saw for posts, sills, plates, and corner braces. They filled the hollow walls with round logs. They cut tongues into the ends that fit into vertical grooves they had sliced into the posts. The builders applied a thick mud plaster inside and out to keep the logs in place and insulate the interior. From the first log homes, these buildings followed center-chimney plans and in many of them the builders designed elaborate cooking and smoking chambers and flues. These chimneys were often 7 feet square; these heated the house while they baked bread. The newer houses were much larger than the semlins, often up to 20x30 feet before the barn was added.

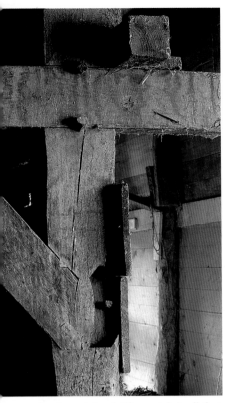

An elegant dovetail/lap notch is all that remains in the post and beam to mark where a sway brace once was fitted. This one would have cracked enough heads that it was removed to allow safer access to the rear of the barn. Separating the dairy portion of the barn from the horse stables was the threshing floor, called the "sheen."

In the Mennonite communities, farmers generally built their barns a few years after the houses. In the interim, they wintered their livestock in the old semlin log house. When the barn was built, it usually stretched twice the length of the house, but it was still attached to it, often sharing the same roof ridge line. It was generally slightly wider than the residence. Timber-frame construction used principal rafters at first, but then later, they went to common rafters. A small room called a *gang* led into the barn. The gang was a kind of air-lock that usually also provided access to the house cellar.

Ray and Marilyn Hamm's connected house-barn in Altona, in the center of the western Reserve Territory, is like the other dozen on each side of their road, perfectly aligned with its neighbors.

"One of the stories people joke about," Marilyn Hamm said, "is that before the trees grew, you could open front and back doors and see through the entire line of houses.

"There were strong church rules about living in villages," Marilyn continued. "The women all remembered how land sales took place. There were many of long evenings with lots of loose smoke and noise from the living room. These early rules said that land could be sold only with the approval of three-fourths of the village. And there were rules about cutting up your farms for your children. The places could end up too small to support themselves. So parents had to buy places for their children."

The Hamm's live in the second home that Ray's great-grandmother built on the land she homesteaded when she and her second husband arrived in 1876. (Homesteads were quarter sections: 160 acres configured in long, narrow slices.) No one in the family remembers why the first house, built immediately in 1876, came down, but the second one was built in 1890. A second floor dormer was added just before World War I.

"In the traditional four-room plans, the front room, farthest from the front door but nearest to the kitchen, was always the master bedroom," Ray Hamm explained. "In this house, the current master bedroom upstairs was originally the hired man's room. It didn't have a hardwood floor and only the back stairway for access so the hired man could zip down to do morning chores without disturbing the household."

Typically the barns behind the houses were for horses and cows, with cows closest to the house and horses farther back. These were the animals that needed the hired man's attention every day. Pigs and chickens were in a separate building on the other side of the yard.

"You knew if you didn't get to them every day, they'd still be okay," Ray Hamm said. "They were across the yard because the odor of pigs and chickens sticks more, and chicken dust is a fine powder that just gets through any door.

"Winters up here are really cold. Almost every winter we have a few days of minus 40 degrees Fahrenheit. We don't get so much snow lately, but what we get stays. In my memory, though, I can remember two or three times when the buildings have been buried by snow."

*M*ontana—like Manitoba—can be a hard land to accommodate; both challenge newcomers and longtime residents equally with winters recording successive weeks when temperatures rise only to 30 degrees below 0 by midafternoon. A half-week of 5-above constitutes a winter heat wave. Of course, Montana rewards its inhabitants with snowfall enough to soak the ground for spring growth, and they get scenery fit for the pages of *National Geographic* magazine. Still, Montana demands much of its residents.

But there are obligations and then there is endurance.

Paul Kleffner has endured. He has restored by himself the ranch that took a crew of carpenters and stone masons three years to build. The slight roundness in Kleffner's lower back betrays the fact that his foremost chore for the past half century has been the maintenance of his ranch's architecture. In conversation, Kleffner's smiles are reflected in his warm blue eyes.

Kleffner was 25 when he and his new bride, Thelma, moved onto the William Childs Ranch in East Helena, Montana, in 1943. They were tenant farmers.

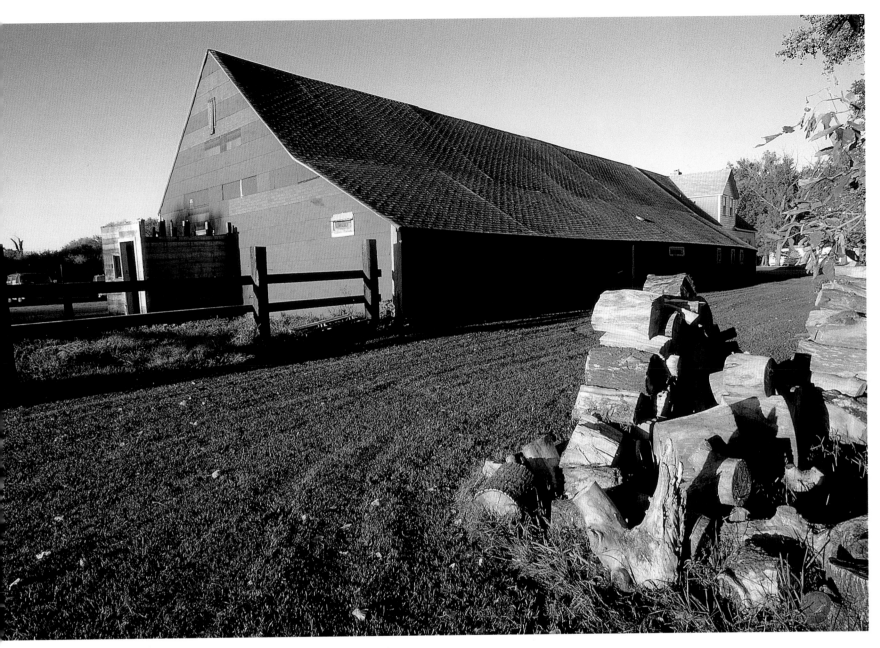

In the 11 years before he and Thelma arrived, the ranch suffered six tenants. Each of them only *took* from the place. Lacking any proprietary sense for their rented home, none of them put anything back into the ranch.

Iowa native William Childs had been successful mining gold in the 1880s in Montana. But he had lived through the drought of the summer of 1885 and through the brutal winter of 1885–86. That long winter was distinguished by 100 days of temperatures below zero. Thousands of cattle died when they couldn't find food beneath the frozen snow. A painting by Charles Russell called "Last of the 5,000" immortalized that hard winter as one lone surviving steer was set upon by wolves.

By the mid-1880s, however, Childs was wealthy beyond his imagination. He had the notion to become a cattle baron, but he wanted a barn large enough to house 500 head of cattle and adequate feed through a brutal winter. He set out acquiring purebred Herefords. He already owned 3,000 acres of rolling land, some of it heavily forested with old-growth 4- and 5-foot diameter pines.

The northeast corner of the barn shows efforts made with the addition of a shed to get roof eaves closer to the ground to better deflect the hard prevailing winds. Tradition in the community orients the house/barn structures perpendicular to the road. In this case, that puts its long sides flat against winds out of the north or south.

WAY
OUT WEST

Kleffner cattle barn, West Helena, Montana
When Paul Kleffner and his wife, Thelma, first bought the ranch, they found dozens of reasons to question their decision. An original 12x12-foot-by18-foot-tall cupola was threatening to collapse the entire roof, all 70 windows were broken out, much of the roof was leaking, the chicken house had collapsed, and the previous tenants kept their large flock of broilers on the second story of the house.

The barn was completed as a cattle ranch in 1888 by William Childs. There was a drought during the summer of 1885, followed by 100 days below 0 during the winter. The weather had killed thousands of head and Childs wanted a structure large enough to winter his herd of Durhams. In the past decade, the shingle roof was replaced with metal and the granite walls were remortared.

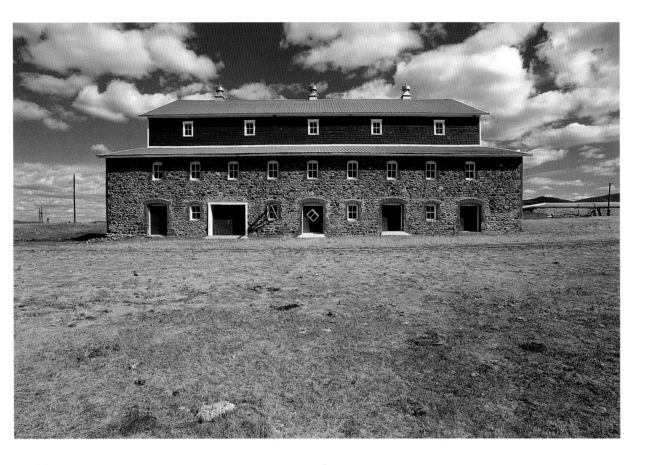

To construct his dream, Childs imported carpenters and 40 stone masons from Italy. The elapsed time of construction is not really known, but a photo dated during the summer of 1889 shows the barn and house complete and in use. The ranch house was an octagonal building, one of New Yorker Orson Fowler's offspring gone far astray. For Childs, innovation and ostentation went hand-in-hand.

"As William Childs' workmen excavated the ground for foundation footings for the barn, they found gold!" Paul Kleffner laughed at Childs' consistent luck. "In fact, they found enough gold that for some time there was a question whether to mine the site or build the barn. But there was an awful lot of gold in this area, on either side of Prickly Pear Creek here, so Childs ordered his crew to continue construction.

"The walls of the barn and cow shed, the ice house are all glacial granite. But granite stones are round. There are no square ones, square enough to use for a flat wall. To lay up a wall, the Italians

had to find the flattest side. And lots of the stones had no flat side.

"So the Italians simply chipped the rocks to make straight, flat walls. Let me tell you, those 40 stone masons had their work cut out for them." In August 1994, Kleffner completed his own project restoring the granite-and-concrete retaining wall on the Creek side of the house, a wall about 120 feet long and at its worst, nearly 8 feet tall.

"Some of those stones weigh at 150, 180 pounds. My back is still feeling it. I can't imagine how those men ever hefted those stones up 20-foot-high walls. It took me two years just to do this."

Childs built his showplace octagonal house with a huge ballroom on the second floor. Because the railroad ran right past the house, he took advantage of its proximity. He hosted lavish parties where guests were transported from Helena out to his East Helena ranch by rail. They rode the train back to town again at the end of the evening. But Childs' extravagant lifestyle broke

him. He had lost his fortune and, by 1903, the vast ranch with it.

A second family acquired the ranch from Childs' creditors. They made a valiant effort at running the place and keeping up the property until 1914 when they, too, failed. The Vollmer family moved in next and they tried to make it work, hanging on until 1932 when the Federal Land Bank took over. Between then and 1943, another six families tenanted the ranch. But to each of them, it was simply the next rental farm in their lives. The last family, chicken farmers, found Childs' chicken coop had collapsed. They moved their flock up into the octagonal ballroom that occupied the entire second floor of the house. What few windows had not yet been broken out by disrespectful tenants and town vandals, they removed, covering all the openings with chicken wire.

In 1943, Paul Kleffner and his bride, Thelma, signed on, renting the ranch for one year and then the next. The size of every part of the place challenged them. That ballroom was one of dozens of obstacles facing Kleffner. The floor was covered with nearly half a foot of chicken droppings. He removed one of the last window frames and began scooping the waste out the window. It slid down the roof and fell into wheelbarrows waiting below. By the time he got to the hardwood dance floor, he still didn't know that he had gotten there. It was black from two years of dampness. He tried scrubbing, for months. Finally a floor finisher from Helena arrived with a sander so heavy that it took the two of them to haul it up the stairs. When the dust settled, the 3/4-inch-thick maple was once again creamy yellow.

But that was typical of the struggles. The greatest was the barn. Its 70 windows were already broken out, and most of its more than 10,000-square-foot roof was missing or perforated. What was left leaked as though it was not there. Siding had fallen into disrepair or had slid off altogether. Should the Kleffners repair that big barn or simply tear it down? It took a lot of nights of talking with Thelma before they decided.

They would try to buy the place and repair it all.

Because there was more time than money in those days, Kleffner left his 760 head of mixed-breed cattle to themselves and he tended to the barn.

The peak of the roof, 55 feet above the ground, originally carried a 12x12-foot cupola that stood 18 feet tall. But its great weight had broken roof rafters and separated collar ties. Before it fell—and took the rest of the roof with it—Kleffner dismantled it, saving the wood for future repairs.

He relaid a lot of the planks on the first floor and up in the haymow that had rotted away. "But it doesn't show because it's been down for 50 years now," he said.

"I used some of the cupola wood and built three grain storage bins inside the barn. They held about 1,500 bushels each. And 300 tons of hay up there as well. That barn's big enough that I could keep every bit of my farm machinery inside it, too. But I quit farming in 1985, and so I pulled out the bins.

The 70 windows in the barn offer plenty of light. All of them were broken out when Paul and Thelma Kleffner first rented the property in 1943. The barn was well built, using 2x6s for wall joists. The barn is practically all white pine, harvested on the ranch. The frame was sheeted with pine 1x6s, 1x8s, or 1x10s, covered with a layer of paper and then finished with shiplap siding. The barn was last painted in 1989, using a mix of 200 gallons of paint and linseed oil.

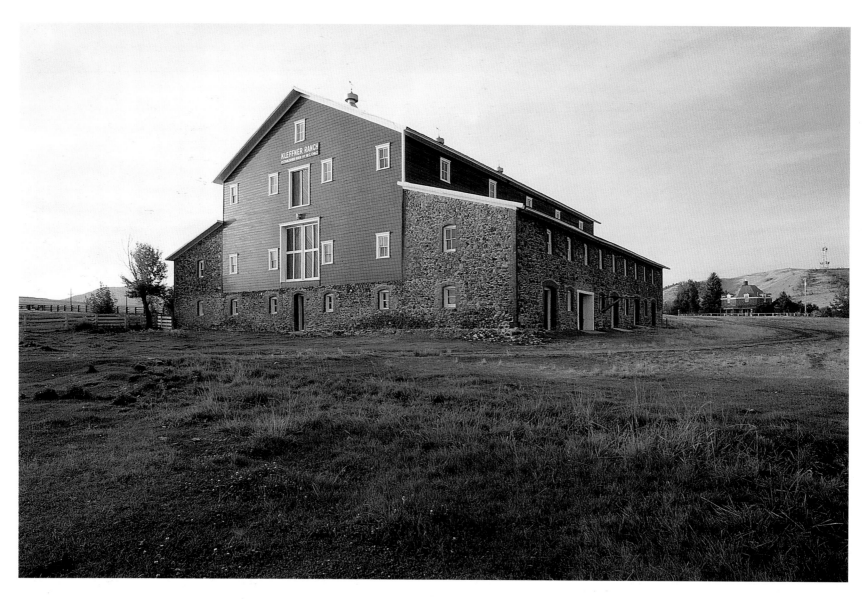

Late fall sunrise meets the southeast corner of the barn. The stable walls are glacial granite, 22 feet tall. The barn is 101 feet long, 105 feet wide, including the side sheds, and stands 54 feet tall from the ground to the roof peak; however, with its wide, broad "sheds" on either side, it appears lower. The granite absorbs the brunt of the brutal winter winds that come down from the Canadian prairie provinces. A ramp used to exist on this end of the barn as well as the other.

THE
AMERICAN BARN

"I left the haymow as a kind of museum. Well, not really a museum. There is a 12-foot-square hole in the floor from the mow. Used to be you'd drive your horse wagon in and use a sling, a grapple fork, or a Jackson fork to lift the loose hay up to the mow. But nobody uses loose hay now. That's a thing of the past. So, I left the equipment up there just for people to see.

"When we moved in, no one before us had done any maintenance. They had just used the place up. Down in the basement, there was so much manure. . . . The other tenants had wintered their own herds inside the barn. Rather than mucking out the eight dozen livestock pens in the basement, each tenant seemed to have left the job for the next

resident. The 40-year accumulation reached 4-feet deep. Well, it was like mining, getting through it. Then, when I got it cleared out, I found that a lot of the timbers had rotted away to nothing. Literally. I did a lot of work with a 50-ton jack shoring things up. The whole building would moan and creak."

Pine for the barn originally was harvested on the ranch, with posts and beams of 8x8-inch pine. Rough 2x6s were used for wall studs, then sheeted with 1x6s, 1x8s, or even 1x10s. On top of that, Childs' craftsmen put a layer of paper and then the shiplap siding.

The barn is 101x105 feet *inside* on the main floor and 2 feet larger outside. The granite basement foundation walls are 18 inches thick. To the

north of the barn is a low building that was a combination milk house/icehouse/root cellar/bunkhouse. It is built of the same stone as the house and barn—native Montana granite—and it is 40x70 feet. It looks much smaller, compared to the barn.

"I painted the barn again in '89. This time, we scaffolded the whole thing. Any holes that we found, nails or whatever, we caulked. This is the second roof I put on it, too. First one was shingle and that went bad. Now we have a metal roof put on with screws. It will last," he said.

"I replaced that big cupola with those three ventilators. Some people criticized me, but I really think it would have brought the whole barn down. I also put on lightning arresters and a ground line.

"It's been struck by lightning twice. The first time I don't know what saved it. It was so full of smoke you couldn't see across it. The second time it seemed fine, but the next morning we found the ground line flailing in the wind. Its end was just cut clean through right at the ground."

The waist-high corner bricks around the 10 animal doors in the basement of the barn are worn smooth and round. For nearly 90 years, hundreds of cattle rubbed their way in and out. The efforts of 50 years of maintaining the place have smoothed and rounded just about everything on 80-year-old Paul Kleffner. He has mostly retired from ranching. His herd is now 120 head of mixed cattle.

"Three years ago, a group of Japanese came to visit. They were impressed with the barn, but I could tell they were looking for something." He smiled and his eyes narrowed. "Finally one of them looked at me, I was wearing this feed cap, and he said 'Malobulo Man?'

"Marlboro Man. . . . So I disappeared back inside the house and came back out with my ranch hat.

"'Ahhh. Malobulo Man! Malobulo Man!' And so I got the part!

"United Airlines came and did a commercial here showing a Japanese businessman coming to buy cattle from a Montana rancher, me. It took them three days to shoot a 30-second commercial. They sent me a copy of it. It's beautiful. I can't understand a word of it, of course. It's all in Japanese. But it is *really* beautiful."

The hayloft above the second floor was designed to hold 300 tons of hay, enough for a herd of 500 head to get through a winter. Slings and Jackson forks were used to lift the hay to the 70-foot-by-100-foot third-floor hayloft.

WAY
OUT WEST

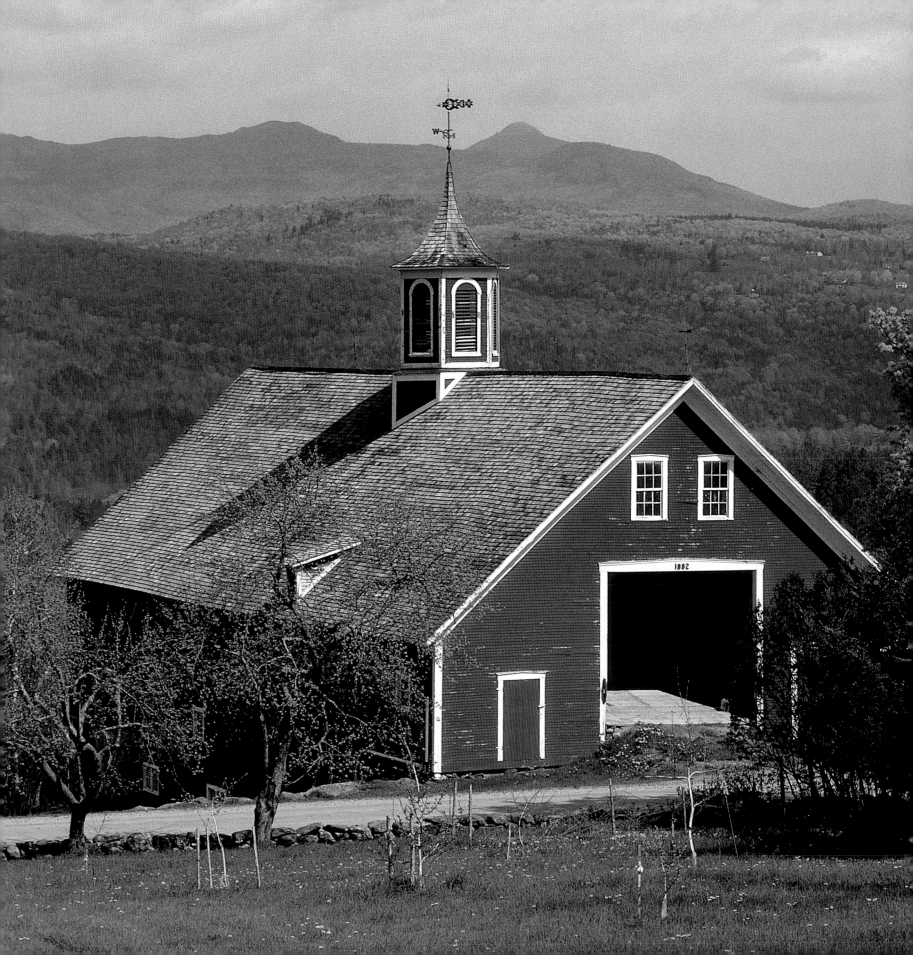

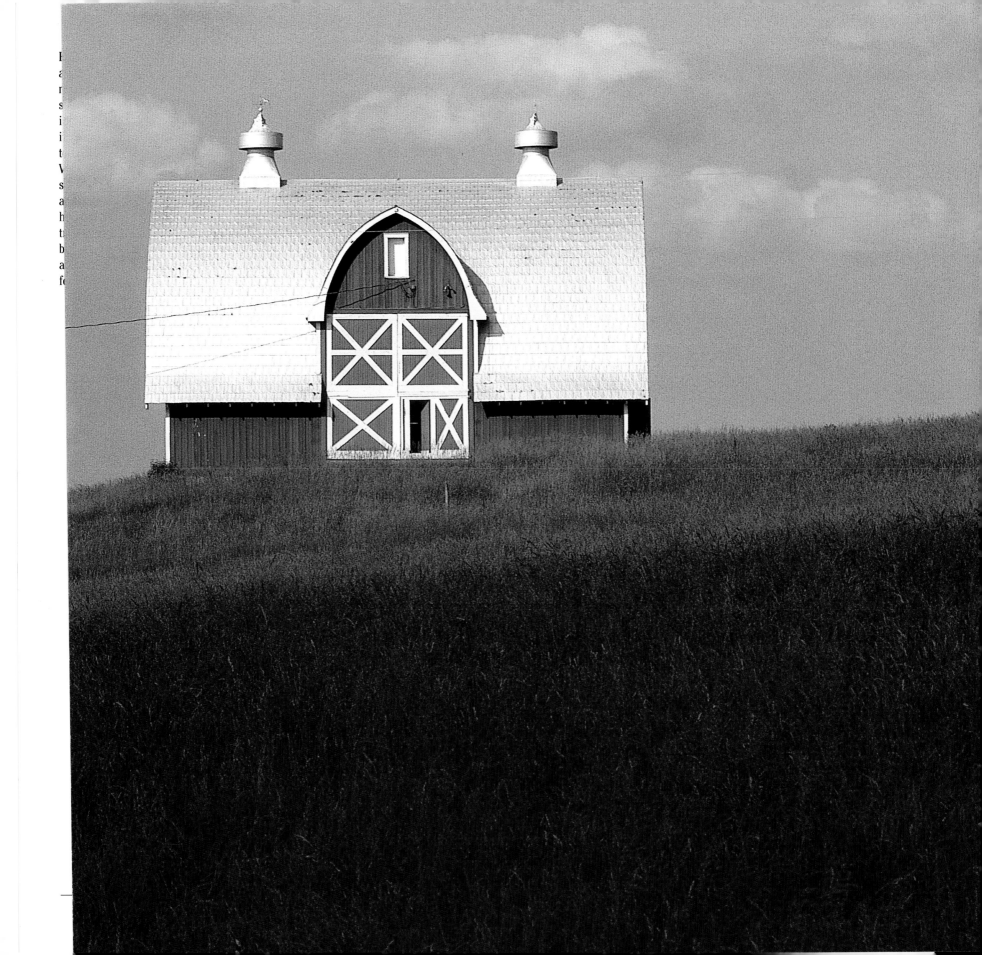

BARN RENAISSANCE

*T*he year 1900 began not only the Century of Electricity, but it was also the start of a new era of science, research, and hygiene. Chemists looked into the wholesomeness and purity of milk and found bacteria and dust in wood barns. Scientists inaugurated elaborate procedures. They told farmers to clean and groom their cows one hour before milking to remove barnyard filth and loose animal hair. An hour, they reasoned, was long enough to let the freshly stirred dust settle inside the barn and for the cows to calm themselves. During that hour, the farmer was to disrobe, shower, and scrub thoroughly, and then dress again in fresh, clean milking clothes. Only after the last cow was milked, the last drop of milk stored safely and securely (and the farmer had changed back from the "milk" clothes into the "barn" clothes) could the herd be fed its dusty, dirty, insect-ridden meal of hay and grain.

"It should never be forgotten," Dr. William Sedgewick wrote in his *Principles of Sanitary Science and the Public Health*, published in 1912, "that if water were to be drawn, as milk is, from the body of a cow standing in a stable, by the hands of workmen of questionable cleanliness, and then stood and transported over long distances in imperfectly cleaned, closed cans, being further manipulated more or less, and finally left at the doors at an uncertain hour of the day,

**Sears kit granary,
Meadowfarm, Orange, Virginia**
"'Springfield Modern Barn No. 3023" was ordered in the smallest size that this barn was offered, measuring 30 feet, 5 inches wide and 41 feet, 11 inches long. It stands 30 feet, 1 inch to the peak, not including its ventilator. Each of the five barns—two dairy barns, two horse barns, and this granary—was ordered and built in the early 1930s, probably in 1933.

As with all other Sears barns, the building is constructed of yellow pine for framing, flooring, and sheathing. Buyers could order cypress, "The Wood Eternal," as the catalogs referred to it, for siding. Doors were cypress and window sashes were California white pine. The gothic arch trusses were laminates of five pieces of 1x4-inch pine, spaced 22 inches on center. This barn was configured as a granary.

few would care to drink it, because its pollution and staleness would be obvious. . . ."

This unappetizing litany made sense to a growing population of city dwellers. By the turn of the century, U.S. towns and urban areas were populated with entire generations removed during their parents'— or even grandparents'—lives on a farm. America was becoming urban. Still, it would take state and federal legislators to enforce what common sense—and the variety of scientists—were saying should be done to protect milk drawn by hand into open buckets. In the meanwhile, farm and agricultural journal writers and magazine editors joined architects who had begun to discuss and consider on paper some solutions to the problems of sanitation.

In his 1913 book *Modern Farm Buildings*, professional architect Alfred Hopkins devoted 206 pages to contemporary thinking and his own ideas about developments in barn design. Hopkins argued that, to ensure certification for the farmer's milk, a separate milk room should exist, "entered by double-swing doors which must be opened by the milker pushing them with his elbows and not his hands. . . . The real reason for this room," he wrote, was "to provide a place that may be kept free from flies, odors and dust."

Hopkins had devoted more than a dozen years to farm building design by the time he finished writing his book. In it, he consulted not only his own imagination but also the experiences of farmers and the opinions of bacteriologists to establish his sometimes preaching text. Practices that had been universally accepted for hundreds of years were overturned in page after page. Each formerly standard procedure was now dismissed as unhealthful.

"The material for the interior surface of the cow barn," he went on, "is selected with a view toward the elimination of all wood. Even in a wooden structure the interior walls can be entirely covered with nonabsorbent materials, which render it possible to make a wooden building just as sanitary as one of masonry. To get this result it is necessary that the walls to the height of four feet above the floor be plastered in Portland cement, using the same mixture as for the top coating of the concrete floor."

Hopkins pointed out that while the concrete floors of the recommended 4-inch thickness got extremely cold in the winter, "it nevertheless remains true that for clean milk, the wooden floor is on no account to be tolerated, whether in barn or dairy." Cork brick and other materials that were introduced at this time came about primarily to protect bedded dairy cows from the cold.

The results of all this scientific discovery and architectural reasoning was a flurry of legislation that issued strict rules—and created new expenses—to farmers who sought to sell their milk to the public. In some regions, these kinds of costly modifications came as one more nail driven into the coffin of small farming.

*N*ew England farmers in the early 1600s had tried grain farming and had been defeated by rocky soil. Those who succeeded in any measure were then told to move the entrance of their barn from the long side to the gable end. This would make barn expansions easier when their farm flourished.

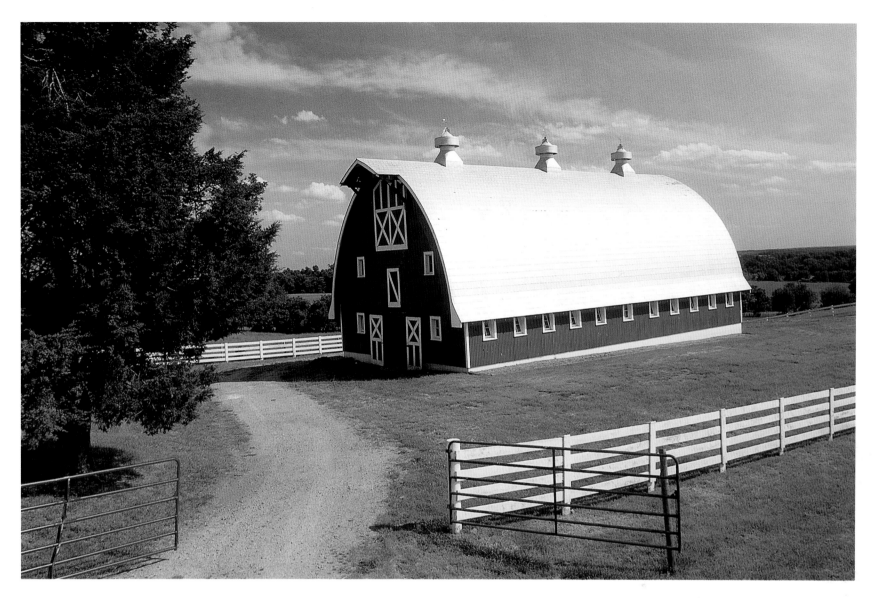

But few New England farms really flourished. Farmers in the Midwest plains states demonstrated how efficiently they could cultivate large fields and how inexpensively they could ship their harvests back east by barge or steamship, and later by rail, to a hungry eastern populace. New Englanders, lacking the Midwest's rich soil and economy of scale, adopted small home industries such as leather tanning and shoemaking, woodworking and finish carpentry, and other small trades to augment their meager farm income. And they picked up and relocated their wood barns with doors in the gable ends and attached them to their homes in order to make them more efficient.

When all the diversity of home industry proved too much for any one farm family to master, New England farmers discovered dairy farming. This required no more field clearing, no planting, cultivating, or harvesting. It needed only the tedious and exhausting twice-daily milking inside their wood barns. These were barns already a century old and long paid for.

The beginning of the age of hygiene, science, and research, however, rendered obsolete in a decade what thousands of unnamed barn builders had produced for centuries. Its effect on New England's often struggling small farm operators was devastating. Many of them already were working at barely subsistence-farming levels. They got by only

Taylor horse barn, Meadowfarm, Orange, Virginia
Sears, Roebuck and Company sold this barn through its mail order catalog. The "Honor Bilt" gothic roof barn, model number 2061, was offered in widths ranging from 24 to 40 feet and nearly any length the farmer desired. Paint was included. The structure was built mostly of top-grade yellow pine, and originally the roofs were either red cedar or slate-surfaced asphalt.

Sears workmanship was exceptionally high. This 1929 model was even available with Sears' carpenters who would do the construction. The kits arrived in a variety of shipments, timed to match the pace of construction, an early example of Just-In-Time inventory control. The barn was balloon-frame construction, with 2x6 wall studs 3 feet on center and 2x10 joists on 16-inch centers. The kits even included bathroom fixtures and plumbing hardware.

through a myriad of small home industries. For these farmers, the costs of updating their barns to new local, state, and federal hygiene standards was unbearable. Added to this was the emergence of larger scale industries—based in New England—that produced the same products as the farmers' home businesses but at much less cost. Under this weight, a large portion of New England farming was brought to its knees.

Large-scale industry wasn't finished with America's farmers and barns. The development and popularization of the hay baler put an architectural and engineering burden on century-old barns. These machines reduced the bulk of loose hay by nearly two-thirds. A ton of loose hay took up nearly 500 cubic feet, and this was one reason that the haymows assumed the proportions they did. A ton of baled hay occupied only 150 cubic feet, spreading the same load on a much smaller floor area.

*L*oad-bearing structural support and new hygiene requirements weren't the only thing on New Yorker Alfred Hopkins' mind. While taking into account updated regulations and new developments, architect Hopkins was also concerned about the visual appearances of the various structures. Silos, for example, gave him trouble, no matter what material was chosen for their manufacture. "Architecturally," he wrote, "the silo becomes a difficult problem, for while it is certainly typical of the farm, it is a most unmanageable thing to the architect. Perhaps the best way to dispose of the silo is to place it among the trees, where its rigid outlines are softened, but unfortunately such an environment is

not always available, and while it is possible to enclose the silo within a construction that shall partake of the appearance of the rest of the buildings, yet to erect one structure in order to confine another seems unarchitectural in the extreme."

After years of neglect, only at the beginning of the 20th century did any architects—let alone those of any consequence—begin to consider barns. And in one case, a background in farming seemed clearly to be a prerequisite.

The farm just south of the Wisconsin River was conceived at first as a home for Frank Lloyd Wright's mother, Anna Lloyd Jones Wright. But in 1911, plans changed. Wright had fallen too much under the public eye as a result of his private life. Because of this, his mother advised him to take the property she owned and turn it into his own retreat/home/studio. Come back home to Wisconsin to work, she suggested. So he quickly revised the plans he'd done for her home and turned them into his own farm estate.

Wright, already one of America's most visible architects, had gone to Germany in 1909 to prepare a body of work for a new client there, and he was accompanied during his travels by Mamah Borthwick Cheney, the wife of Edwin Cheney. Wright had designed the Cheney's home in Oak Park, Illinois, in 1903, and she and the architect fell in love as Wright's design was being built. When Wright's work in Germany was completed, they continued on together to Fiesole, Italy, for a long stay out of the sight of a curious public.

Anna Lloyd Jones Wright's property—initially 31 1/2 acres—was located in the Lloyd Jones/Helena Valley at Hillside on the Wisconsin River just south of Spring Green, Wisconsin. The complex that the architect began to design for himself in April 1911 spread out over some 37,000 square feet. It was meant to be not only his residence and design studio but also a working farm. He included horse stables, a cow barn, piggery, chicken house, and hay storage on the west end in an area described as the back, upper court. Another barn, a large octagonal one, already existed at the Hillside Home School which was on property Wright soon acquired and joined to his own.

On a vast farm in the Shenandoah Valley, part of an original 13,500-acre land grant from King George II, the Honorable Helen Marie Taylor has worked hard. She diligently and energetically re-acquired land previously sold off, and she renovated and restored the five Sears, Roebuck mail-order barns on Meadowfarm, her hilly, forested home. The Sears' barns were built on property that belonged for a time to a Sears' heir.

INDEX

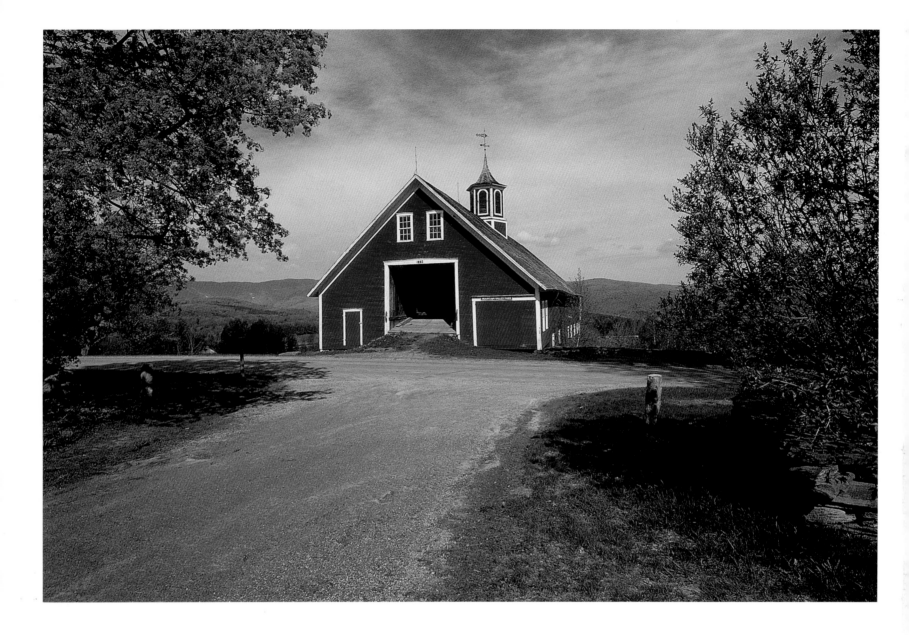